To Ading,

The Tibetans

Pu Rangzen

Shehman

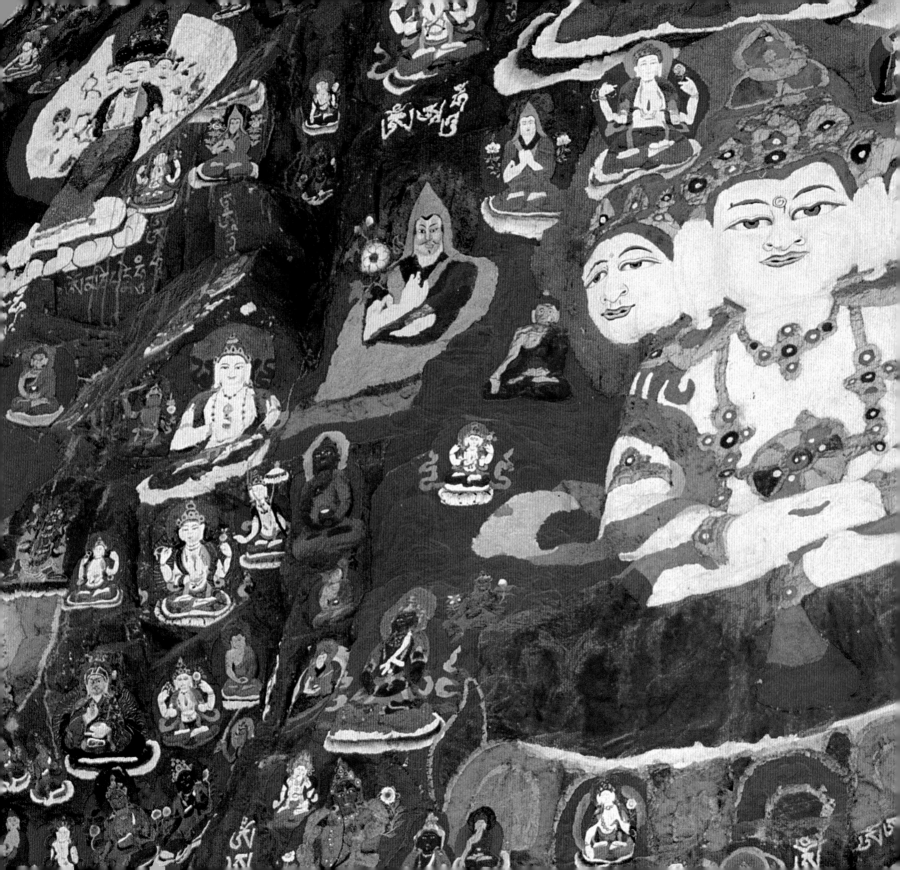

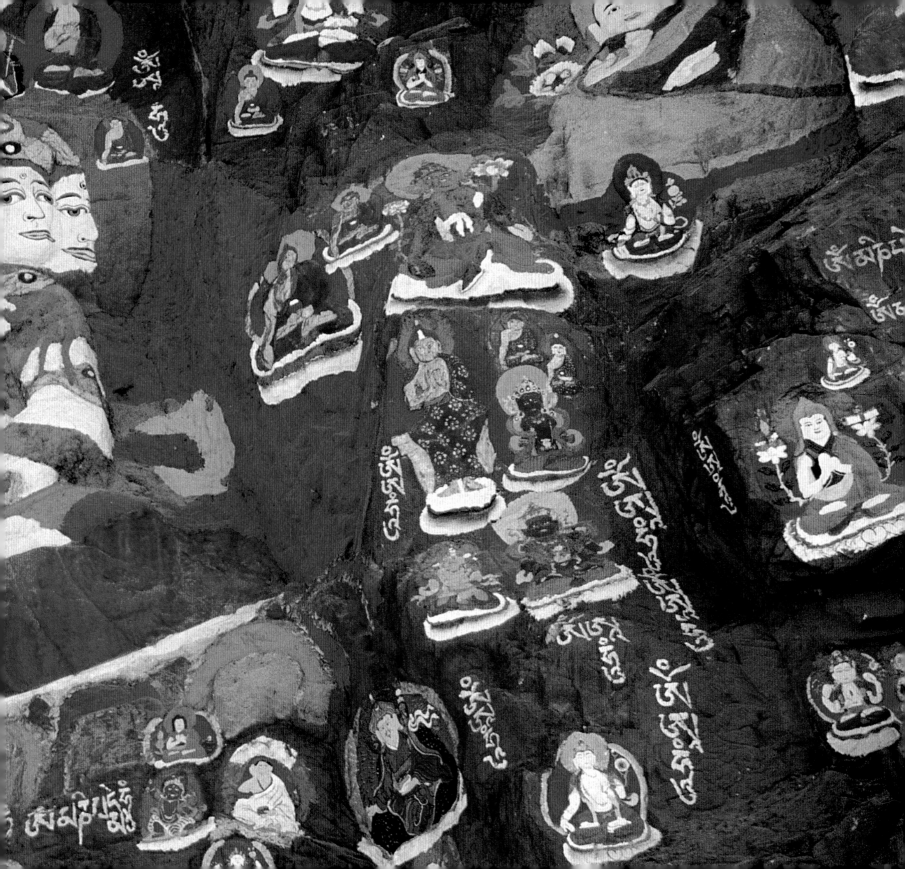

The Tibetans
A STRUGGLE TO SURVIVE

BY STEVE LEHMAN

introduction by robert coles essay by robbie barnett edited by mark bailey

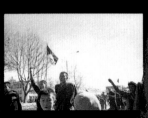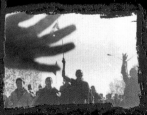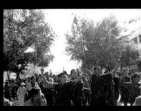

a red wheelbarrow book published by umbrage editions

Dedicated to those who risk all to stand up against oppression

In memory of my colleagues—

Cynthia Elbaum March 19, 1966–December 22, 1994

Dan Eldon November 12, 1970–July 12, 1993

Gad Gross June 25, 1964–March 29, 1991

The Tibetans
© 1998 by Steve Lehman
Photographs © by Steve Lehman
A Red Wheelbarrow Book.
Published by Umbrage Editions, New York
Distributed by Twin Palms Publishers, Sante Fe

Editor: Mark Bailey
Project Director: Nan Richardson
Copy Editors: Amy Hotch and Elaine Luthy
Assistant Editors: Catherine Byun and Rula Razek

Design by Francesca Richer

The generous support of the following individuals
and foundations made this book possible:

Circum-Arts Foundation
The ARCA Foundation
The Charles Engelhard Foundation
Tibet House
William D. Zabel
Steven Farber and Dr. Cordulla Kirchgessner
R.E.M.
Virginia Warner
Nardulli Custom Lab
Gary Breece

For information, please contact:
Umbrage Editions, Inc.
515 Canal Street
New York, New York 10013

First Edition

Printed in Italy by Arti Grafiche Motta, Milan

Library of Congress Cataloging-in-Publication Data
Lehman, Steve
The Tibetans
 p. cm.
 ISBN 0-944092-65-9
 1. Tibet 2. Photography
 I. Title. II. Lehman, Steve.
98-061503

ADDITIONAL CAPTIONS Endpapers: Official seal of the Fourteenth Dalai Lama of Tibet. Title page: Contact strip of the September 27, 1987, demonstration. The cover image, outlined with red grease pencil, shows Chinese police trying to prevent Steve Lehman from photographing. Dedication page: Chinese police stop Lehman from photographing in Lhasa. pp. 2-3, Blue Buddha, a religious fresco carved into rocks along the Lingkor pilgrim route that surrounds Lhasa. p. 7, View from sentry post guarding Tongmai Bridge near the Chinese-Indian border. The region remains tense due to continuing border disputes between China and India. pp. 26-27, Chinese government regulations for foreigners posted after the October 1, 1987, riots. pp. 40-41, Tibetan protester is arrested by Chinese security forces during unrest of March 5, 1989. In the following days, up to 200 Tibetans were killed by security forces and at least 400 were arrested. Martial law was declared on March 7, and the People's Liberation Army (PLA) took control. pp. 50-51, Political prisoner montage, Row 1: 1. Lobsang Tenzin, 31, former student at Tibet University, arrested March 19, 1988, and sentenced to life imprisonment for allegedly killing a policeman; 2. Tsewang La, 61, accountant, arrested June 16, 1995, whereabouts unknown; 3. Lobsang Choekyi (Paldon), 24, nun at Garu Nunnery, arrested June 15, 1992, and sentenced to six years; 4. Tsering Dhondup, 43, former student at Nechung Monastic Institute, arrested March 19, 1988, and sentenced to ten years in Drapchi Prison; 5. Phuntsog Yangkyi, 20, nun at Michungri Nunnery, died in police hospital on June 4, 1994, after being beaten in Drapchi Prison while serving a five-year prison term; 6. Lobsang Delek, political prisoner, additional information unconfirmed; 7. Losang Thargyal, monk at Sang-ngag Monastery, arrested 1993 and sentenced to seven years; 8. Gyaltsen Pelsang, 18, nun at Garu Nunnery, arrested June 14, 1993, at the age of 12 and released after serving twenty months, then escaped to India in 1996; 9. Geshe Lobsang Wangchuk, 75, leading political activist, theologian, and historian in Tibet during the 1980s, sentenced to eighteen years, died from severe beating by a prison guard in 1987; 10. Thubten Yeshe, 41, farmer, arrested June 1, 1992, and sentenced to fifteen years. Row 2: 1. Kelsang Phuntsog, 25, monk at Sera Monastery, first arrested August 4, 1991, and given a three-year sentence. Arrested again on July 9, 1996, for printing a pro-independence document; 2. Dorje Tsering, 33, additional information unconfirmed; 3. Sonam Gyalpo, 42, tailor, arrested September 27, 1987, sentenced to three years and nine months in Drapchi Prison, arrested for second time in July 1993, and released in 1994; 4. Lhundrup Zangmo, 28, nun at Michungri Nunnery, arrested August 21, 1990, and sentenced to four years, increased to 9 years for singing and recording pro-independence songs in prison; 5. Dorje Wangdu, 39, radio repair mechanic, arrested April 22, 1991, and sentenced to three years in a labor camp; released after several months perhaps because of international pressure; 6. Unidentified political prisoner; 7. Chadrel Rinpoche, abbot of Tashilhunpo Monastery and leader of the search committee for the reincarnation of the Panchen Lama, sentenced to six years in prison on April 21, 1997, for "plotting to split the country" and "leaking state secrets"; 8. Lhakpa Tsering, 20, sentenced to three years in prison, died on November 14, 1990 after being denied medical treatment for injuries sustained during a severe beating by a prison guard; 9. Thubten Namdrol, 63, monk at Palhalupuk Temple, arrested December 14, 1987, and sentenced to nine years in Drapchi Prison, recently released on parole; 10. Ngawang Sandrol, 22, nun at Garu Nunnery, serving three sentences totaling eighteen years in Drapchi Prison. Her initial sentence was extended for recording and smuggling pro-independence songs out of prison, refusing to stand in the presence of an official, shouting a pro-independence slogan during punishment, and not tidying up her bedding. Row 3: 1. Chung Tsering (Lobsang Tenzin), 34, monk at Ganden Monastery, arrested May 13, 1994, current status unconfirmed; 2. Gyaltsen Kalsang, 24, nun at Garu Nunnery, arrested June 14, 1993; after eighteen months of her two-year prison sentence, she died on February 20, 1995, from health complications caused by severe beatings; 3. Ama Penchoe, 68, housewife, arrested in the summer of 1995, whereabouts unknown; 4. Ngawang Rigdrol, 24, nun at Garu Nunnery, arrested June 15, 1992, and sentenced to six years in Drapchi Prison. Row 4: 1. Unidentified political prisoner, early 20s, nun at Ani Tsangkhung Nunnery, being held in Lhasa Gutsa prison, possibly released; 2. Tachen, 49, arrested summer of 1995 and released in September 1995; 3. Ngawang Jungney (aka Tashi Tsering), 28, arrested January 13, 1994, and sentenced to nine years; 4. Drolkar Kyap, 27, student at N.W. Minorities Institute in Lanzhou, arrested on June 19, 1995, and sentenced to seven years in prison; 5. Tseten Yangkyi (female), arrested February 1989, missing and presumed dead; 6. Gyaltsen Drolkar, 27, nun at Garu Nunnery, arrested August 21, 1990, and sentenced to four years in Drapchi Prison, later given an additional eight-year sentence for recording and smuggling pro-independence songs out of prison; 7. Name unavailable, nun at Garu Nunnery, arrested on June 14, 1993; 8. Nyima Gyaltsen, nun at Chubsang Nunnery, arrested on June 16, 1993, and sentenced to three years; 9. Yulu Dawa Tsering, 72, a tulku and former abbot of Ganden Monastery, one of the most significant political prisoners in Tibet, spent over 25 years of his life in Chinese prisons and was released on parole in 1994; 10. Gendun Rinchen, 51, tour guide, and one of the most important Tibetan political activists, accused of "stealing state secrets" and "separatist activities" arrested on May 16, 1993, released in 1994, and later escaped to India; 11. Ngawang Choephel, 32, former ethnomusicology student at Middlebury College in Vermont and Fulbright scholar, arrested in August 1995 and sentenced to eighteen years in Ngari Prison for espionage; 12. Tseten Tashi, 23, arrested in 1989 and served two years in Sangyip Prison; 13. Tsam-la, businesswoman, arrested December 10, 1988, and sentenced to three years in Gutsa Prison, died August 25, 1991, five months after release. Photo Credits TIN: Row 1: 2, 5, 8, 10 (Gu-Chu-Sum). Row 2: 1, 3, 5, 7, 8, 10. Row 3: 1, 2 (Gu-Chu-Sum), 3. Row 4: 1, 2, 4, 6, 7, 8 (Gu-Chu-Sum), 10, 11. TCHRD: Row 1: 3, 6, 7. Row 2: 2, 4, 6. Row 3: 4. Row 4: 3, 5, 12, 13. pp. 126-127, Tibetan currency. A one-hundred srang note minted between 1945-1950 by the Tibetan government.

NOTES The photograph of Jampa Tenzin rallying the crowd on pp. 30-31 is a cropped image with a rough border added digitally to maintain consistency. The shadow detail and contrast in the portrait of the nomad boy on p. 121 was maintained through the production of a digital negative. Flair damage on the bottom of the image was repaired by recreating the black border. The shadow detail in the horse racing photograph on pp. 140-141 was lightened digitally in Photoshop. The photograph of Jampel Tsering, Ngawang Phulchung, and Nima Oeser on p. 16 is a snapshot provided by The Tibetan Center for Human Rights and Democracy (TCHRD). The photograph on pp. 44-45 was reproduced from a Chinese magazine and most likely taken by a Chinese military photographer. The version published in the book was obtained by the Tibet Information Network (TIN). p. 48 is a still photograph taken by Steve Lehman from a Chinese police video obtained by Western news sources and distributed through TIN.

THE PHOTOGRAPHS and information in this book were gathered over a ten-year period. Steve Lehman made six trips to Tibet, three trips to India, and one to Nepal, spending nearly two years in Tibetan areas to conduct the necessary fieldwork. The quotations accompanying the photographs were derived from hundreds of interviews. The interviews in Tibet were conducted primarily in Chinese language, with translation by Steve Lehman. The interviews conducted in India were in English, Tibetan, or Chinese. Because of the political sensitivity of the work, the names of many individuals are fictitious. When a quotation is attributed to only a first name, the name and occupation of the source have been changed to protect their identity.

THIS BOOK is printed on BVS-PLUS, matte surface, a 100% chlorine-free product by Scheufelen. The wood pulp used in this paper was produced by Sodra Cell, a leader in sustainable forestry and clean papermaking techniques. In the publishing of this book every effort was made to use a paper manufactured with minimal negative environmental impact. We were unable to use recycled paper due to the higher cost and our own budgetary constraints. The higher price of recycled papers is directly related to their smaller market share, governmental subsidies and weak legislation that allow the cost of virgin wood paper products to remain artificially low. The low market price of virgin wood pulp does not reflect the hidden costs of habitat loss, water pollution, and soil degradation caused by deforestation. For more information on alternatives to virgin wood paper products please contact Re-Think Paper at (415) 398-2433.

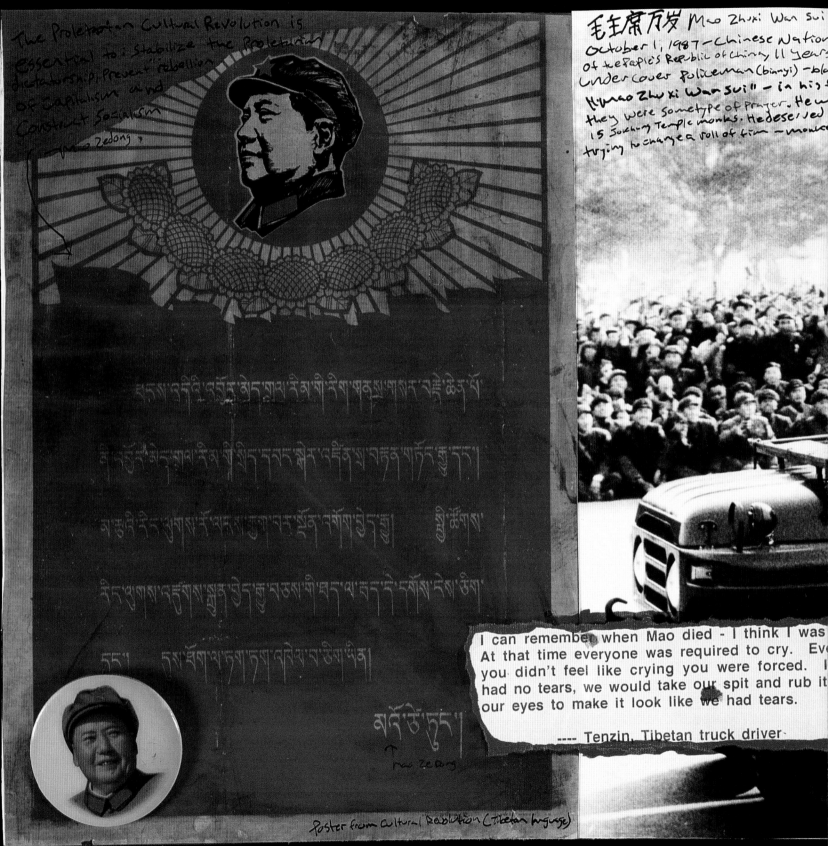

The Proletarian Cultural Revolution is
essential to: Stabilize the Proletarian
dictatorship, Prevent "rebellion
of capitalism and
Construct Socialism
— Mao Zedong

毛主席万岁 Mao Zhuxi Wan Sui
October 1, 1987 — Chinese Nation
of the People's Republic of China 11 years
Undercover Policeman (binyi) — bla
"Mao Zhuxi Wan Sui" — in his
they were some type of prayer. He w
15 Jokhang Temple monks. He deserved
trying to change a roll of film — monke

I can remember when Mao died - I think I was
At that time everyone was required to cry. Eve
you didn't feel like crying you were forced. I
had no tears, we would take our spit and rub it
our eyes to make it look like we had tears.

---- Tenzin, Tibetan truck driver

Mao Zedong

Poster from Cultural Revolution (Tibetan language)

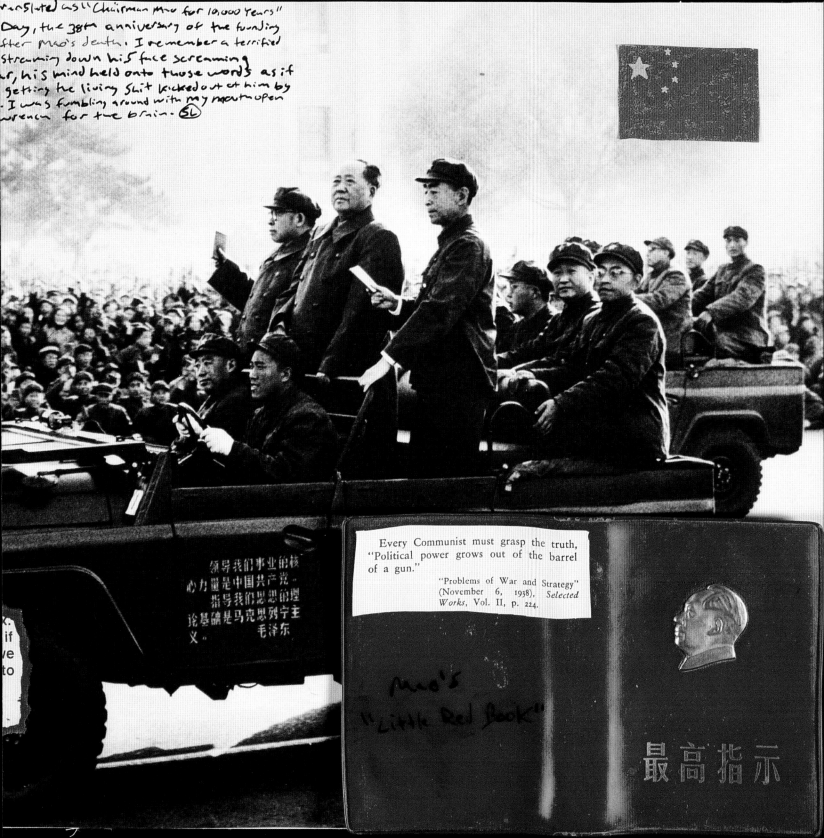

preface by steve lehman

Tibet is one of the most beautiful and spiritual places in the world; it is also one of the most repressive. This book hopes to help redefine people's perceptions of what Tibet is—to illustrate this dichotomy and to challenge romantic stereotypes.

In 1984, at the age of twenty, I first traveled to Tibetan areas in Nepal. My interests were not fully formed and I was motivated by the desire to explore one of the last untouched cultures. I was drawn to the land, hoping to reexamine my life experience by immersing myself in an environment so different from my own. Upon the opening of Tibet in the late 1980s, I returned to work on an anthropological project documenting a village of cave dwellers. I had very little awareness of politics. Tibet had always been one of the most isolated places in the world and the foreigners who had visited largely wrote exotic travelogues.

My first day in Tibet proper, I was attacked by dogs and sought aid in the home of a Tibetan family. Upon entering, I was greeted by an elderly man. From his face, I knew intuitively that something traumatic had happened in his life. For his involvement in the Tibetan resistance movement, Tenzin had spent fifteen years in prison and three of those years in solitary confinement—a small dark room, with only a cup of barley flour and a glass of tea each day. Tenzin wanted his story remembered; he wanted to tell someone the truth of what had happened. The conversation left a deep impression on me and it was through his story that I was introduced to Tibet. I began to resent the myths of Shangri-La created by my predecessors.

On the morning of September 27, 1987, I was in Lhasa near the Jokhang Temple buying supplies for my expedition to the village of cave dwellers. There was some commotion near the temple that I assumed was a festival and decided to ignore— I was leaving in two days and was extremely busy with the final preparations. I planned to be away for at least a year. Finally I decided to investigate. As I approached, a group of young monks emerged from the crowd; they were carrying Tibetan flags— demonstrating for independence. Immediately I understood the implications of their actions and knew that they were either going to be shot dead in the street or imprisoned. I was moved by their selflessness, by their decision to stand up for their beliefs and give up their lives for the greater benefit of Tibetan society. It was clear that they wanted me to photograph the demonstration and I reacted. There was no hesitation— witnessing those young monks sacrificing their lives was very powerful and I felt an obligation to do what I could. I documented the demonstration and ensured that the story reached the outside world. I realized that trying to find an untouched culture was naive, a romantic myth. What was important in Tibet was the people's active struggle to maintain their identity—to survive the political repression and the process of assimilation.

Several years later, on another trip to Tibet, I realized how quickly time had passed. My friends' children were nearly grown—young boys and girls now adults. I walked around looking for people who did not exist anymore, places and events related to memory—a young boy shot in the back, monks throwing stones. I recorded the changes.

I wanted to visit my Tibetan friends, to laugh about old times, but resisted the temptation. I was acutely aware that those who became seriously involved in politics were all imprisoned or forced to flee to India. The situation in Tibet is gray; the deeper one investigates the more complex it becomes. The Chinese have repressed the Tibetans, and the Tibetans have repressed each other. China could never have been as successful in their occupation of Tibet without high levels of Tibetan collaboration. In order to survive, people make compromises. In Tibet, they call it "having two faces." I learned not to trust anyone, knowing that my association with a person as a foreigner and journalist might mean they spend ten to twenty years in prison for espionage—"passing state secrets to the enemy." In the course of my work I have been harassed and detained—the police know who I am. They have gone from hotel to hotel with my photograph, searching. Journalists are not allowed in Tibet without direct approval from the Ministry of Foreign Affairs and the accompaniment of an escort. This approval is rarely granted and highly circumscribed. As a consequence, it is extremely difficult to gather information, let alone to form relationships or enter into people's homes. At times, I fear that my work, despite all precautions, may have implicated people.

This book incorporates a wide variety of photography, from news photographs, Chinese police photographs, and snapshots of prisoners made in the late 1980s to medium-format portraits and color images made in 1997. While the technology of recording images can arguably be objective, the nature of the medium is rendered subjective by the point of view the individual brings to the process. Lhasa has several advanced surveillance systems mounted in areas of frequent unrest, and China has consistently used photography in Tibet as a means of identifying and arresting political activists. In my work, I try to give voice to people who do not have the ability to bring their stories to the outside world. At times, I consider my role to be that of an interpreter. Ultimately, this book is my individual point of view, a personal interpretation of people, places, and events.

After a decade of covering Tibet, I have come to view China's relationship to Tibet as a colonial occupation. Historically, this type of political relationship has proved ineffective because of the economics involved. Over the long term, China's presence in Tibet will prove to be economically unviable. I feel the high cost of development, governmental infrastructure, and the maintenance of the military apparatus, coupled with the potential for serious international repercussions both politically and economically, will force a compromise in policy. China is a much different place from when I first visited fifteen years ago. Increasingly dependent on the West, both for investment and as a developing export market, it can no longer ignore these forces. For these reasons, the aspirations of Tibetan nationalists are more realistic than they are popularly perceived. If the Tibetans are able both to increase the pressure of internal dissent and to sustain their international political movement then there is hope for their struggle for self-determination.

FREE TIBET

SAVE TIBET

HINTS ON HIGH ALTITUDE

Some people arriving in Lhasa may feel the effects of Lhasa's high altitude at 3,683 metres/12,000 feet. Less oxygen in the air can cause a range of symptoms such as headache, tiredness, sleeplessness, nausea and breathlessness which may occur individually or together.

If you are not feeling well at high altitude, the Himalayan Rescue Association says it is most likely you have some mild symptoms of altitude sickness.

布达拉宫

ཕོ་བྲང་པོ་ཏ་ལའི་ལྟ་སྐོར་བརྟན་ཏེན།

A souvenir of the trip to the Potala Palace

Tips for Travelers to the People's Republic of China

intake each day. By drinking these fluids, kidney function is incr this then takes excess water from the body (fluid retention increa high altitude especially in the lungs and brain, hence headaches). recommended people drink one litre of fluid per thousand metres, th everyone arriving in Lhasa (3,683 metres) should consume at least If fluid a day on arrival is sufficience. It is also advisable to go when you arrive in Lhasa as it will take some days to acclimatize

PAR AVION

SEND: URGENT PRESS PHOTOS

DON'T TAKE PICTURES OF THE BRIDGE

核武器 héwǔqì - nuclear weapons
核动力 hé dònglì nuclear power
核试验 héshìyàn ⊕ nuclear test

introduction by robert coles

The mind's imaginative life seeks symbolic expression constantly; we invest our aspirations, yearnings, anxieties, and worries in various people, places, things. Put differently, we are always on the lookout, through the way we regard the world, for an inner statement of sorts—as if we know that what interests us or troubles us gives us a sense of definition, and shows the world a good deal about who we are. For certain individuals, for a long time, Tibet has been such a symbolic place—its inaccessibility, its mysteries, its stubborn cultural and spiritual singularity a magnetic "come-on" for westerners themselves afraid of becoming lost, anonymous, and morally adrift amidst the secular seductions, the hype and glut of a "market economy" that seemingly knows no bounds. No wonder Tibet looms large for some of us—both its religious life and its present-day vulnerability remind us of what we've lost, what we fear, what we yearn to have, but can't seem to find, no matter our relative privilege and power.

Yet, an interest in something, even an obsession with it, does not necessarily guarantee an adequate (never mind thorough) knowledge of what has commanded so much attention and concern. Tibet's "hold" on some of us, its power to elicit in us alarm, empathy, and outrage, has yet to result in an outpouring of words and pictures that really tell us how it goes in that distant territory, that social and cultural and spiritual world that both eludes and intrigues us. True, we can learn about ourselves by examining the nature of our perceptions of Tibet—the way we have chosen to regard it in film, in photography, through the published word. That Tibet (the one that preoccupies us) has been the nation of Buddhism, of mountains as tall as any in the world, of striking landscapes, and a distinctive religious tradition that has been attractive to a relative handful, and of no real interest to others. But the ordinary people of Tibet and the ordinary village life of Tibet have not commanded our general interest, and so are beyond our ken.

Now, however, we who most likely will never travel to Tibet have an opportunity to see it and learn about its current travail through the words of its own people and the pictures of a photographer who knows the country well, and wants us to learn about its urgent struggle to survive—yet another instance of a proud but vulnerable people become objects of colonial aggrandizement. Here, in a book, we have a people's contemporary history as it has been tragically unfolding these

recent years, and as it is described by men and women who have ample cause to feel themselves and their relatives and their neighbors to be victims. Here, we at a great distance from those people have a chance to read what they have to tell us about their lives and their experience of assault and plunder from others who have on their side might, not right.

That is, alas, the bottom-line story of today's Tibet—a people known for their pastoral and spiritual qualities have become a kind of prey to the fierce insistence of a powerful neighbor bent on taking, absorbing, and controlling not only land and property, but a whole way of life shrouded in centuries of customs and beliefs. Under such circumstances, the hurt of victims, their sadness and dismay, their moments (and longer) of confusion and outrage, become a psychological story important to be known on its own terms—but also a serious moral challenge to the rest of us who are, after all, fellow human beings of the Tibetans, alive with them at a particular moment in the world's history, a time when, actually, we are all so close together, no matter the distances that separate us, courtesy of airplanes, E-mail, and yes, the willingness of photographers such as Steve Lehman to overcome all sorts of obstacles (of terrain, of politics) in order to take the measure of one or another social scene.

What follows belongs to a tradition of documentary observation that has given us, in this century, a chronicle of economic collapse, war, social upheaval, and political turmoil. What once was described in retrospect (Tolstoy with respect to the Napoleonic invasion of Russia, George Eliot with respect to the parliamentary reforms of the early nineteenth century, Dickens with respect to the "poor laws" of that same time) is now the subject of contemporary observation with the help of the camera and the tape recorder, not to mention the ingenuity of those who use them, no matter the obstacles meant to deter such inquiry. Not rarely, such documentary work becomes itself an aspect of the particular struggle or tragedy described in pictures or through the words of those interviewed. By no means is China's military and political and cultural victory over the Tibetans final and secure. A country can be seized, and its people stripped of their previous autonomy; a country can be invaded, so to speak, by those who follow in the wake of soldiers, and who aim to assume a growing economic and social authority, but still those so threatened can resist tenaciously, and summon for help others at a distance—the readers of this book, for instance, who have their own right to make known what they have learned, and what they believe ought be done in the name of justice.

In perhaps the most distinguished of all documentary efforts, *Let Us Now Praise Famous Men*, James Agee constantly pays tribute to the people he came to know in Alabama in the middle of the 1930s, and as well, to the powerful and knowing accuracy of the photographs taken by his friend and working companion, Walker Evans. But Agee goes further. He speaks directly to his readers, reminds them that they are a part of what documentary work intends to be—an effort not only to explore factuality, to render what has been spoken or witnessed, but to establish a larger moral community: suffering explored and put on the record, suffering understood and felt by those who buy books, contemplate their significance, take their lesson to heart. In no small sense, then, the Tibetans, here, join with us, wherever we are, as comrades in jeopardy at the end of this second millennium—their ordeal becomes ours as well: the occasion of joint and intense anguish.

Jampel Tsering Ngawang Phulchung Ngawang Oeser

Lhasa, Tibet - 1987

oral history by jampel tsering

Jampel Tsering is a Drepung Monastery monk who led the September 27, 1987, demonstration that revived Tibet's claim to independence. He spent five years in Drapchi Prison, accused of "participating in the criminal activities of a counter-revolutionary clique." In 1996, Tsering escaped across the Himalayas to India, where he has since lived in exile.

My name is Jampel Tsering, my nickname is Kelsang. I am now twenty-eight years old. I was born in the Medrogongkar region, which is about two hours east of Lhasa. I joined Drepung Monastery in 1981 and studied there as a monk until I was arrested during the 1987 demonstration.

I was brought up in an environment where there was a strong faith in religion. This had a powerful impact on me. Since I was young, I was interested in exploring spiritual matters more deeply. This is the reason why I entered the monastery and chose to become a monk.

My parents were very religious and supported my decision to become a monk. They were farmers. Both my father and my mother were born peasants, and like most families in the countryside, farming was their main occupation. My mother passed away when I was eight years old. And my father did not live long enough to see me being released from the prison. He died eighteen days before.

The fact that my father had passed away just before I was released was really, really sad for me. From a Buddhist perspective, I comforted myself by examining the principle of impermanence and understanding how everything must change—but it still brought a terrible sense of loss, personal loss, it affected me deeply. It was tragic that he did not live long enough to see me again—there were only a few days left before I was released.

I would like to say a few words about my father. My father was not educated in the sense that he studied at school. Nor was he educated in modern science or technical subjects. Even in spiritual matters he was not really learned. He was a very simple man—his philosophy was to be honest and live harmoniously with other people. For these qualities, he was respected

in the society. In Tibetan language, people would describe him as a *Lama Kunchok*, a person with the highest moral principles.

I do not remember very much about my mother. Most of what I know is what I heard from my father and all I remember about her is that she died when Tibet as a whole and our family in particular were going through a very difficult time. During the Cultural Revolution, my mother was subjected to harsh "struggle sessions"; she was paraded in the streets as a "counterrevolutionary" and forced to wear this long hat—in English you would call it a dunce cap. I feel my mother died because she could not take the trauma that came with these humiliations. Because she died when I was so young, my father had more influence on me.

My father was always very straightforward when speaking with people. He was straightforward to the point of being abrupt. He believed that no one should be two-faced, showing one face to society and then another in your own personal dealings. That sense of honesty, that sense of straightforwardness stuck with me right from childhood—along with my father's belief that we should not try to harm other people, but try to help as much as we can.

My parents used to discuss the situation in Tibet with us, but not specifically. They never spoke openly about Tibetan independence. In fact, I never heard them speak of how Tibet was occupied by China or anything like that in front of me, but yes, they did recount their experiences of the Cultural Revolution and how my mother suffered. It was rare, but on several occasions they spoke of the situation prior to 1959, they would say how much harder their life was now. When my parents discussed these issues, there was this air of deep fear—the political situation was very strict and my mother was still accused of being counterrevolutionary, so they needed to be careful. Although we never discussed Tibetan independence, these conversations were the beginnings of my interest in politics, and had a definitive influence on my later actions.

When I was sixteen or seventeen years old I started to think about independence. I would ask questions to myself and try to analyze things in my mind. The fact that Tibet was an independent country was obvious. I didn't need to see documents. We are a distinct people, speaking a different language and having different customs from the Chinese—this speaks for itself. We did not have to dig very deep to see that we have a history of being an independent country.

I started to get involved in pro-independence activities in 1987, often discussing the issue of Tibetan independence with my friends. Before I go on, it's important to give you a sense of who I am as a person. My basic nature is that I like talking and I like being with friends—most of all I like talking to friends. When I was young there would always be a group of friends circled around me and most of the time I would be doing the talking. For this quality, I was reprimanded by my teacher. He used to scold me and say, "Why are you always doing the talking? Even the older ones are listening. What do you have to say that's so important that everyone is listening to you?" During these early conversations, my friends would also tell me their feelings on this issue and everyone would be welcome to speak, but most of the time I was the one who did the talking on independence.

When I discussed Tibetan independence with my friends, we did not discuss the issue in specific terms and we did not talk about what we should do to get back our independence.

During this time, I often listened to the Dalai Lama's speeches and read things about politics; they interested me deeply. These speeches by His Holiness were on cassettes. I got most of these from Tibetans returning from India and some from westerners whom I had met. These foreigners did not speak Tibetan. Whenever we met foreigners the first thing we would do is ask for the Dalai Lama's picture. And then if we were lucky, if the foreigner was kind enough, he or she would give us cassettes of the Dalai Lama's speeches.

I remember one incident that stands out in my mind. While traveling on a bus, there were a few nomads from western Tibet, from Nagchu—I think they were from Nagchu—they were from a very remote area. These people looked, well, very dirty, they had no sense of hygiene. They were wearing *chupas* made from animal skin. Because they come from an area that is very cold, the skins had never been washed and were filthy. Their feet hadn't been scrubbed for a long time, and their hair was all matted. The Chinese sitting near them made faces and put their hands over their noses—they were racist and looked down upon these people. This had a very strong impact on me, it was very insulting. I really felt angry because the Chinese were discriminating against us on our own land.

When I was later arrested I remember telling the Chinese authorities this same story during my interrogation. I told them that they were arrogant. If they were so bothered by these smells and lack of hygiene, then it's better that they didn't come to Tibet to begin with. Tibetans have every right to be as dirty or as clean as they want to be, because they are living on their own land. Tibet belongs to Tibetans. And if the Chinese feel that they cannot put up with the Tibetan people just because they are unhygienic, or for whatever reason, then they should leave. This incident left a strong impression on my mind. I feel that the racism and discrimination influenced my decision to become involved politically.

When I first took part in the demonstration of September 27, 1987, I was nineteen. Prior to demonstrating, we fully understood the risk and the danger involved in this type of action. However, we felt that there was no other option left. We could not remain silent to the things that were happening. To tell you the truth, when we were in the monastery we were not very, I wouldn't say not interested, but not very active in political matters, in political things. We concerned ourselves more with religious matters. I would say the main impetus for our taking part in that demonstration was the Dalai Lama's presentation of the Five-Point Peace Plan to the American Congress on September 23, 1987.

After the Dalai Lama put forward this peace proposal, the Chinese mounted a propaganda campaign to discredit his efforts. The language was very harsh and insulted him personally. The television, radio, and newspapers carried statements saying that the Dalai Lama was collaborating with Western anti-China forces in hopes of splitting the motherland, and his actions were

against the wishes of the Tibetan people and against the interest of the masses. They said that the Dalai Lama was trying to revive feudalism once again for his own personal benefit. Since the propaganda that the Chinese had started was very strong, we felt that if we Tibetans did not do anything the whole world would take that propaganda as the truth.

Tibetans in Tibet have a strong faith in the Dalai Lama—he is our leader. And we know that whatever the Dalai Lama does is for the welfare of the six million Tibetans and not just for his own personal benefit. So to be a party to the Chinese propaganda was not acceptable to us. But we knew that if we participated in a demonstration or if we did anything to counteract the Chinese propaganda, we would have to pay a very heavy price. We had been brought up on the horrible accounts of how Tibetans were persecuted during the Uprising of 1959 and how they were killed, imprisoned, and tortured. We knew this and could make the logical conclusion that if we stood up to the Chinese in any way, then we would all end up as dead people. Dead. And our families would also have to pay a big price. But at the same time we were not willing to keep quiet. We felt that it was our moral obligation to support the Dalai Lama's peace proposal. We wanted to tell the world community that the Chinese propaganda was wrong, that the Dalai Lama was right, and that Tibetans were not happy inside Tibet. So we decided to demonstrate. We had precise aims and reasons to do so.

After a long discussion, my friend Ngawang Phulchung; my brother, Ngawang Delek (who escaped with me to India); and I made the initial decision to carry out a peaceful demonstration. We then went about rounding up participants. They told us, "If you lead, then we are ready to follow you." In all, we were twenty-one people. My brother, Ngawang Delek (who is two years older than me), did not participate in the actual demonstration. That's because we thought that if we demonstrated we would all be killed. We were sure about that, that we would die. We did not think at that time that we would be sent to prison or anything like that. We thought that we would be killed.

Since my brother and I were the only sons in our family, we didn't want the two of us to get killed. We mutually decided that only one should take part. So the problem was who? My brother insisted that he would do it, while I insisted I would. Finally my stubbornness prevailed and my brother had to stay back—in case anything happened, he would have to carry on. Also our teacher was very old at that time and needed someone to watch over him. So therefore it was me, Ngawang Phulchung, and the nineteen other monks who set out to demonstrate.

Ngawang Phulchung, my brother, and I, we are all very close to each other, we knew each other very well. And each of us knew a couple of people. I knew most of the people in the monastery, and my brother also knew many people, and Ngawang Phulchung also knew a lot. It's not as if we had a whole big group meeting in a big hall or anything like that. First, we three discussed the initial plans for the demonstration and then the first person that I tried to convince to participate was X (since we were sharing the same dormitory).

I didn't tell him what we were going to do, at first. I told him that I was going to do something very good and something

crucial for Tibet and I asked him if he was interested. He wanted to know what was the good thing. So I explained to him in great detail. I tried to convince him that a demonstration was very important at that stage. If we did not do this now, the Dalai Lama's efforts would be wasted and the Chinese propaganda would be taken as truth. In great detail, I discussed this with X, he said yes and was willing to join me. And then X told Z and Q about it. We had meetings on five or six occasions to try and recruit new people, some with the people that we had already told—a maximum of five or six in one room, a minimum of one or two new people. The reason that I asked people in small groups was because there had been almost no demonstrations like this since 1959 and they might be shocked to hear what I had to say. There were two or three people who tried to discourage us, but they did not give the information to the Chinese. When we tried to convince people to join us, we told them that they were free to withdraw or they were free not to join at all, but they should not tell the Chinese. We stressed this to them and they listened. One or two promised to contribute in their own way, but they did not want to join. They said that they would pray for us.

The three homemade flags, Tibetan national flags, used in the demonstration were made by W. We had not discussed it. We had not decided beforehand to make the flags. They were entirely his decision and his doing. W had seen an old picture of the Tibetan national flag, and he drew the flags from looking at those pictures and copying them. We had decided to have a banner, a kind of long banner. But since we were short of time and since we did not have many resources at our disposal, we weren't able to do that. Every one of the twenty-one monks contributed in his own way in order to make the demonstration a success.

We decided on the eve of September 26 to demonstrate the next day because the twenty-seventh was a Sunday, and we knew that there would be many people around the Jokhang Temple in Lhasa. Before September 26, we spent three or four days establishing our objectives and discussing how we should answer the Chinese if we survived the demonstration and were not shot. If they interrogated and imprisoned us, then what were we supposed to tell them? If we were arrested, we felt that it would be very embarrassing if they asked us our reasons for taking part in the demonstration and we didn't have anything to say. So we had discussions on what to say, so we could be ready with the reasons. We decided that the points we should keep in mind were the historical facts about Tibet being independent from China, and that we were denied basic freedoms such as the right to religious freedom—even though they say that we are free to practice our religion. We explained to each other how we would tell the Chinese that their restriction on the admission of monks and nuns into monasteries and nunneries in fact violated their own statements concerning religious freedom. The final point was that the Chinese government intentionally discriminates against the Tibetans, that we are treated differently than they treat other Chinese. We spent the three or four days leading up to September 27 discussing these issues.

The night before, I took the key to the big assembly hall in Drepung from my teacher—he was praying at that time. Actually, I snuck it away from him. I opened up the assembly hall and we all gathered inside. We took an oath that whatever happened

we would not back out. We swore that if we were not killed and were imprisoned, then we would not tell the Chinese the details of the organization and that we should not inform on each other. We took the oath and disbanded.

In the morning we got up and met just below Drepung at seven. Before we left for Lhasa, we said a few words to each other. We discussed how it was important for us to stay in a group when we demonstrated and agreed we should not hit the Chinese if we got arrested, that even if some of us were killed we should never raise our hands against the Chinese. We firmly believed in the principles of nonviolent struggle. Violence only perpetuates more violence and results in continued suffering. The effects are devastating; there are no winners, only losers. Even though nonviolent struggle takes much longer, it is worth it.

When we left it was early in the morning and there were no buses at that time, so we took two small tractors. Ten monks boarded each tractor. We reached Lhasa early in the morning; there weren't many people around. We decided that it was too early to demonstrate. So we had some tea in a restaurant and waited for the right time.

Before the demonstration, I didn't feel scared or anything. I was very relaxed. But a couple of my friends were so nervous that they couldn't bear to sit down. They were just standing and pacing back and forth. They were not scared that they might get killed or anything. They were scared that the demonstration might fail to happen, that we would get arrested, that the Chinese might know before we were able to make it to the street. But I don't think that they were scared of being killed or anything like that. Before we left for Lhasa, I remember telling them that if any one of them felt scared or did not want to go ahead with our plan then they had the full right not to participate. But none of them did, they were all willing. If they were nervous at all it was from fear that they might be arrested before the demonstration.

Before leaving for Lhasa at that time, at seven in the morning, my friend Ngawang Phulchung told everyone that maybe we might not live to see each other again. Or, if we were not killed and we survived being arrested, then maybe we would all be subjected to harsh punishment and torture. We might be subjected to a life worse than death. Ngawang Phulchung said that if during the interrogation we felt that the torture was too much for us, then we all had the full freedom to tell the Chinese that he, Ngawang Phulchung, was the ringleader. I said the same thing to my friends; I encouraged them to do this. There were three or four others who said the same, "Point to me, point to me, make me the one accountable."

At around ten we decided to start the demonstration. We came out of the restaurant and then made five circuits around the Jokhang shouting slogans. Then we headed for the Tibet Autonomous Region's government offices. And as you already have witnessed, there were hundreds of people watching us, some of them were shouting out and shedding tears. A few Chinese policemen were watching us. At first they didn't do anything, they just watched. As we neared the gate of the TAR government office, there were many police, three or four policemen for every one monk. Suddenly, they broke on us and we were arrested. We were bound using the Chinese way, with ropes spiraling up our arms and behind our back.

R was being arrested and I was already put in the van. He could not stand the Chinese manhandling him, so he fought them.

He got involved in a scuffle. Emotions were running very high at that time. It was really tense. I wanted to jump out of the van to back up R, to really hit the Chinese hard. I was really very angry. But then I thought about our pledge that we should not hit back. And I tried to gain composure again. So as far as I know, it was only R who really hit the Chinese. After we were driven in the van and taken to a lockup nearby, from there we were all taken to Gutsa Prison.

We were all physically searched, then taken to our cells. We were made to enter the cells in mixed groups. There were some prisoners already in there and we were sent in, in groups of two or three. That very night the interrogation started. We were not tortured or beaten badly at that time. But yes, during this interrogation we were beaten on and off. One of our monks, V, was beaten really badly by the guards. And S was beaten really badly as well. The food that we were served was very bad. The Chinese deliberately made an assortment of all the bits of food that were just thrown on the floor or were left over. They then boiled them and served it to all of us. That was very humiliating. After four months of imprisonment, we were released when the Panchen Lama intervened on our behalf.

The serious beatings and torture occurred the following year when I was arrested again. I cannot narrate one special instance because beating was part of my life—it was not extraordinary, it was normal. On three or four different occasions they used an electric baton on me; this was extremely painful. The reason for one of the times was because I was in the possession of prayer beads. They shocked me on the mouth for fifteen minutes. Another situation that I can remember clearly was in April 1991. This was when the real beating started. It was after we confronted prison guards about the status of two prisoners who were in solitary confinement. They put us in shackles and beat us with rifle butts. I was beaten badly and I could hardly move. They hit me in the eye so hard that it remained black for twenty-eight days. I was then placed in solitary confinement for twelve days. While in solitary they gave me only one piece of bread and one cup of water in the morning and in the night.

Several factors interacted to make it possible for our demonstration to occur. Tibet had begun to open up to the world and for the first time there were many foreigners who brought in a lot of new information and ideas. The political atmosphere was more open than any other time in the past. These things coincided with the Dalai Lama's visit to the United States and China's reaction to his visit.

We carried out the demonstration because we knew that the world community at this time was starting to take an interest in the situation inside Tibet. We had already sacrificed our lives for the demonstration—we did what we could but we were concerned that it wouldn't be useful.

Though I did not have much access to materials from outside Tibet, either in radio or print media, one thing always inspired me. It was strongly embedded in my mind when I was taking part in demonstrations and when I was undergoing the imprisonment and torture. This was the speech given by the Dalai Lama in 1986. I remembered that speech very well—it left a

lasting impression on me. In that speech the Dalai Lama said that the Tibetan issue was the responsibility of all the six million Tibetans and not just the Dalai Lama's alone. He said that all of the Tibetan people, every single individual, was obliged to contribute to the best of his ability. And that he, His Holiness, would work to the best of his ability to take the struggle to its completion. However, the main responsibility was on the Tibetan people. This speech kept me going in the face of all the adversity. This speech was very strong in my mind.

After our release from Gutsa, we went back to the monastery. But soon after our return we continued our political activity: ten of us, nine monks from the original group and one layperson, formed an underground political organization called the "Volunteers for Tibet." The purpose of the group was to continue our struggle for independence through the dissemination of information about the situation inside Tibet to Tibetans and to the outside world. We tried to contact foreigners and relay messages through them. We also printed documents and distributed them among the Tibetan people. We printed copies of the Universal Declaration of Human Rights translated into Tibetan, as well as the draft of a constitution for an independent democratic Tibet. These were very important documents and we felt that in spite of our experiences in prison that it was crucial to educate the Tibetan people.

The demonstrations continued. I participated in the one on December 10, 1988, International Human Rights Day. The Chinese opened fire on us and several people were killed and injured. I also participated in the Monlam demonstrations of March 1989. My role in these demonstrations was minor; my activities at this time were focused more toward publishing and distributing information. We did a lot of work behind the scenes to help facilitate the demonstrations.

We knew that we would be imprisoned if we continued our political activity and we understood that things would be much harder if we were arrested again—that next time it might not stop at imprisonment, we could also be killed. To tell you the truth, what kept me going was that I felt that we needed to liberate our country, religion, and culture from the oppression of another nation, and that it had to be done in our generation. For those reasons we continued our struggle—what we started needed to be taken to its completion. That was my motivation and nothing could stop me from this path.

Thus we continued our work and eventually many of our people were arrested. Some were arrested in the March 5, 1989, demonstration. As for me, I was arrested for a second time along with three other people including Ngawang Rinchen on July 18, 1989. And I spent five years in prison. I escaped to India in 1996.

In life, it is very easy to live a normal existence—to live for your own purposes. It is easy to enjoy things without thinking of others' suffering, to chase your own happiness by drinking and hanging around, but it is very difficult to live a life that is for the benefit of other people. In Buddhism this is very important. If the world had more people like this, it would be a better place.

The biggest contradiction of my life right now is that on one hand I feel a great sense of accomplishment from my work in Tibet. Though only a small contribution, the September 27, 1987, demonstration helped reawaken the world to the situation in

Tibet; this was very important to our struggle. At the same time, I have great sadness because my friends that I started out with are still suffering in prison. This is a very great sadness for me. Five from our group of ten are still in prison: Ngawang Phulchung, serving 19 years; Jampel Changchub, serving 19 years; Ngawang Oeser, serving 17 years; Ngawang Kenser, serving 17 years; Jampel Loser, serving 10 years. And in 1996, Kelsang Thamdup died as a result of torture in prison. But it's not only those six that my heart goes out to, but to all the political prisoners.

I managed to escape to a free place but it's difficult to say what will happen in my future. I escaped from Tibet with such high aims. My fellow prisoners wanted me to learn about the outside world and continue our struggle. I feel that I have a job that remains unfinished.

Interviewed by Steve Lehman in Dharamsala, India on September 28, 1997
Translated by Topden Tsering

al affairs of [...]
ties that are incompati[...]

3. Foreigners are not al[...]
watching and photog[...]
manipulated by a few s[...]
not do any distorted p[...]
turbances, which is n[...]
facts.

4. In accordance with ou[...]
punishment to the tro[...]

le with their status.
owed to crowd around
aphing the disturbances
plittists, and they should
opaganda cocerning dis-
ot in agreement with the

r lows, we shall mete out
uble-makers who stir up,
te in the disturbance

Jampel Lobsang, Age 38
member of the "group of ten"
Serving 10 years in Drapchi Prison
for Participating in criminal activities
organized by a counter-
revolutionary clique and Spreading
counterrevolutionary propaganda
and inflammatory disinformation.
Scheduled for release this year (1998)

Jampel Leksang, Age 37 ?
arrested
for 9/27/87 demonstration. Served 3 months
in gutsa prison. Escaped to India. studied
at school of Buddhist Dialects in
Dharamsala. Disrobed + now married
with one child.

Ngawang Woeber, Age 33?
4 months gutsa prison for
Participation in 9/27/87
demonstration. Escaped to India
now is teacher at T.C.V. in
Patikul, India.

Ngawang Rinchen, Age 32
member of "the group of ten"
Served 6 years of a
nine year sentence. charged
with espionage and participating
in criminal activities organized by
a counter-revolutionary "clique"
Escaped to India in 1998 - now studying at
Institute of Buddhist Dialects in Schara, India
trying to Continue Political work - beaten + tortured
in prison.

Ngawang Pulchung, Age 36 (approx)
9/27 demonstration leader; member of
the group of ten" Serving
a year prison sentence in Drapchi for
espionage, organizing a counter-Revolutionary
"clique", and Spreading counter-revolutionary
Propaganda. Beaten + tortured in prison; schedule
for release in 2008.

September 27, 1987

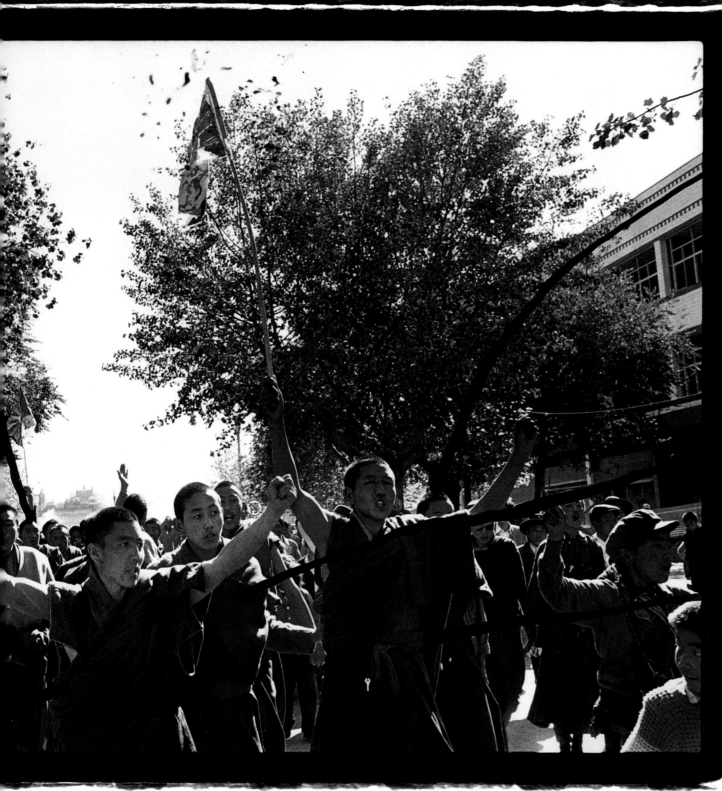

Jampel Tsering, Age 28 Demonstration leader. member of "the Group of Ten". Served 5 year sentence in Drapchi Prison for participating in criminal activities organized by a counter-revolutionary organization "clique" Escaped to India in 1996 Now studying at Institute of Buddhist Dialects - Sarka, India - trying to continue political work. Beaten + tortured in prison.

Ngawang Oesor, 34 member of "the group of Ten" serving 17 yr sentence in Drapchi Prison for forming a counter-revolutionary clique + spreading counter-rev. propaganda + inflammatory disinformation Scheduled for release in 2006. Beaten + tortured in prison.

Jampel Changchub Age 34 (approx) serving 19 year sentence in Drapchi Prison for founding a counter-revolutionary clique, collecting + passing information to the enemy, espionage, seriously undermining national security and spreading counter-revolutionary propaganda - member of "the Group of Ten" Beaten + tortured in prison scheduled for release in 2008

Lhasa, Tibet

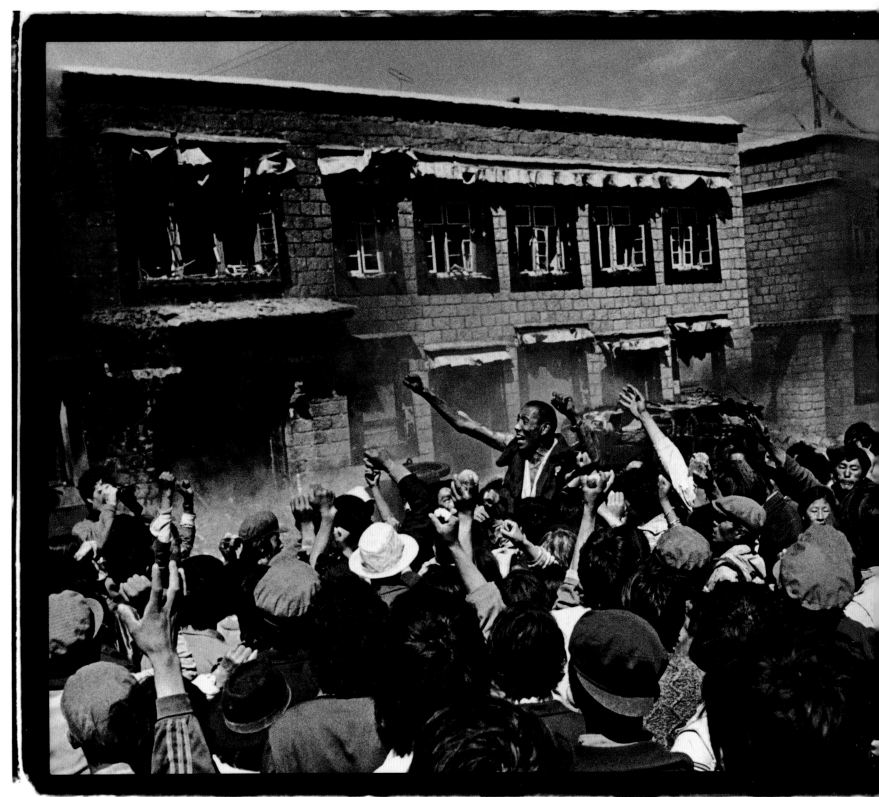

Chinese National Day - October 1, 1987 Lhasa, Tibet

On October 1, 1987, Jampa
Tenzin, a fifty-five-year-old
Jokhang Temple monk, rallies
Tibetan protesters. The day's
protests, among the largest in
Tibetan history, will leave over
ten dead and forty wounded.
Jampa Tenzin is severely
burned and spends several
months in a Chinese prison.
In February 1992, he is found
strangled in his room in the
Jokhang Temple. Although
Jampa Tenzin's death remains
a mystery, there are strong
indications that he was
murdered by Chinese
authorities for his continued
participation in pro-
independence activities.

No one told us to demonstrate. The Tibetan cause is a cause for truth and when you are fighting for the truth you cannot wait for someone to tell you to fight.

—Jampa Tenzin, Jokhang Temple monk

I threw stones at the Chinese police. What I did was not in violation of my religious beliefs. I did it to save others. I ran into the fire to save others and sacrifice myself as a protest against the Chinese.

—Jampa Tenzin, Jokhang Temple monk

October 1, 1987. Tibetan monks and women throw stones at a Chinese police station during unrest in Lhasa. The protest turned violent when twenty to thirty monks from Sera Monastery were arrested for peacefully demonstrating and then publicly beaten with belts and shovels. The outraged crowd demanded the monks' release and a riot ensued.

October 1,

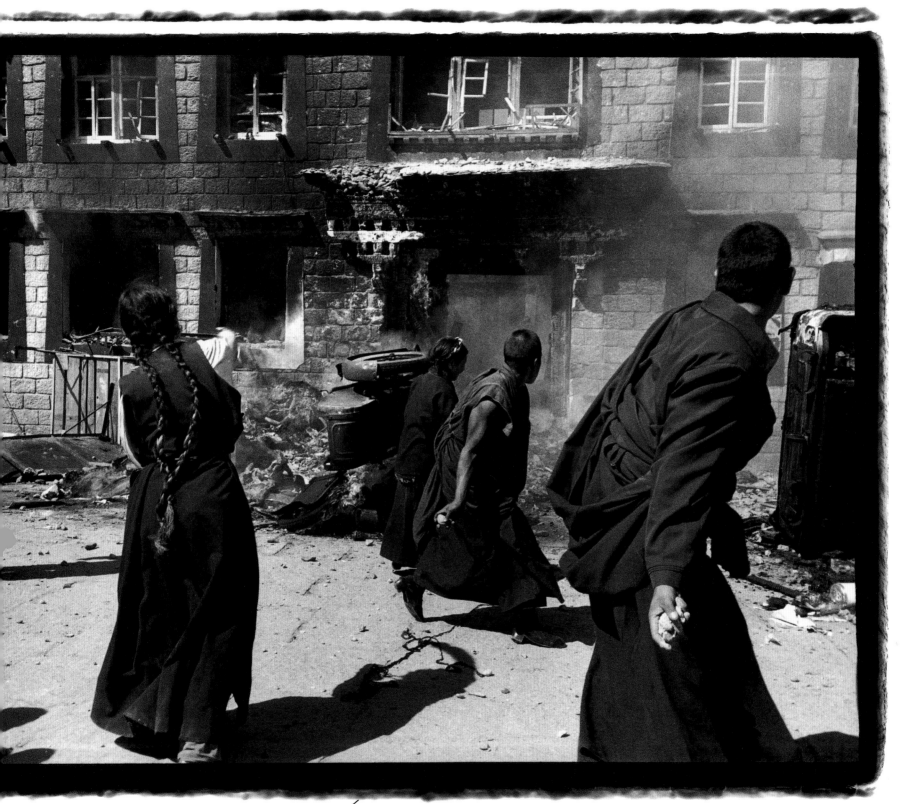

87 — Chinese National Day / Monks threw stones at burning Police Station

We were not frightened. We thought the worst thing the Chinese could do was either kill us or put us in prison. We were already prepared to give up our lives for the six million Tibetans.

—Ngawang Phulchung, Drepung Monastery monk

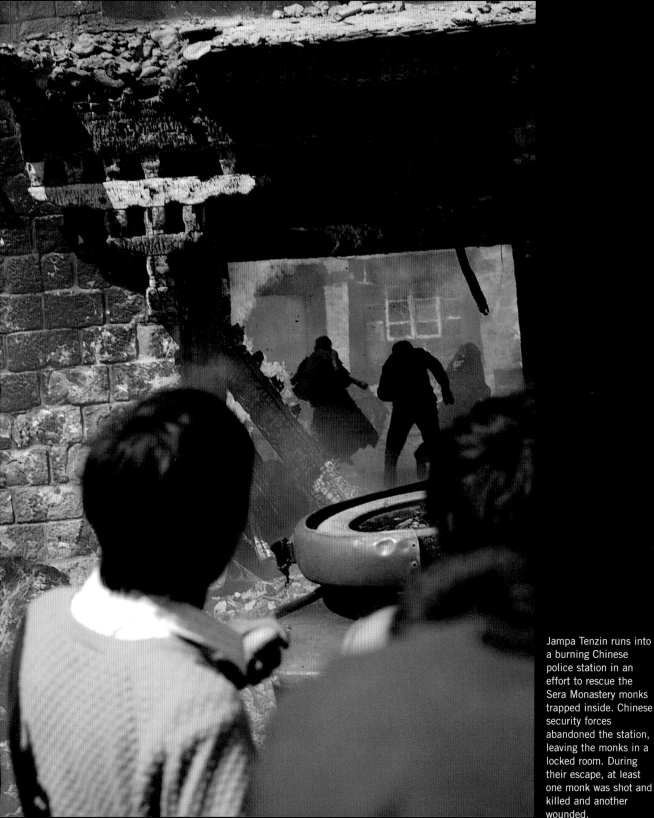

Jampa Tenzin runs into a burning Chinese police station in an effort to rescue the Sera Monastery monks trapped inside. Chinese security forces abandoned the station, leaving the monks in a locked room. During their escape, at least one monk was shot and killed and another wounded.

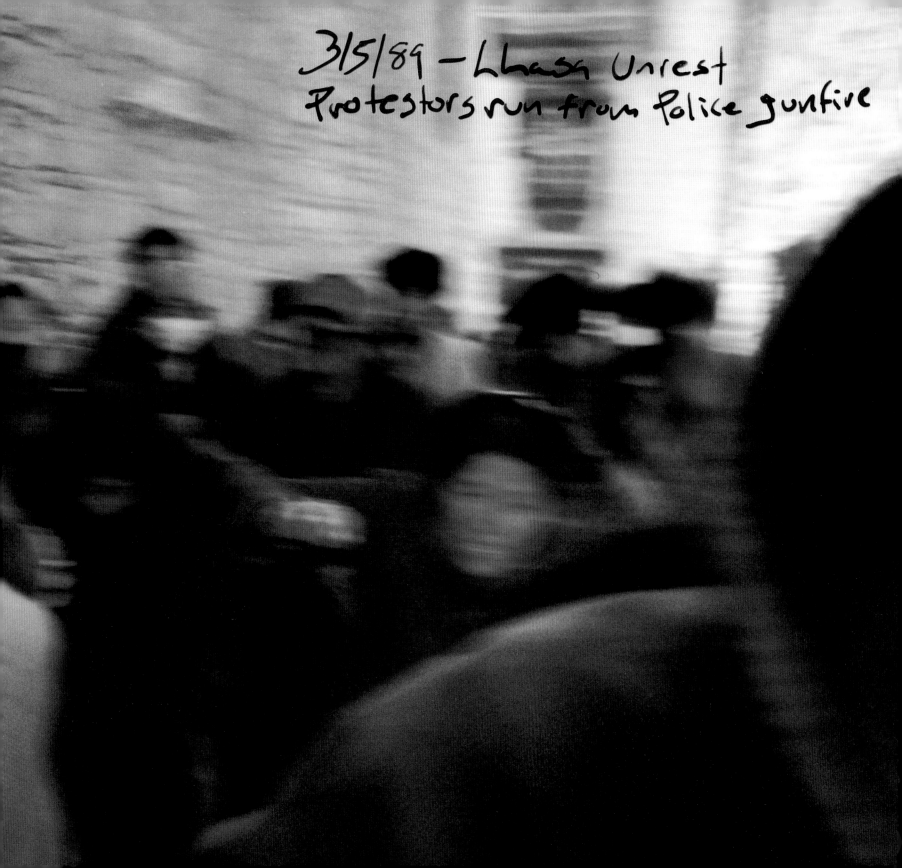
3/5/89 — Lhasa Unrest
Protestors run from Police gunfire

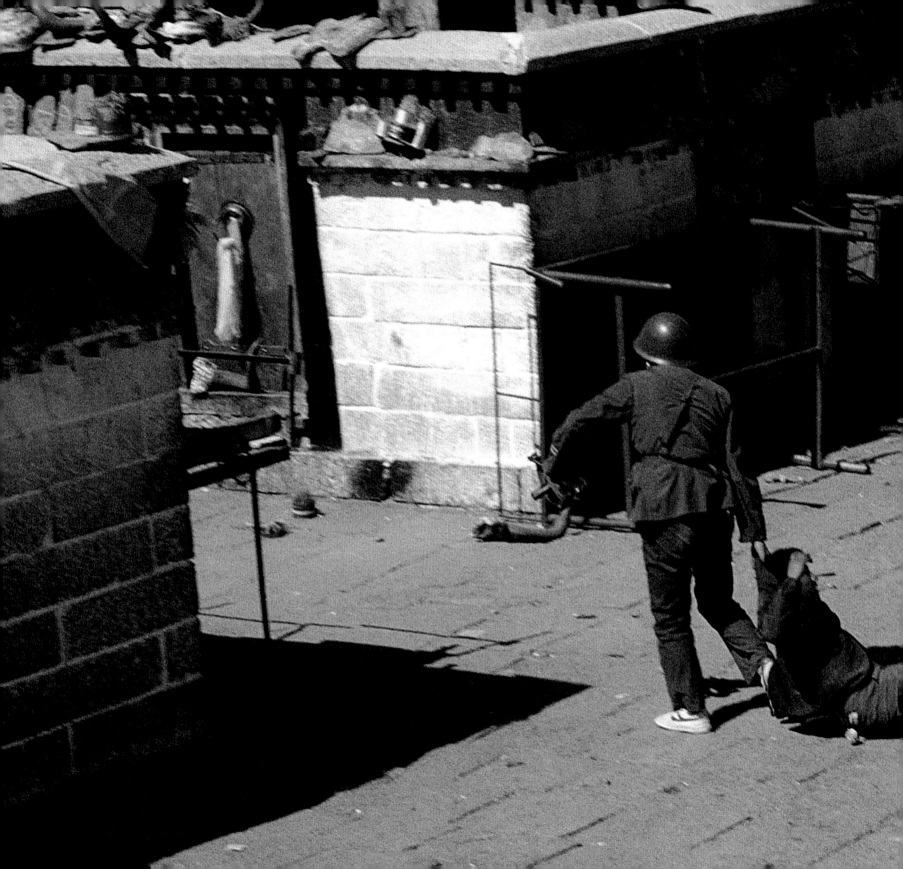

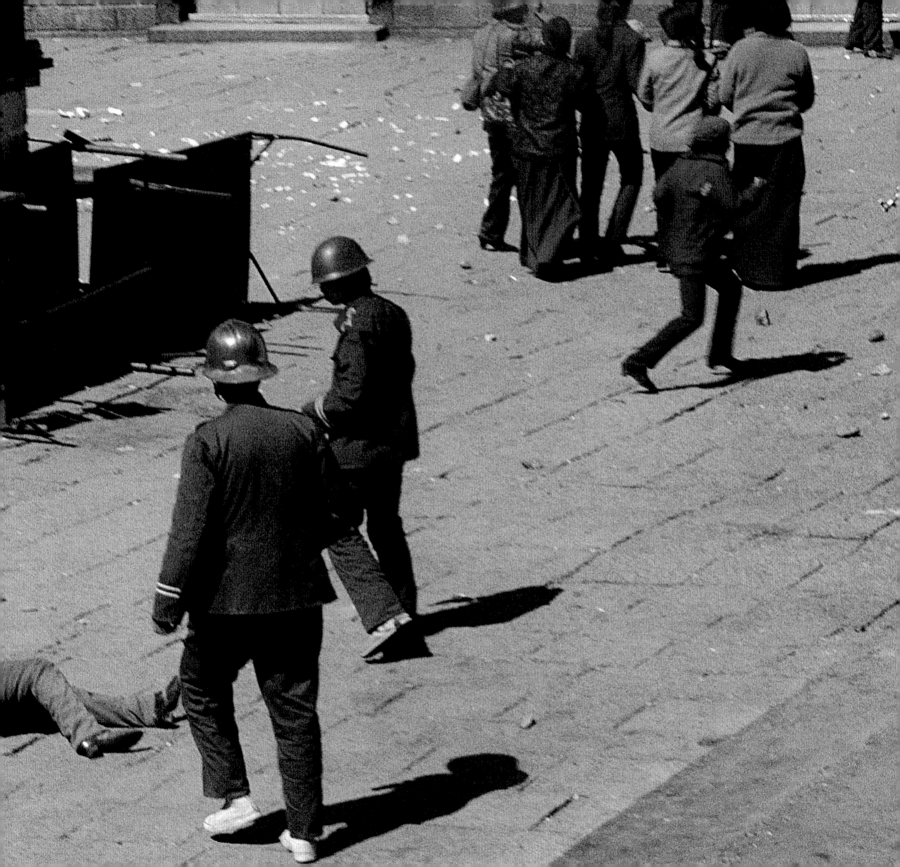

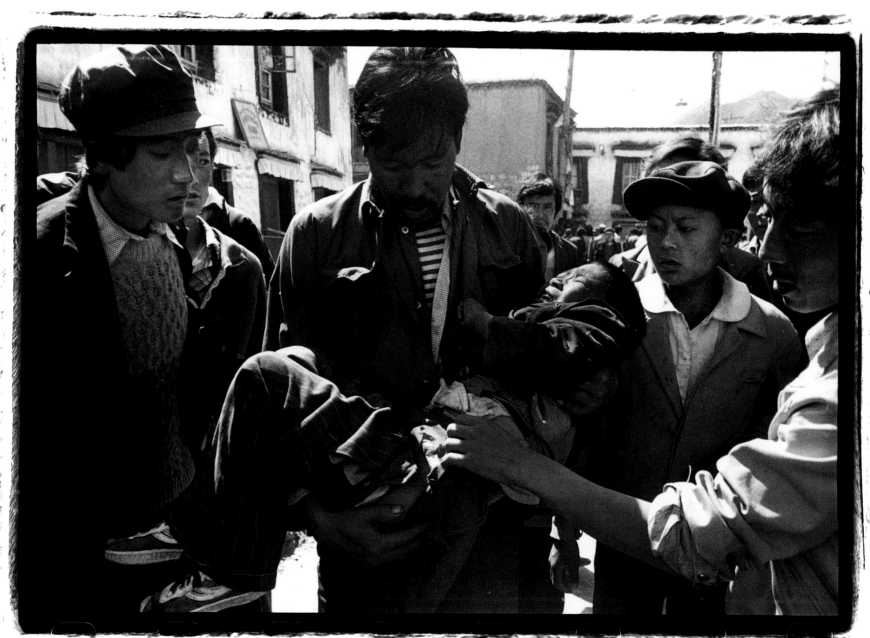

October 1, 1987— Eight year old boy shot in the back/he died from his wounds.

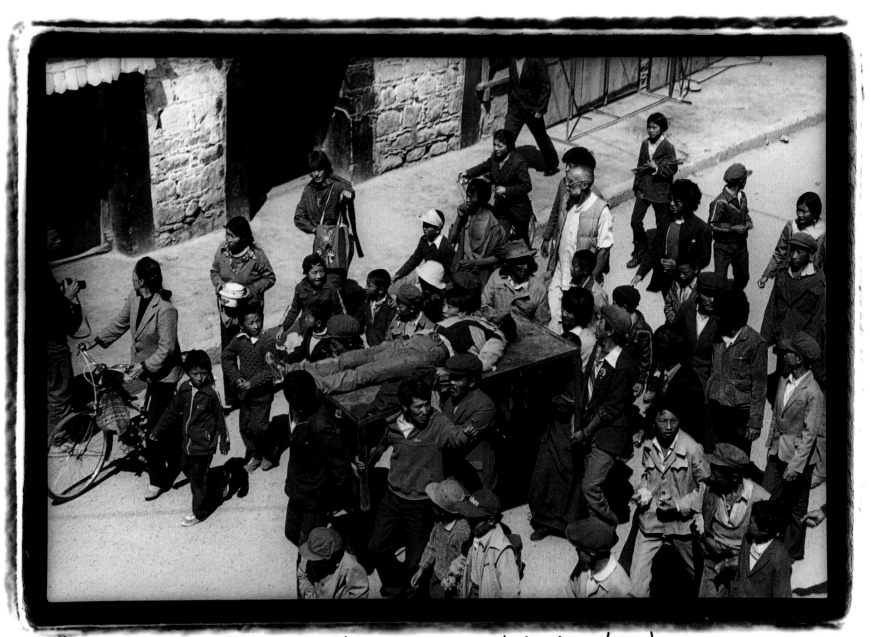

October 1, 1987 - Sera Monastery monk shot in the head

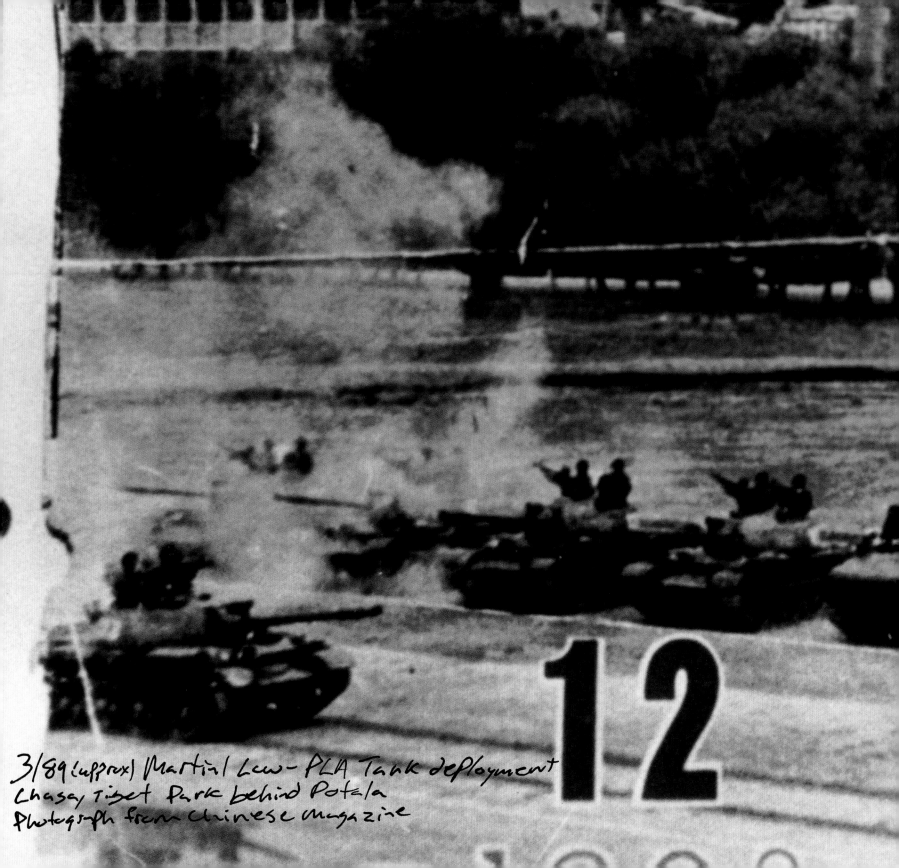

3/89 (approx) Martial Law - PLA Tank deployment
Lhasa Tibet Park behind Potala
Photograph from chinese magazine

12

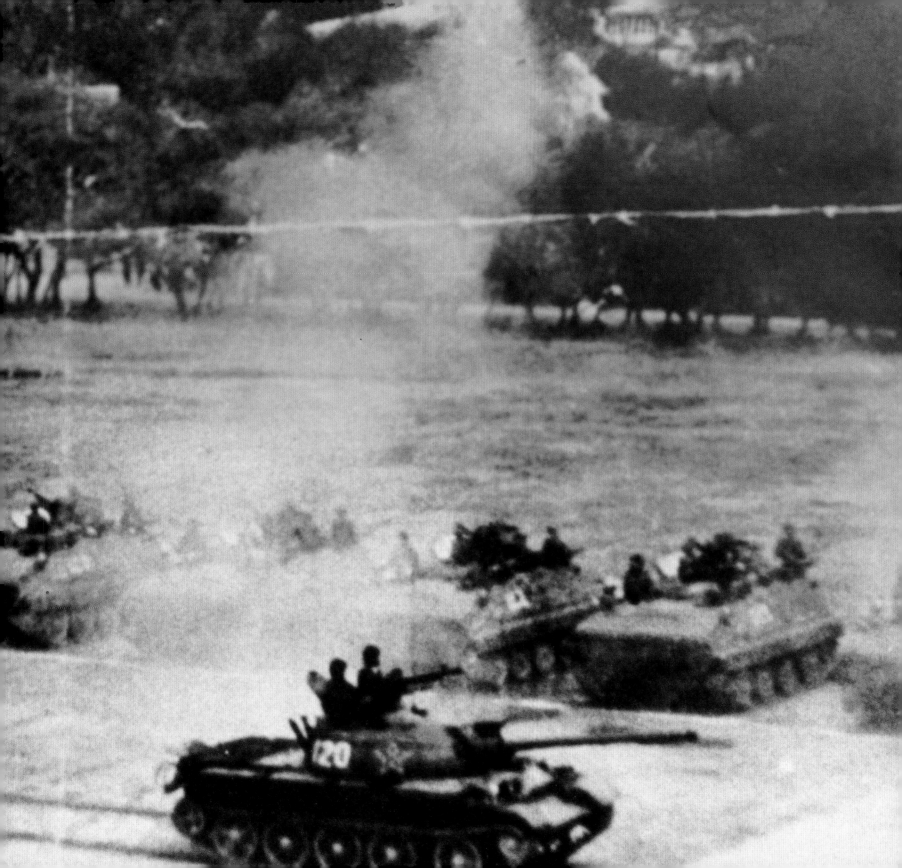

guard →

↰ cell blocks

Prisoners
work in
↗ greenhouses

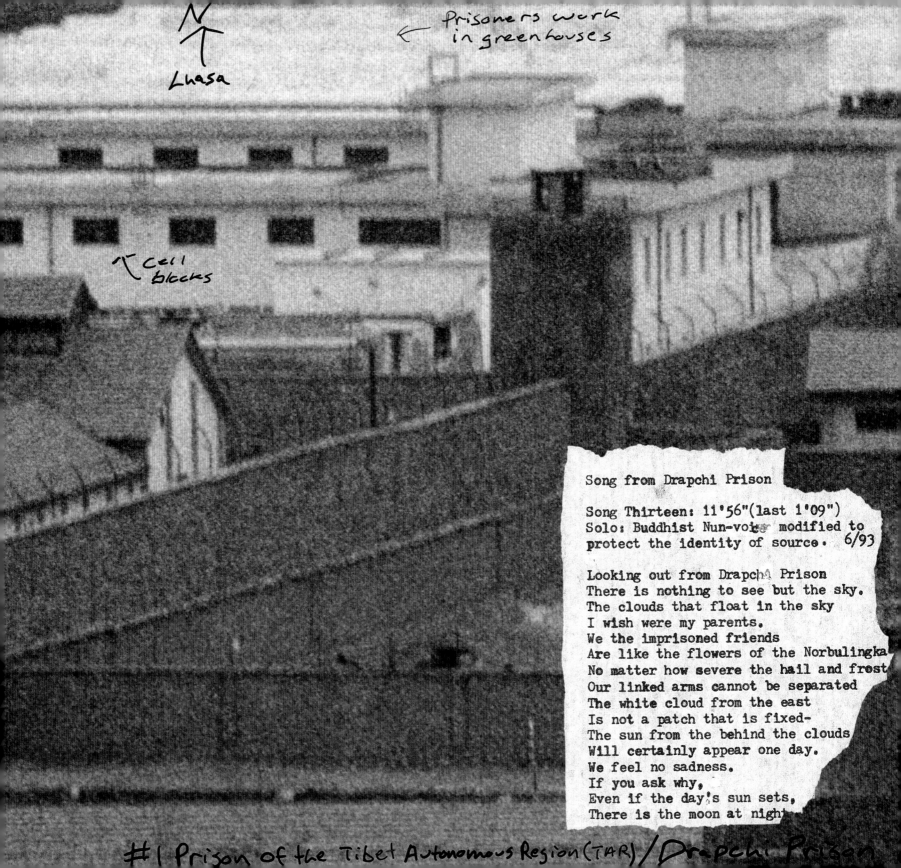

N↑ Lhasa

← Prisoners work
in greenhouses

↗ Cell blocks

Song from Drapchi Prison

Song Thirteen: 11'56"(last 1'09")
Solo: Buddhist Nun-voice modified to
protect the identity of source. 6/93

Looking out from Drapchi Prison
There is nothing to see but the sky.
The clouds that float in the sky
I wish were my parents.
We the imprisoned friends
Are like the flowers of the Norbulingka
No matter how severe the hail and frost
Our linked arms cannot be separated
The white cloud from the east
Is not a patch that is fixed-
The sun from the behind the clouds
Will certainly appear one day.
We feel no sadness.
If you ask why,
Even if the day's sun sets,
There is the moon at night.

#1 Prison of the Tibet Autonomous Region (TAR) / Drapchi Prison

Then we were stripped naked. The guards who did the torturing were women, some Tibetan, some Chinese. They would say, "Tibetan independence is a dream, it will never come. You are disturbing the society with these demonstrations. If you want independence, here, here is your independence!" Then they used electric batons on every part of our body. It was a very severe pain, like all my nerves were coming together. Afterwards, some of the nuns had problems urinating because they put the baton on our private parts.

—Gyaltsen Choetso, Gari Nunnery nun

March 5, 1988. A Tibetan monk with his arms bound behind his back is detained by Chinese police for participation in pro-independence demonstrations. The demonstrations broke out during Monlam Chenmo, the Great Prayer Festival. This photograph, documenting the unrest and subsequent crackdown, was taken from a Chinese police video.

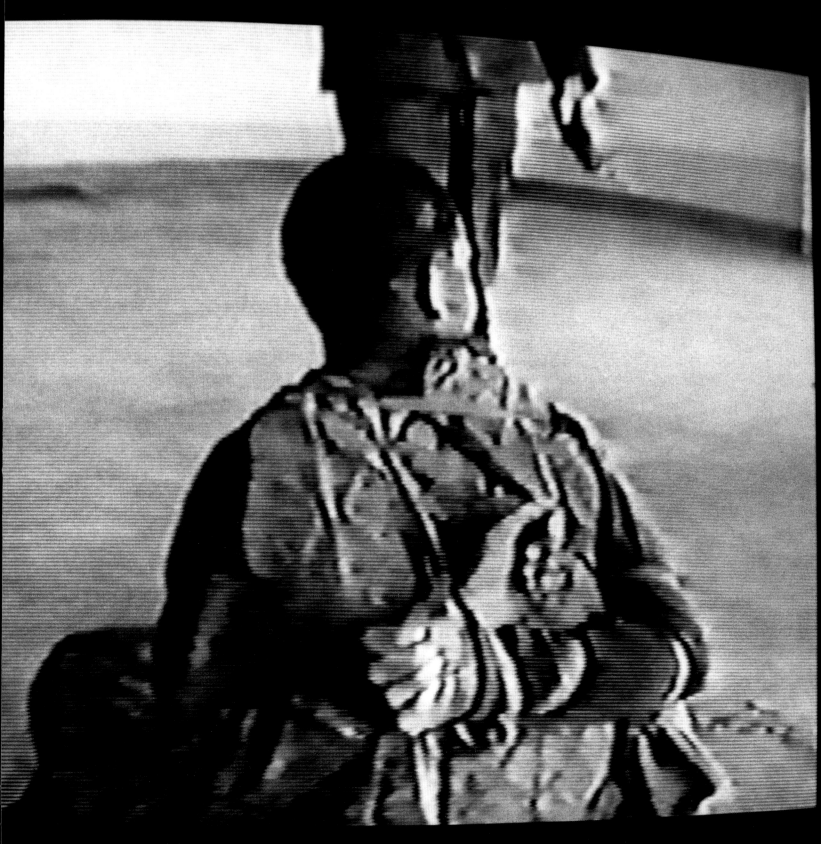

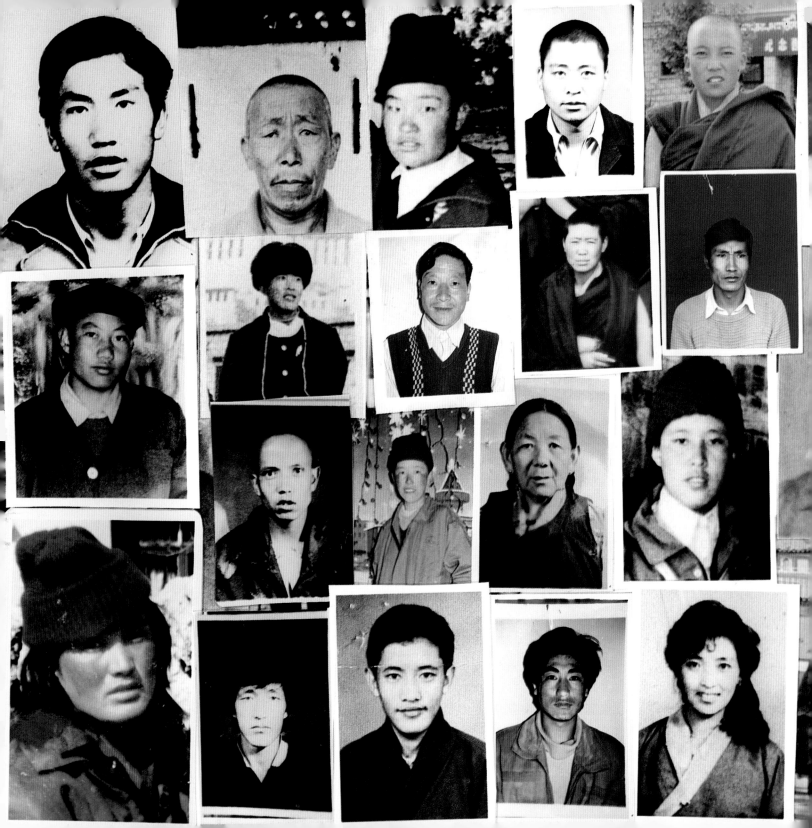

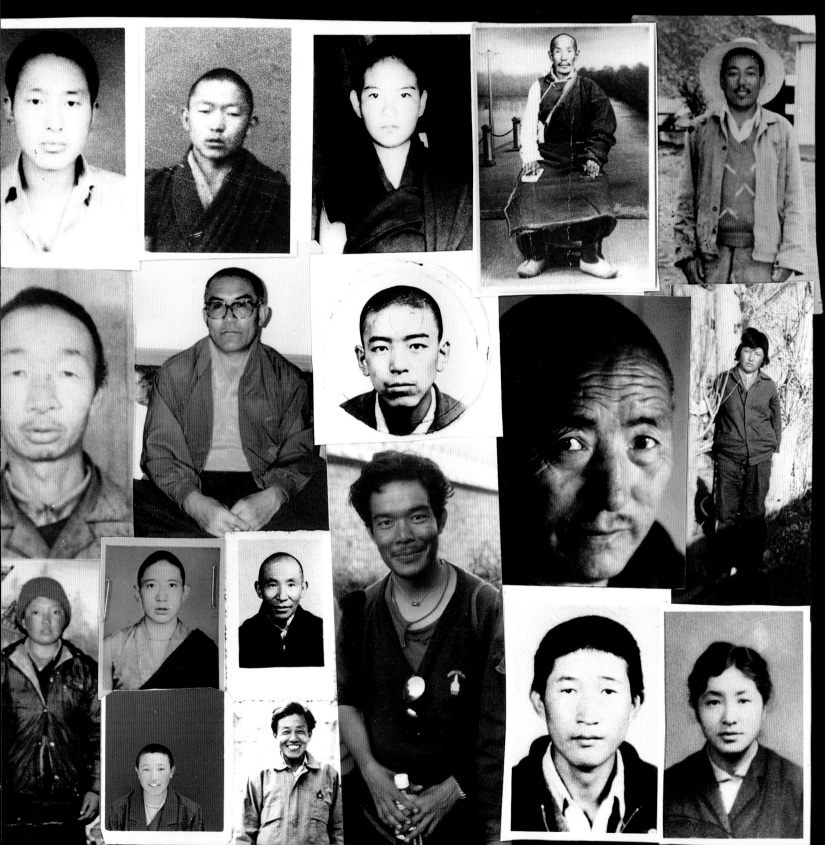

KODAK TX 6043 48 KODAK TX 6043 49 KODAK TX 604

▶6 ▶7

Ngawang Choejom, Age 24 former political prisoner - from
June of 1993 a tape recorder was smuggled into the woman's
In 1993 the 14 women were re-sentenced by a Lhasa court + given
which the nuns have altered the lyrics. Song Seven (translation:
People of Tibet love freedom. The People of Tibet love the blessing of Peace
How sad it is! The barbarians inflict severe beatings + punishments. since we have
imprisoned friends, are like the flowers of the Norbulingka - No matter
conscious, carry your song to our birthplace. oh, destined parents of this life, Do
Clouds that float in the sky. I wish they were my parents. We
10'27" Song Twelve: (translation; last ('29") Oh this song of sadness in our heart
translation; last ('20) land of snows, land of snows my beloved country. Religious + Political fr
Tenzin Gyatso, the heart + soul of our country is my root lama, the wish f
lasts ('09") Solo: voice modified to protect identity of source / Looking out fro
of the Norbulingka - No matter how severe the hail, lift our withered arm

KODAK TX 6043 30 51 KODAK TX 6043 52

►8 ►9

upsang nunnery. participated in pro-independence demonstration
tion of Drapchi Prison (Tibet Autonomous Region #1 Prison). 14 of
ditional sentences of up to nine years. On the original tape several of the
+ 0'35") On the roof top of Planet earth, If you ask who's (and it is
truth. Song Thirteen 11'56 (translation; 1:09) Solo: voice modified to protect identity of
edom—we have become oppressed + tortured. Our revolt against the white cloud
have severe the hail + frost, our linked arms cannot be separated. The white
t be sad—The time will come for our reunion. In the direction of the
e imprisoned friends, are like the flowers of the Norbulingka—No
We sing to our brothers + friends. This feeling that we have in this darkness
om are the source of our happiness. The Red Chinese have separated us from our root
lling jewel. When all Tibetans in Tibet and in exile, unite. The sun will emerge from the sky
Drapchi Prison There is nothing to see but sky. The clouds that float is fixed
not be separated. The white cloud from the east is not a patch that is

Former Political Prisoners

Tashi Dolma, age 39 - farmer from Amdo. Arrested for the possession of pamphlets + cassettes of the Dalai Lama's speeches. Served a 1½ year sentence. Escaped to India in November, 1989.

Ngaweng Jamchen, age 25 former Drepung monk. Participated in September 27, 1991 Pro-independence demonstration, arrested immediately with 3 other monks, sentenced to 5 years in Drapchi. Tortured during interrogations. Released on 8 Sept. 26, 1996. Musty verify information! Picture + name may have been switched.

41 KODAK TXP 6049

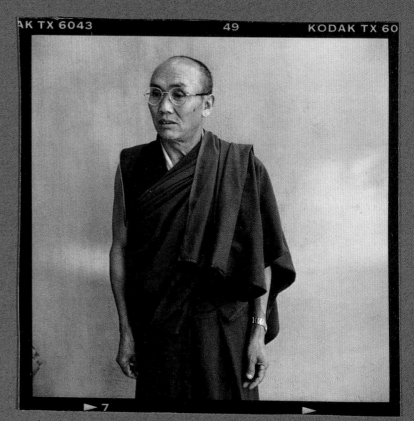

AK TX 6043 49 KODAK TX 60

Ani Pachen, age 64 — originally a nun in Kham. In 1958 she became a resistance fighter and played a prominent role in the Tibetan uprising. she led an armed group of 100 people and carried out numerous raids against the Chinese. She was captured in 1969 and spent 21 years in India released in 1981 (Drapichi + Chumdo Prison). currently, Ani Pachen practices as a nun, she does not wear robes because She has killed people.

Tenzin Lobsang, age 60 — monk from sera.

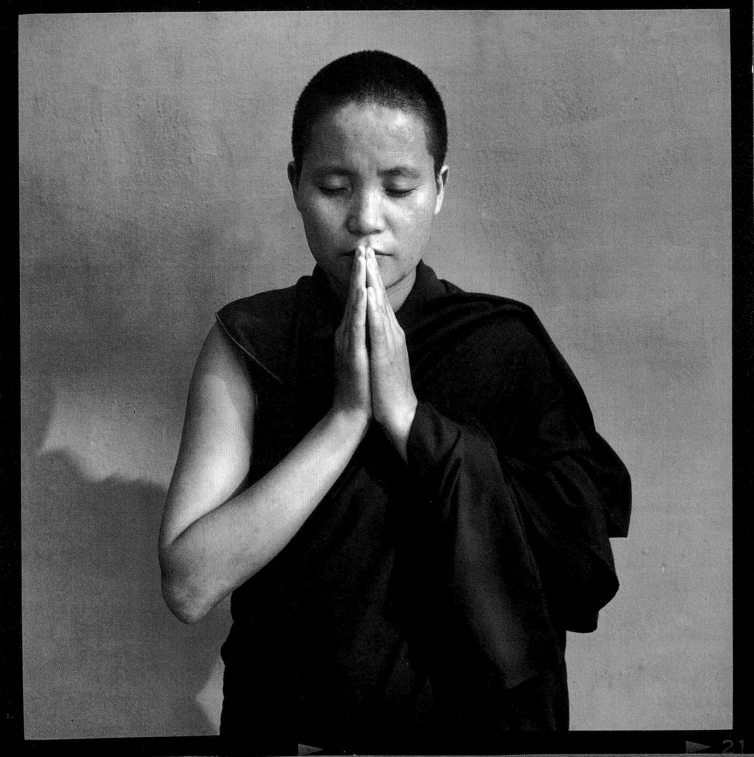

65 KODAK TXP 6049 66

Gyaltsen Choetso, Age 28 - From Gari nunnery/participated in 1987 + 1988 Pro-independence
demonstrations/arrested a 3rd time for celebrating the Dalai Lama's nobel peace prize - spent 1½ years in prison.
Tortured by severe beatings, denial of food + water, dog attacks and electric shocks to all parts of the body.

45　　　　　KODAK TX 6043

▶ 4　　　　　　　　　　　　　　　　　　　▶

Tenzin Choekyi (Age 28) and Ngawang Choejor (Age 24) Hold Hands/Participated in 10/89
Proindependence demonstrations each spent approx 3 years in prison. They wear "Rangzen" (Independence
bracelets) in memory of their friends still in prison

Former Political Prisoners

...''torture'' means any act by which sever pain or suffering, whether physical or mental, is intentionally inflicted on a person for such purposes as obtaining information or a confession, punishing him/her...intimidating or coercing him/her...or for any reason based on discrimination of any kind, when such pain or suffering is inflicted by or at the instigation of or with the consent of acquiescence of a public official... (Article 1, UN Convention Against Torture)

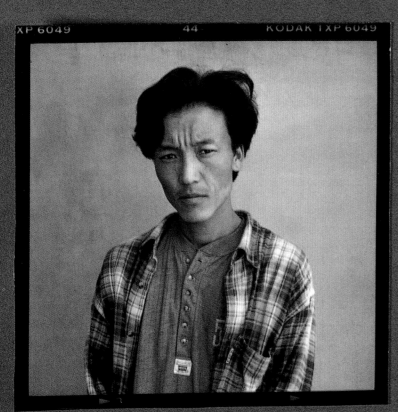

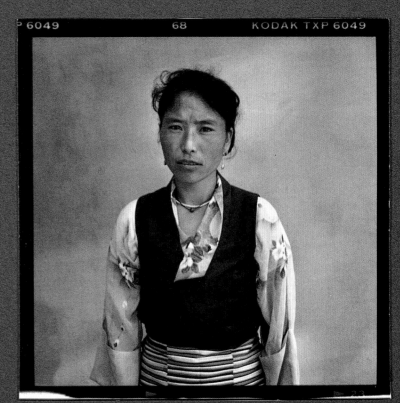

Sonam Tsering, age 31 — former Ganden monk. Participated in March 5, 1988 monlam demonstrations. Arrested + sentenced to four years in prison, released in 1992, was not allowed to return to monastery. Fled to India in 1993 because of fear of additional imprisonment, disrobed upon arrival in India. Underwent torture + source beating in prison. Must verify info! Picture + name may have been switched.

Dolma Sangmo, age 29 — former from central Tibet. Distributed speeches of the Dalai Lama and Tibetan Flags. Was arrested with her husband Jigme Dorje in 1990 and imprisoned 3 years (Seitru + Trisam prisons)

Dharamsala, India — 9/97

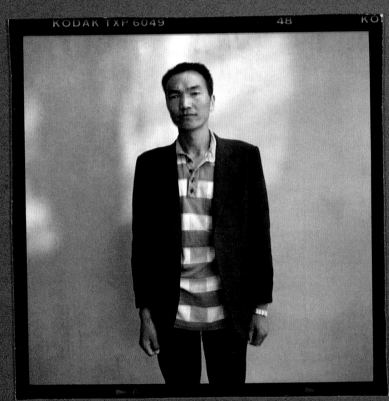

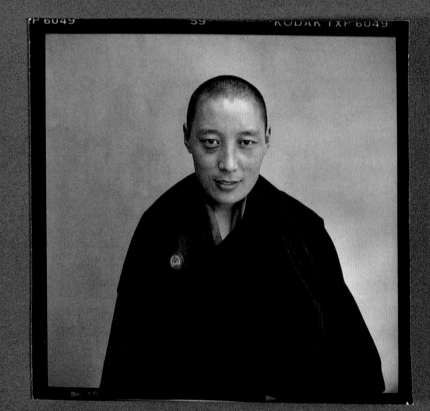

Ngawang Rinchen, age 32 former Drepung monk.
Close friend + associate of Jampel Tsering - fled
to India together. Participated in 9/27/87
demonstration, along with several others . Help form
an underground political organization devoted toward
obtaining Tibetan Independence. The group was
arrested in April, 1989. He was sentenced to 9 years,
(served 6)in Drapchi Prison. Underwent torture +
severe beating while in prison

Ngawang Yangdon, age 26 — Nun
Participated in October 1, 1991 demonstration,
was arrested and imprisoned. Her parents paid
a bribe and she was released.

51 KODAK TXP 6049

9

Ngawang Samphel, Age 24

KIDNAPPED BY THE CHINESE GOVERNMENT

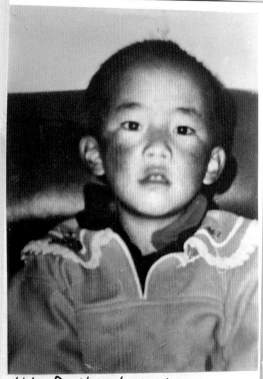

Where is the Panchen Lama?

Students for a Free Tibet flier

11th Panchen Lama - Gedhun Choekyi Nyima

nine (1998) ~~six~~-year-old Gedhun Choekyi Nyima

Only Free will Ti regain relig freed

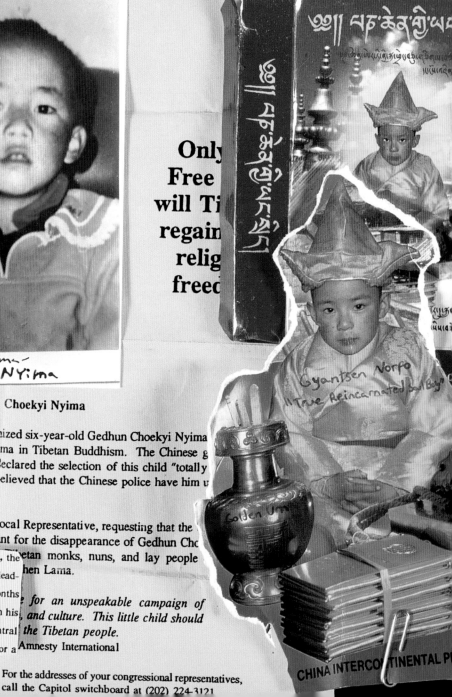

Gyantsen Norbo "True Reincarnated Boy"

Golden Urn

CHINA INTERCONTINENTAL P

In May 1995, His Holiness the Dalai Lama of Tibet recognized six-year-old Gedhun Choekyi Nyima reincarnation of the Panchen Lama, the second highest lama in Tibetan Buddhism. The Chinese g in a political move intended to tighten its grip on Tibet, declared the selection of this child "totally invalid". The young child has now disappeared, and it is believed that the Chinese police have him u arrest.

We urge you to write to the Department of State and your local Representative, requesting that the government urgently ask the Chinese government to account for the disappearance of Gedhun Cho

During the decade-long upheaval of the "Cultural Revolution", Tibetan monks, nuns, and lay people Panchen Lama, just like a great number of the Party and Government lead-hen Lama. ers, was subjected to serious persecution. He spent nine years and eight months *e for an unspeakable campaign of* in prison and underwent the harsh tests. However, he had never swerved in his *, and culture. This little child should* faith in CPC and his love for the socialist motherland. When the CPC Central *the Tibetan people.* Committee decided to rehabilitate him, he said calmly: "I have cherished for a Amnesty International long time the firm belief that this day would certainly come."

Secretary or State Warren Christopher
US Department of State

For the addresses of your congressional representatives, call the Capitol switchboard at (202) 224-3121

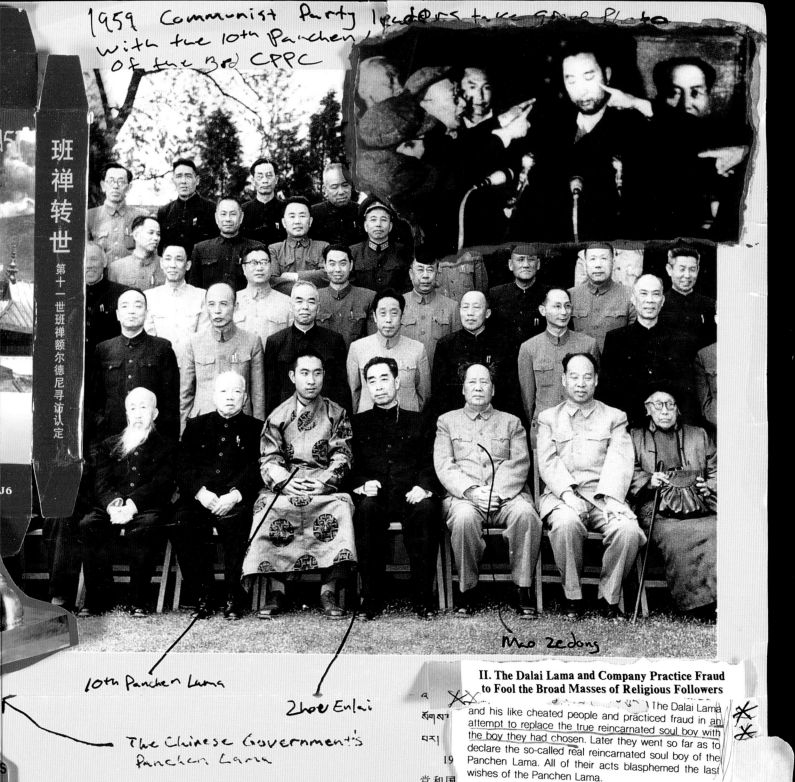

1959 Communist Party leaders take Group Photo with the 10th Panchen, Of the 3rd CPPC

班禅转世 第十一世班禅额尔德尼寻访认定

10th Panchen Lama

Zhou Enlai

The Chinese Government's Panchen Lama

Mao zedong

II. The Dalai Lama and Company Practice Fraud to Fool the Broad Masses of Religious Followers

The Dalai Lama and his like cheated people and practiced fraud in an attempt to replace the true reincarnated soul boy with the boy they had chosen. Later they went so far as to declare the so-called real reincarnated soul boy of the Panchen Lama. All of their acts blasphemed the last wishes of the Panchen Lama.

75

Chinese money

རྒྱལ་ དར།

国 旗 National Flag

guó qí

མེས་རྒྱལ་ལ་དགའ་ཞེན།

爱 祖 国 love the Motherland

ài zú guó

reconnaissance soldier/ scout རྒྱལ་ཞིབ་དམག

侦 察 员

zhēn chá bing

མིག

眼 睛 eye

yán jīng

རྣ་ མ།

耳 朵 ear

ěr duo

སྙིང་།

心 heart

xīn

སྣ།

鼻 子 nose

bi zi

ཁ།

嘴 巴 mouth.

zuǐ ba

ཀླད་པ།

脑 brain

nǎo

"Learning to Read Through Pictures" — A series of textbooks used to t
Tibetan children Chinese language

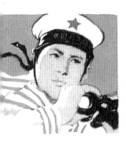

Page 5

མཚོ་དམག

海 军 Navy

hǎi jūn

Book 4, Page 5

གནམ་དམག

空 军 Airforce

kōng jūn

Book 3, Page 2

འབེན།

target 靶子

bǎ zi

Book 1, Page 21

ཐན་ཀེ

坦 克 Tank

tān kè

Cry

Book 4, Page 2

མི་དམངས་ལ་དགའ་ཞེན།

Love the

爱 人 民 People

ài rén mín

ད་ལྟ་སློབ་སྦྱོང་ལ་གཅེས་སྤྱོད།

看图识字

smile

Book 4
Page 27

ཇ་བསྲུབ་པ།

打 茶 make tea

dǎ chá

ch

Book 1, Page 20

གློག་བརྙན་གཟུགས་པར་འཁྲུལ་འཁོར།

电 视 机

diàn shì jī

Television

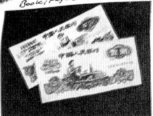

Book 1 Page 36

དངུལ་སྒོར་གསུམ།

三 元 钱 3 yuan

sān yuán qián

Before, when I was a child, I was taught the Chinese "liberation" of Tibet was good and I believed it. We did not know anything else. I didn't know we were a separate country. After the demonstration of 1987, I was woken up and I was forced to ask myself questions. I realized that "liberation" means that they force us to be part of China and that we are slaves to another people.

—Tenzin Dorje, Tibet university student

Chinese People's Armed Police photograph themselves on the first military plane to fly into Tibet. The Potala, former home of the Dalai Lama, lies in the background. Tibet is of major strategic and geopolitical significance to China. Western intelligence sources confirm the existence of nuclear weapons in the Tibetan areas of Qinghai Province and up to 175,000 security personnel in the Tibet Autonomous Region (TAR).

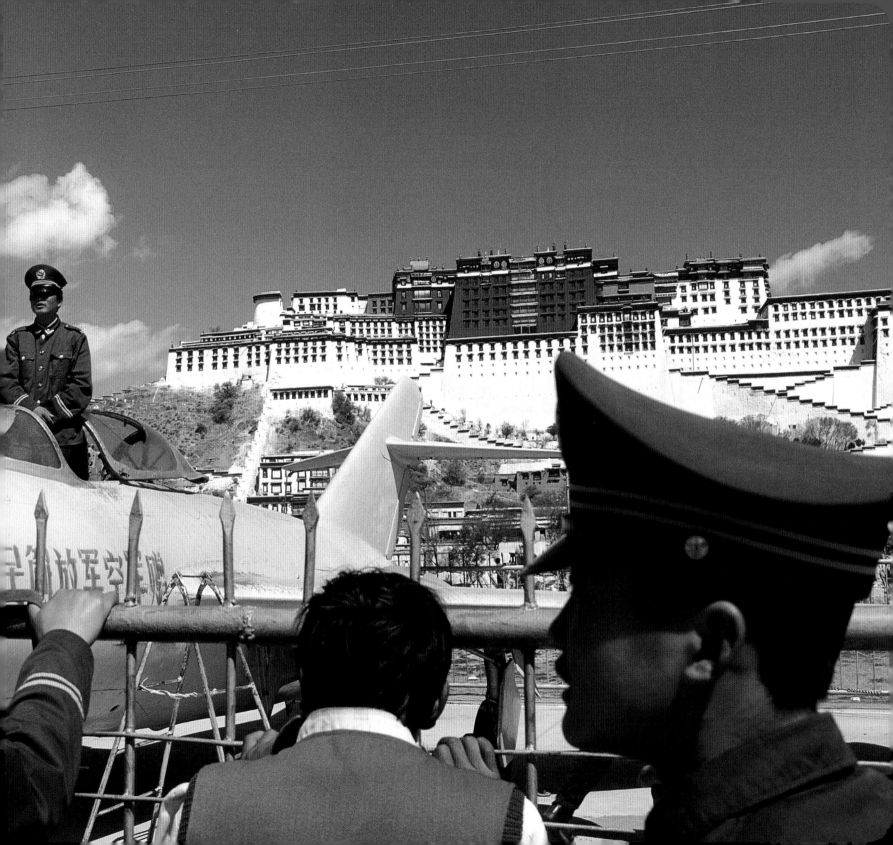

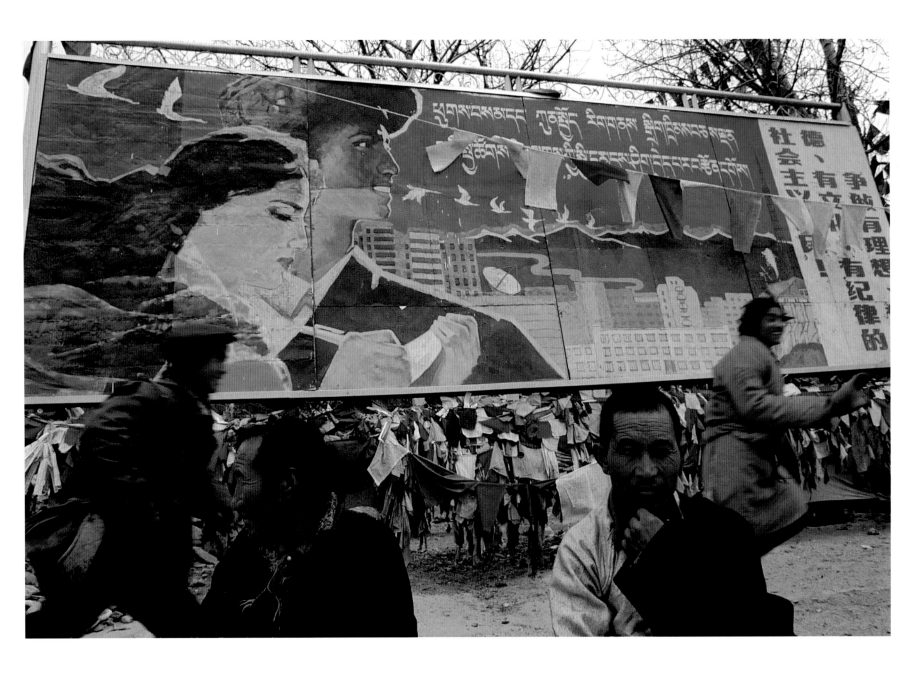

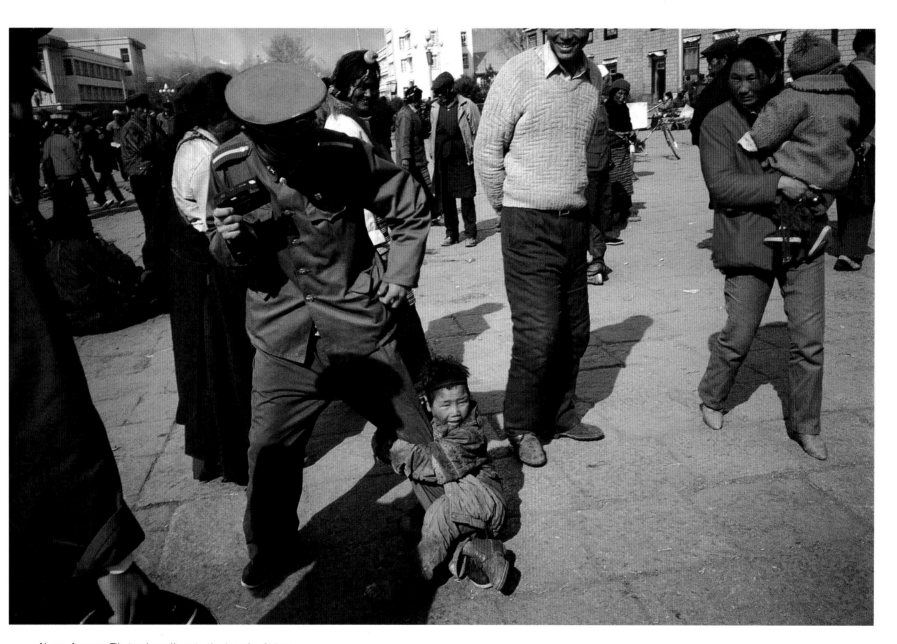

Above, A young Tibetan boy clings to the leg of a Chinese
soldier and begs for money. The influx of Chinese immigrants to
Tibet has brought on high unemployment and extreme inflation
that has resulted in a growing population of homeless in Lhasa.
Left, A Chinese propaganda billboard portrays Lhasa as a
prosperous modern city. A giant *stupa* (large religious
monument) had originally served as the west gate to the city,
but was destroyed during the Cultural Revolution.

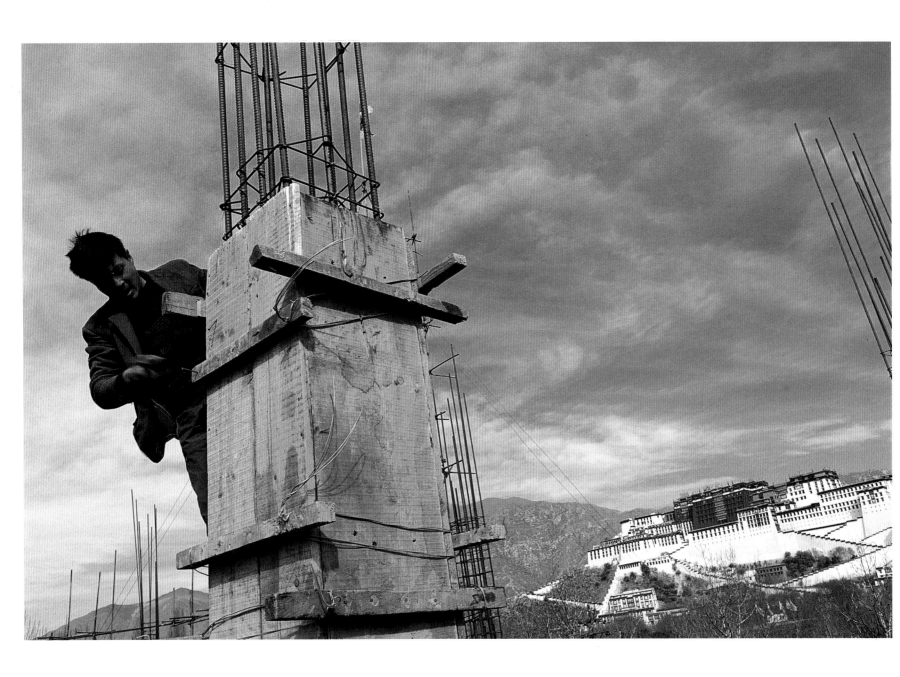

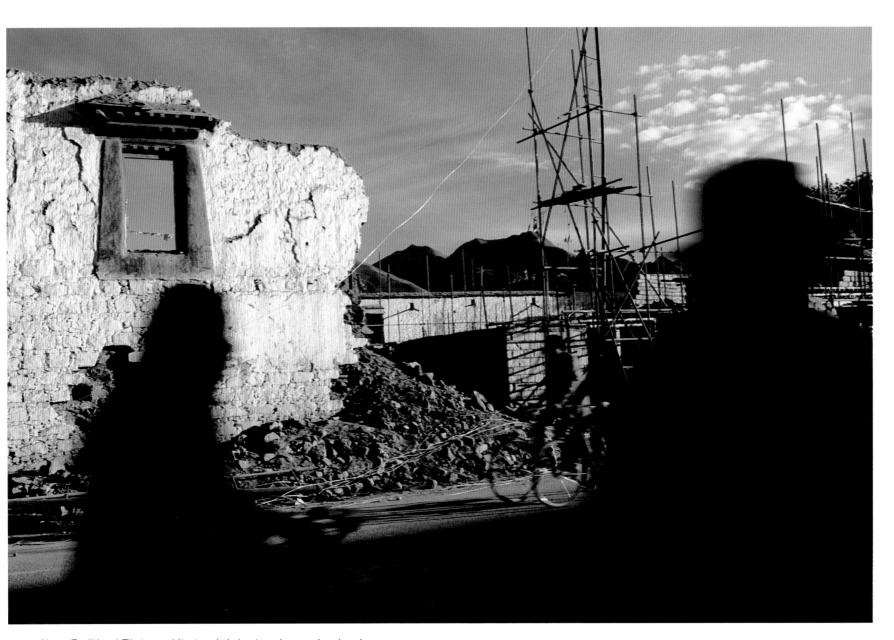

Above, Traditional Tibetan architecture is being torn down and replaced by utilitarian Chinese buildings. The city of Lhasa, formerly one of the most architecturally distinctive places in the world, is now dominated by Stalinist-type structures built by the Chinese in the last decade. In the last ten years, two-thirds of the old city of Lhasa has been destroyed. *Left,* A Chinese immigrant works on a building near the Potala, one of the world's architectural wonders. Chinese workers are lured to Tibet by salaries that are three to five times higher than in their native cities.

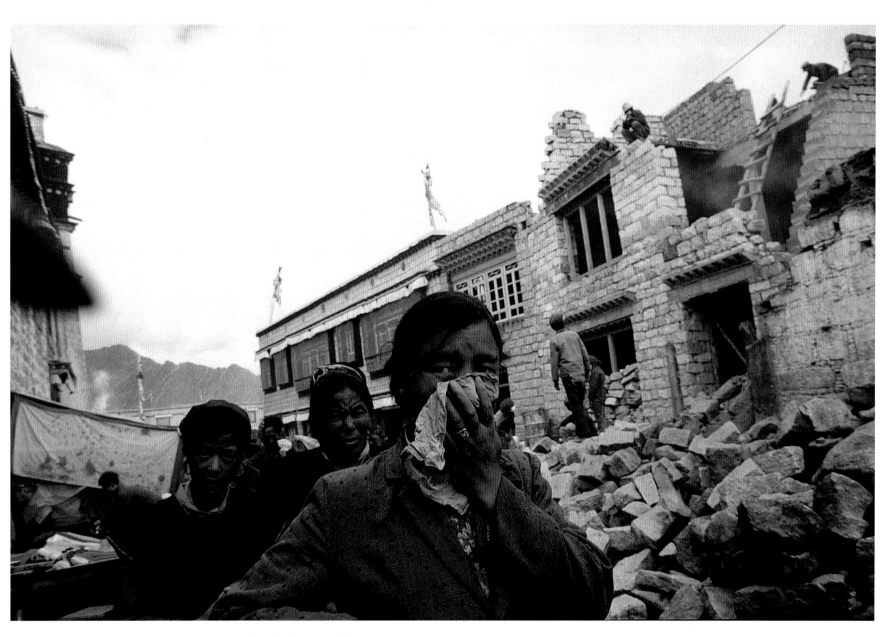

Above, A Tibetan woman covers her mouth against the dust created by the destruction of buildings adjacent to the Jokhang Temple. The temple itself, constructed in the seventh century, is considered to be Tibet's most sacred temple, the Tibetan equivalent of St. Peter's in Rome or the Wailing Wall. The square in front of the temple and surrounding pilgrim circuit have been the site of much of the pro-independence activity that has occurred in the last decade.
Left, Tibetan boy with toy gun.

Tibetan buildings are beautiful—we don't want those ugly Chinese buildings. Our culture isn't just our written language, it's our religion, our customs, even our buildings. This is why we need to maintain our Tibetan architecture. You can see a people's mind through their buildings.

—Diki, shop owner

The new Tibet, characterized by an apartment building in the Chinese settlement town of Golmud. In most cities in Tibet, Chinese settlers already outnumber the Tibetans. The influx of Chinese is marginalizing the Tibetans economically, politically, and socially. The Chinese government has tried to limit the growth of the Tibetan population through strict family planning laws. If the current rate of migration continues, Tibetans will soon become a minority in their own land.

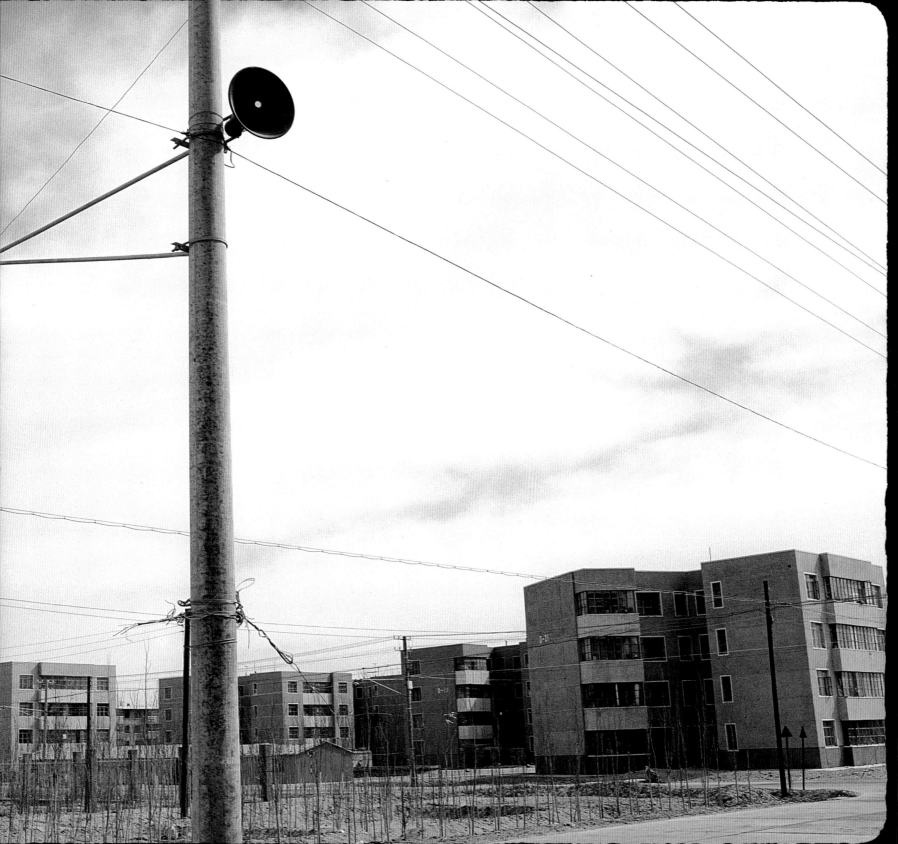

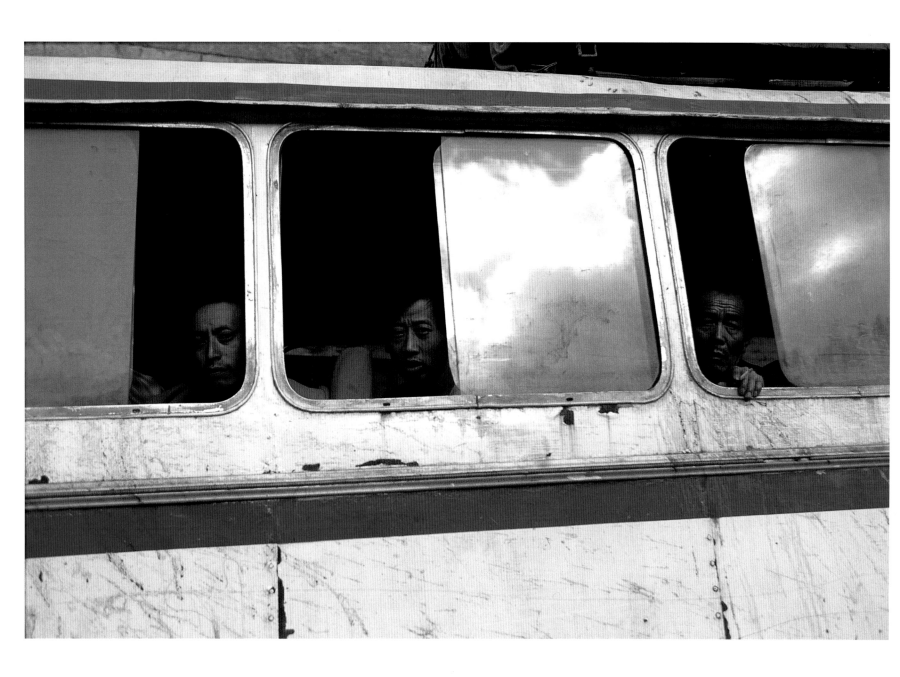

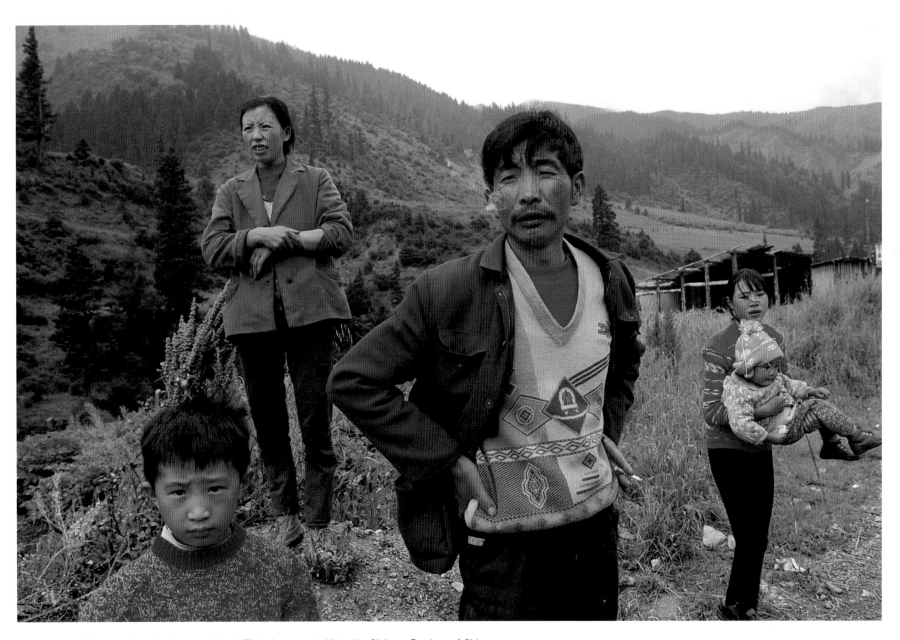

Above, Chinese settlers in Amdo, northeast Tibet, incorporated into the Sichuan Province of China.
Left, Chinese immigrants enter Tibet on the Sichuan-Tibet Highway. This highway is one of the main links connecting China to Tibet. Stretching over 1,300 kilometers, the road traverses the steep mountain ranges of the eastern province of Kham. With an average altitude over 14,000 feet, the route is one of the highest roads in the world, and of major strategic importance, supplying Chinese military bases and serving as the avenue for exporting minerals and lumber obtained in Tibet. Initially built by the People's Liberation Army, some sections of the road are still maintained with prison labor.

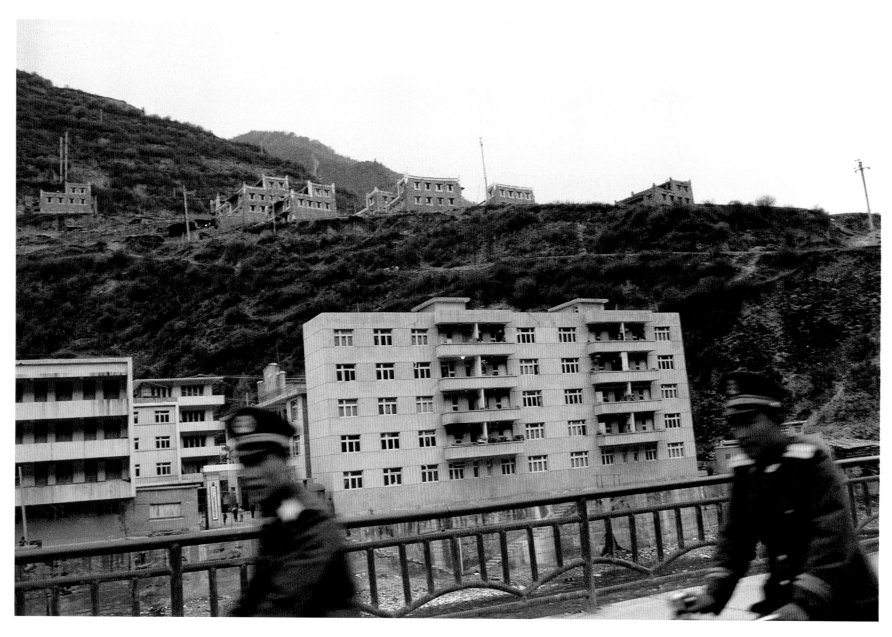

Above, People's Armed
Police ride bicycles
through town in Amdo.
Right, A Tibetan man in
Kham, eastern Tibet,
wears a Mao hat.

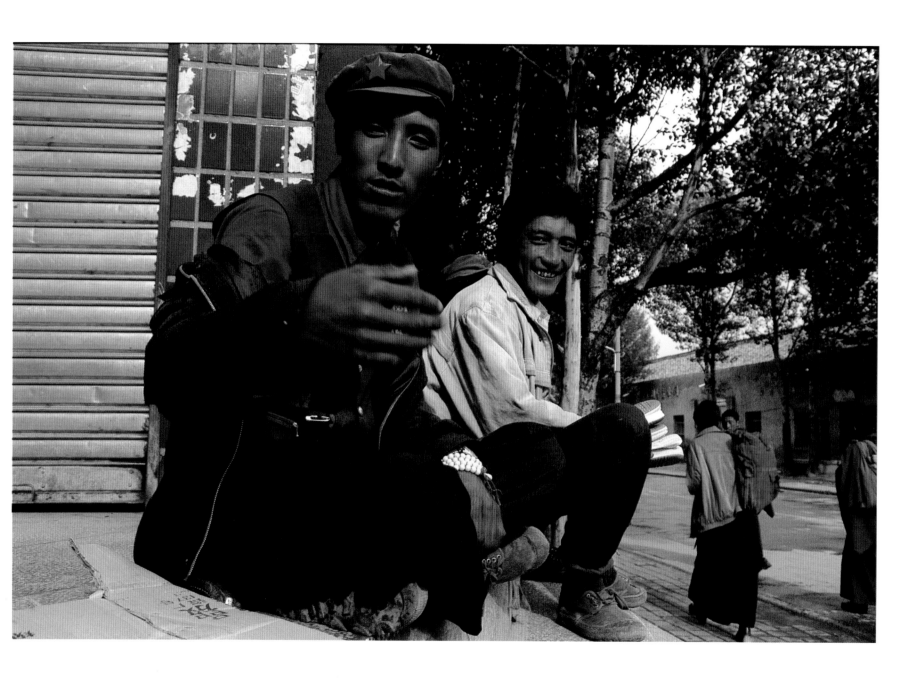

We must recognize that Tibet's most extraordinary circumstance lies in the existence of the struggle against the Dalai clique....We must declare a total war—in thinking and theory and in the ideological realm—on the Dalai and his separatist forces. This is the ideological and political foundation for Tibet to advance to the new century.

—Ragdi, Chairman of the TAR People's Congress, reported in the *Tibet Daily*, January 12, 1998

Tibetan and Chinese government officials preside over the opening ceremonies of a basketball tournament in Amdo. By one estimate, 66 percent of regional government officials in the Tibetan Autonomous Region are Chinese. While Tibetans hold many positions in local government, the top decision-making posts are consistently held by ethnic Chinese.

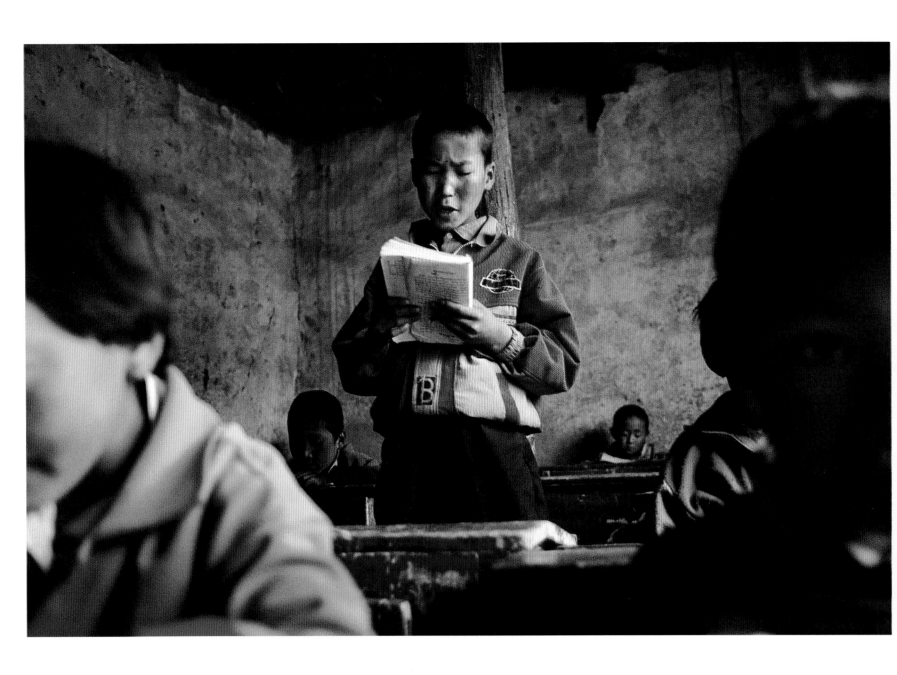

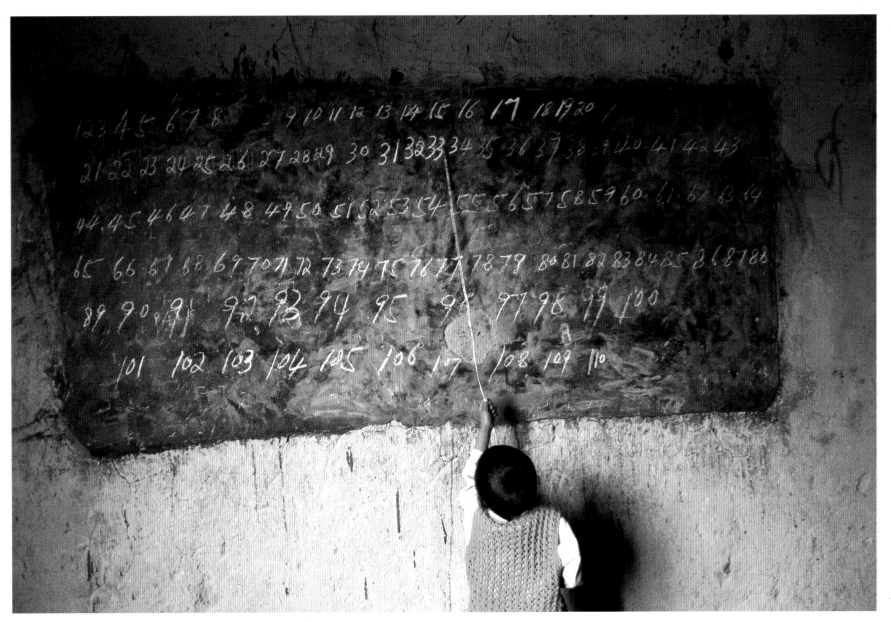

Above, A Tibetan boy learns to count in a village school in central Tibet. If a child is fortunate enough to go beyond elementary school, he or she must use Chinese in all classes (except in Tibetan language courses). In some areas of Tibet closest to China, Tibetan children have begun to lose their ability to speak Tibetan.

Left, A village school in central Tibet. Education is a major concern in Tibet, with 80 to 90 percent of the population illiterate. Of the approximately 1,000 adults in this village, only four could read.

Math and science are taught in Chinese. If we ask questions in Tibetan, our teacher either hits or scolds us. The teacher is Tibetan but he looks like a Chinese, he even speaks Chinese at home. We are Tibetan—we don't want to speak Chinese. Please don't talk about this with anyone else or the police will come after you and put you in jail. Be careful.

—Tenzin, eleven-year-old elementary school student

The flag of the People's Republic of China hangs over a village school in central Tibet. There are very few schools in the countryside and the ones that do exist are usually built by local villagers who donate their time and money. The government generally contributes some funds for building supplies (at the most 40 percent of the costs and, more often, only a few thousand *yuan*). The teachers are poorly paid and often unqualified.

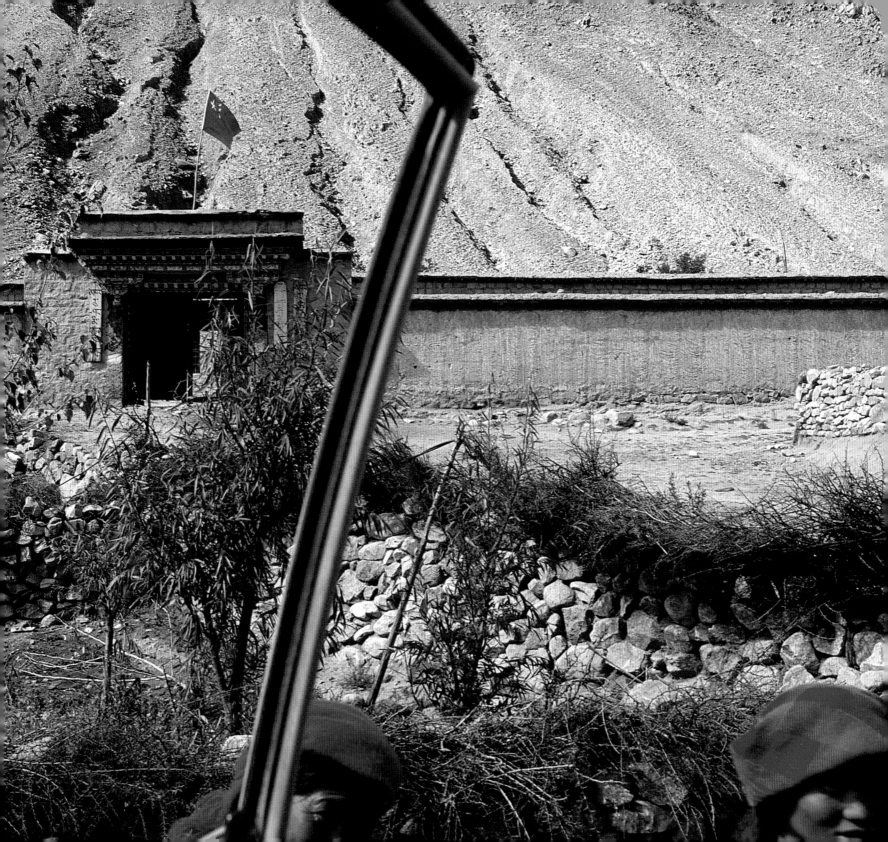

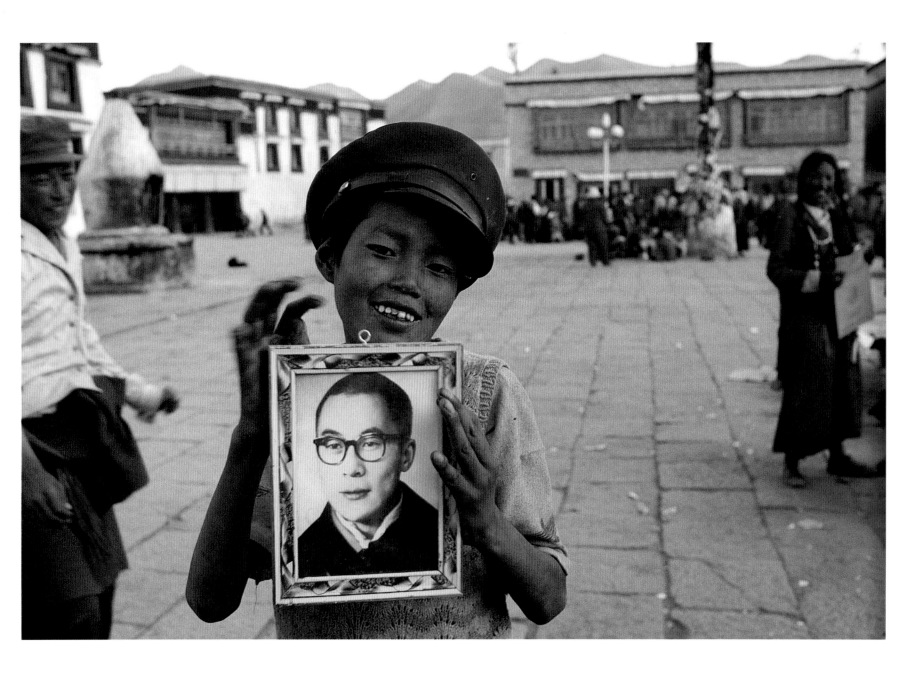

Above, The ruins of Shide Monastery in Lhasa, one of approximately 6,000 that have been destroyed during China's occupation of Tibet.
Left, A Tibetan street child in Lhasa with a photograph of the Dalai Lama, spiritual and temporal leader of the Tibetan people. Prior to the political unrest of late 1980s, Tibetans were allowed to display photographs of the Dalai Lama—by 1995 public display of his image was banned. Tibetans working in the government have also been required to remove pictures of the Dalai Lama within their homes.

Above, Chinese immigrants unload a truck of supplies in Lulang (three days east of Lhasa). The population transfer policies of China pose the single greatest threat to the survival of the Tibetan culture and identity.
Right, Chinese immigrants buy a refrigerator in Lhasa. In many cases the Chinese government encourages migration to Tibet by offering settlers higher salaries, job preference, housing benefits, and vacation incentives.

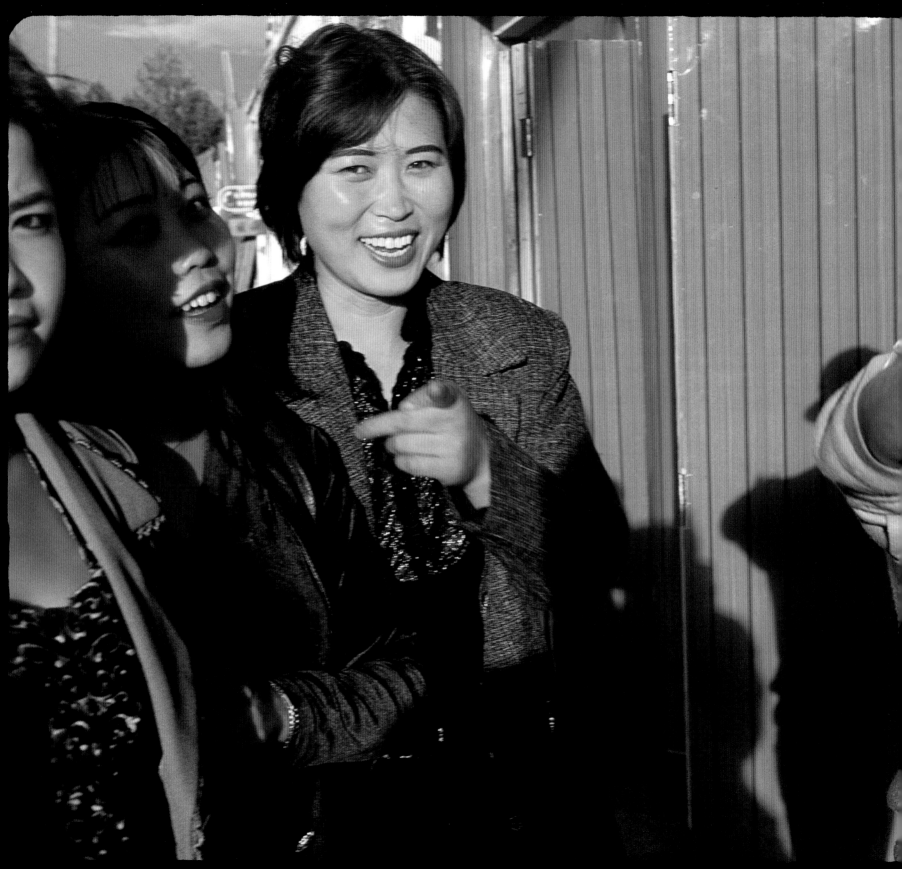

They want to develop Tibet. But what do they develop? Only gambling and prostitution are the things that have really opened up. The people only play. If their minds are on prostitution and gambling, they forget about development and politics. I think many people feel that the government wants this, that encouraging this is an actual policy so people will forget about the important things.

—Jamyang, hotel manager from Aba County, Amdo

Young Chinese prostitutes along the historic Lingkor pilgrim route in Lhasa. The lack of regulation and a flood of immigrants into Lhasa has created an "anything goes" economic atmosphere where prostitution and corruption run rampant. In many ways, China's migration into Tibet is similar to the opening of the "Wild West" in the nineteenth-century United States.

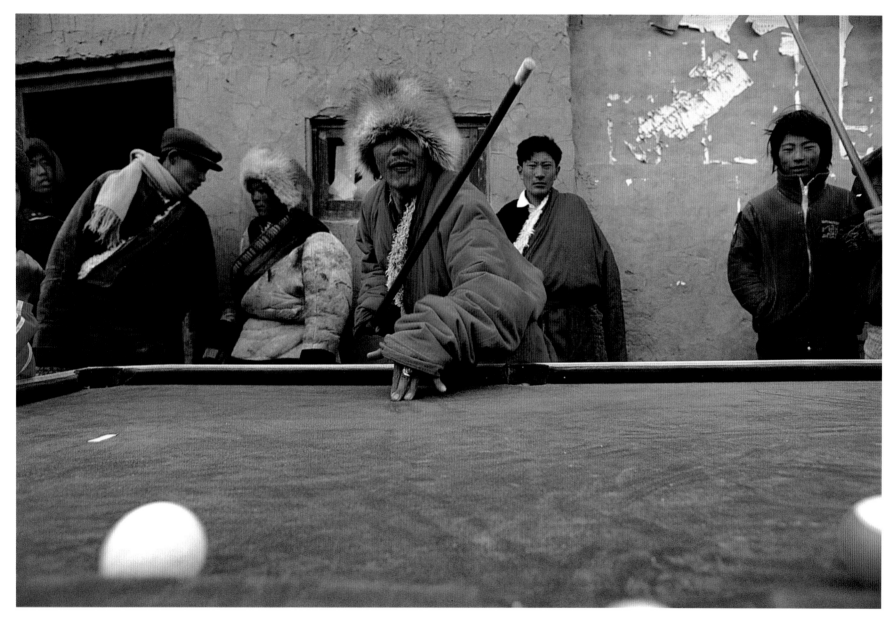

Above, Tibetan nomads play pool in the Chinese outpost town of Nagchu, a sparsely populated region in northern Tibet. *Right*, Tibetan students living in exile in India dance at a graduation party.

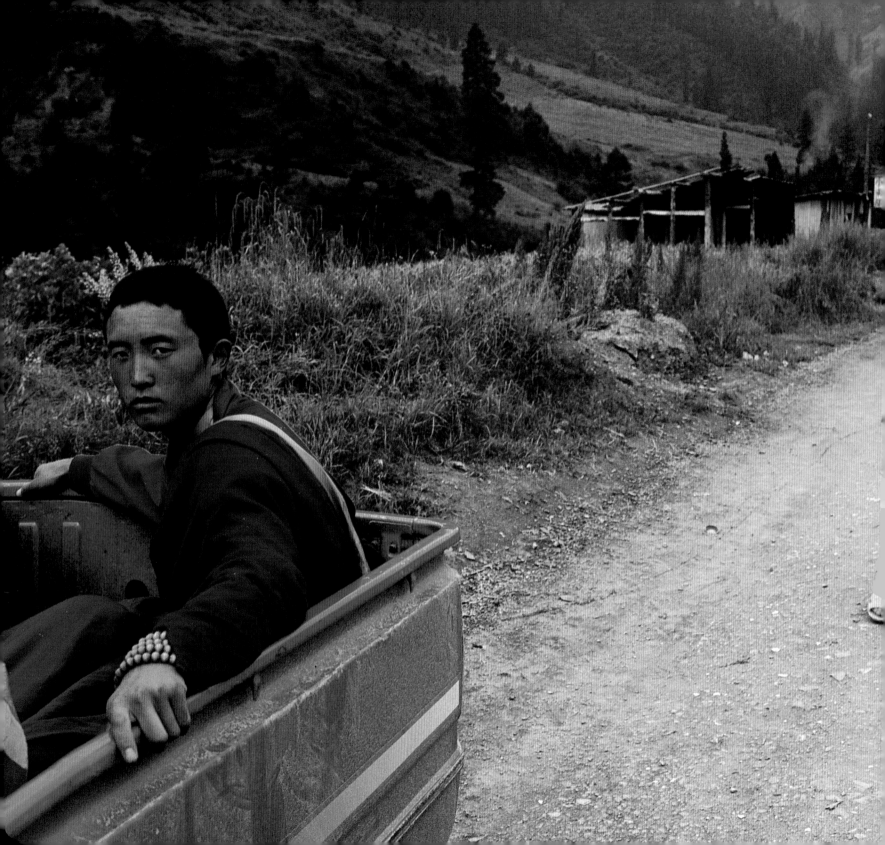

Before there were Mongolian people in what is now Inner Mongolia. Now where are they? Now there are none. There are no Mongolians in Inner Mongolia. This is China's future plan for Tibet—to gradually destroy the Tibetan people and Tibetan culture through assimilation.

—Dr. Dawa, exiled Tibetan doctor

A monk hitchhiking in Amdo awaits his driver while Chinese settlers wait for a bus.

China has had a very large impact on Tibet.
The economy is not very developed—there are
few who have money and many who are poor.
Most people have very little education. In China,
if you have power, you have everything—you
have status, you have money, you have women.
In Tibet, the position of the police is very high.
They have incredible power and authority,
they can do whatever they want, and the
government pays them well. This is why Tibetans
join. They are often from very poor, remote
villages and they don't know any better.

—Paljor, Tibetan translator

Chinese settlers in Amdo
ride by government
propaganda urging citizens
to "love the motherland"
and "strive forward" in the
development of China.

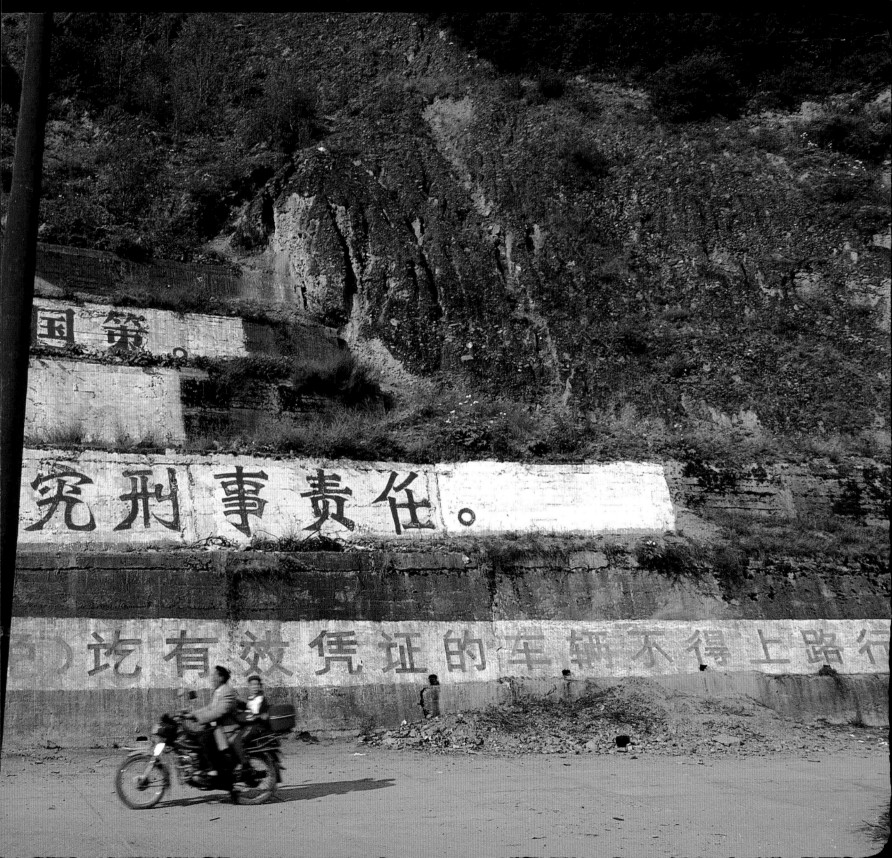

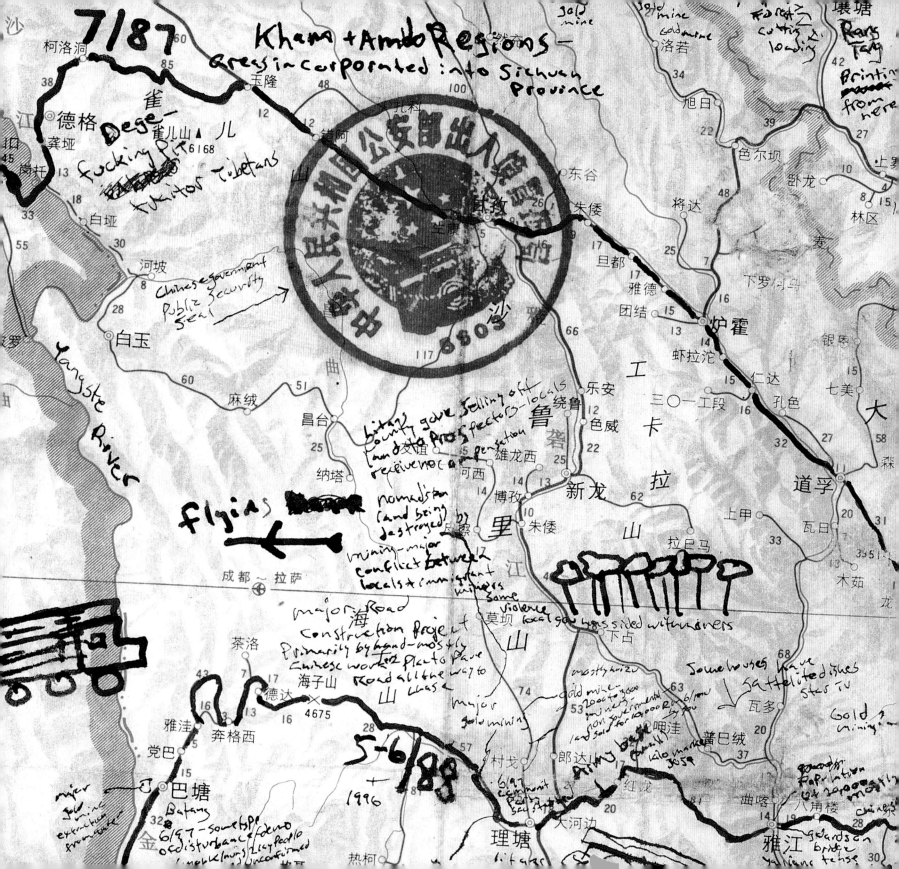

7/87

Kham + Amdo Regions —
areas incorporated into Sichuan
Province

Dege —
fucking PLA
Fuck to Tibetans

Chinese government
Public Security
Seal

Yangtse River

Litang county govt selling off
land and via PROSPECTORS — locals
received no —— gensation

nomadism
(and being
destroyed) by

mining — major
conflict between
locals + immigrant
miners
some
violence
local govt has sided with miners

Flying ▬▬▬

major road
construction project
primarily by hand — mostly
Chinese workers plan to pave
road all the way to
Lhasa

major
gold mining

成都 — 拉萨

mostly Tibetan
gold miners
2000 to 3000
miners

non government
land sold for 10,000 R

Some houses have
satellite dishes
sees TV

Gold
mining

5-6/88
+
1996

major
gold mine
extraction
from water

6/97 — some type
of disturbance of demo
people [monks/nuns] reportedly
unconfirmed

Batang

6/97 — government
people secured?

kilo marker
3059

government
population
124 20000 mostly
Chinese

Jiangseo
bridge
Yalung tense

gold mine
gold mine
Goldmine

Forest
cutting +
loading

Printing
from
here

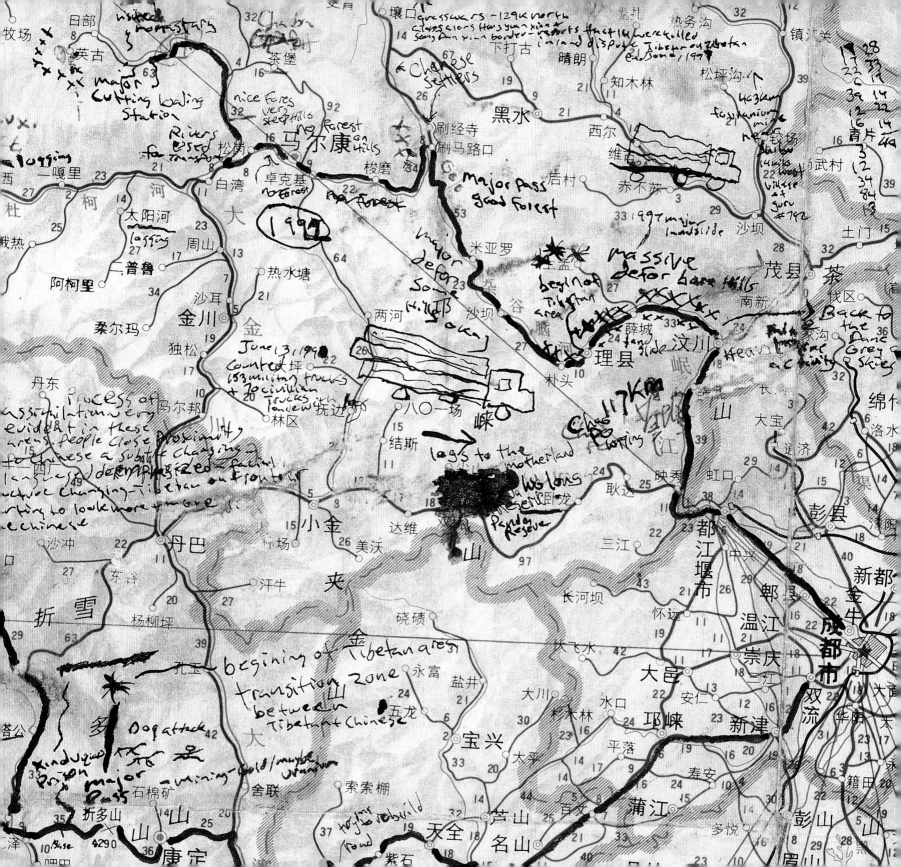

Tibetans believe deeply in religion. I give you an example. If we see an insect on the road, we do not step on it and kill it. We will move it to the side of the road away from harm. Animals are the same as people, they have life. To kill the insect does not do the insect any good and it does not help you. We try to put ourselves in the place of the insect and feel what they would feel. If you were very small and a giant came by, you would not want to be crushed, would you?

—Rinchen, Kham university student

Once a beautiful picnic spot in the middle of the Kyichu River in Lhasa, today Jamalingka Island is being converted into a resort and hotel complex by a Macau company.

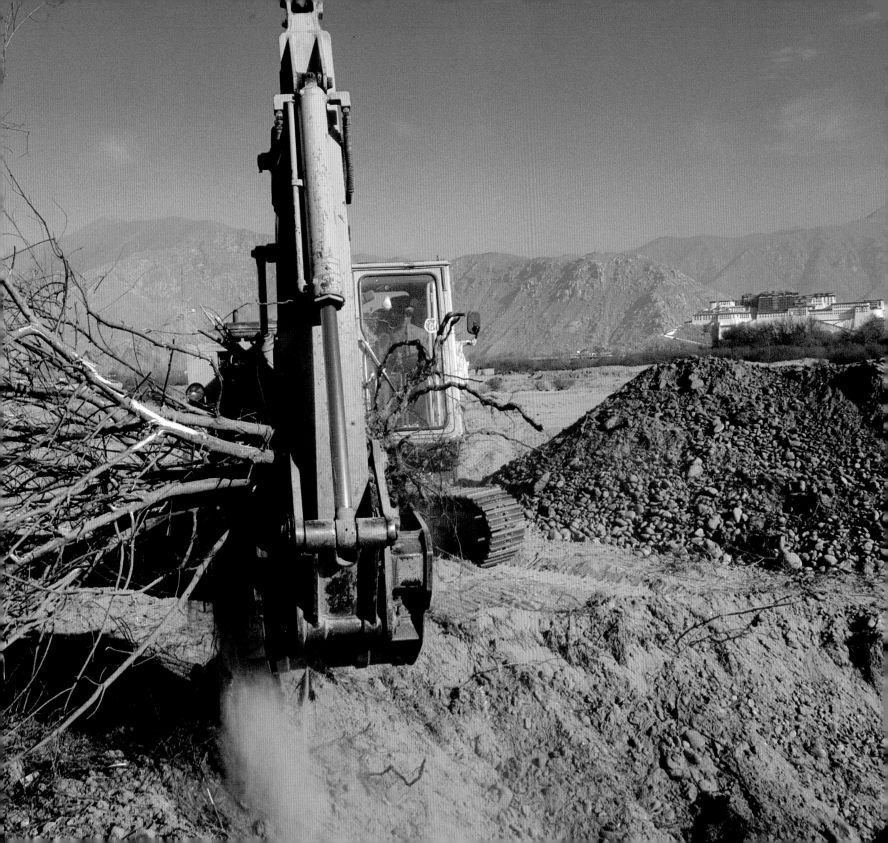

Left, A forest reserved for cutting by the Forestry Department of China. Almost two-thirds of Tibet's forests have been destroyed and billions of dollars worth of timber removed since 1959.

Center, Laborers cut logs for export to China. The majority of China's lumber originates in Tibet. Because Tibet is the source of seven major rivers in Asia, this deforestation has caused flooding, soil erosion, and siltation throughout the region.

Right, A Chinese logging truck carrying lumber newly cut from Tibetan forests to Chinese destinations.

In the time it takes me to drink one cup of tea,
I count an average of fifteen trucks loaded
with timber passing by. I see the wealth of our
land being taken to China every day. I do not
think this is right, but what can I do to stop
this from happening? People don't think of the
effect of cutting trees. They only think of
themselves and making money.

—Sherab, high school student

Minjiang lumberyard, where
logs cut from the forests of
Tibet await transport to
points throughout China.

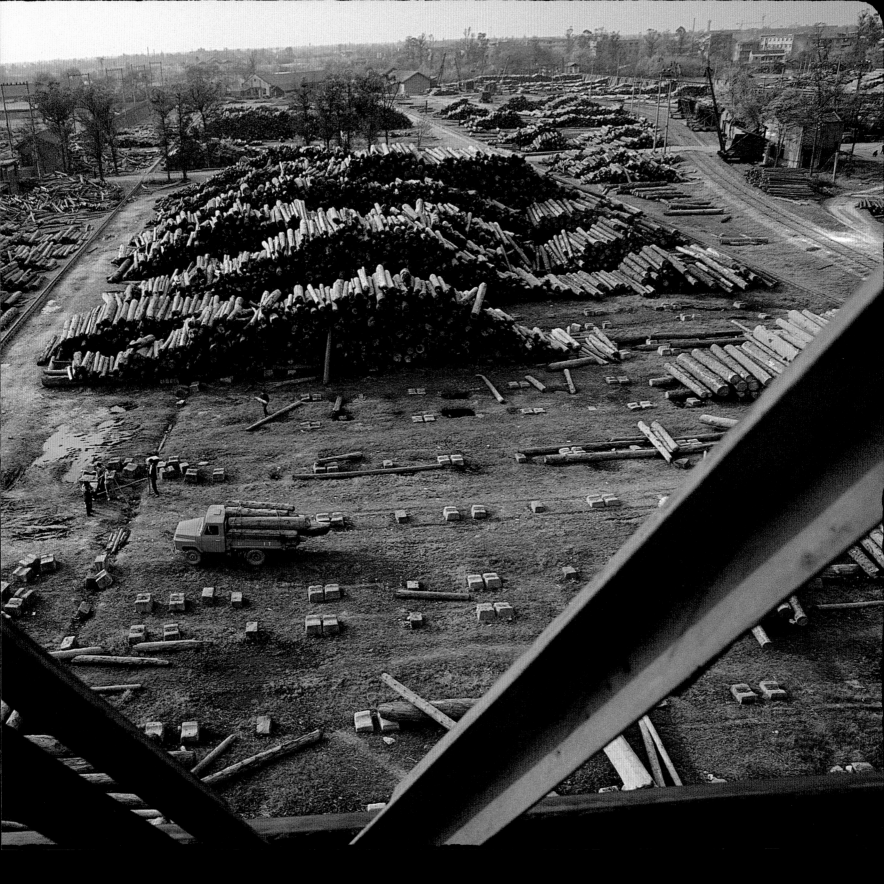

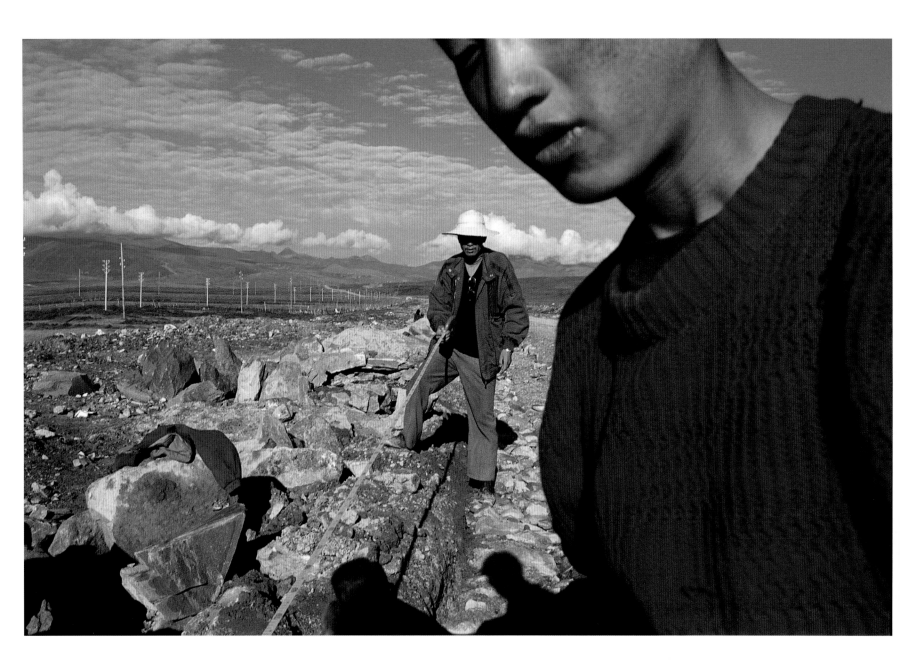

Above, This Tibetan roadworker makes the equivalent of $1.50 a day, less than one-fifth the average salary of immigrant Chinese laborers.

Left, Chinese roadworkers in Kham pave the Sichuan-Tibet Highway. This development project hopes to improve transport in the remote areas of Tibet. In a region largely populated by Tibetans, 70 percent of road construction jobs are held by immigrant Chinese. In Kham, several major gold mines have destroyed fragile grazing lands. Despite appeals to the local government and violence between immigrant miners and local nomads, the mining continues unabated.

Above, Chinese cement factories produce nearly 300,000 tons of cement a year to supply the explosion of Chinese construction in Tibet. The pollution from the smoke-stacks is beginning to create smog in Lhasa. *Right,* Chinese People's Liberation Army trucks enter Lhasa. In the foreground, a cow feeds on trash.

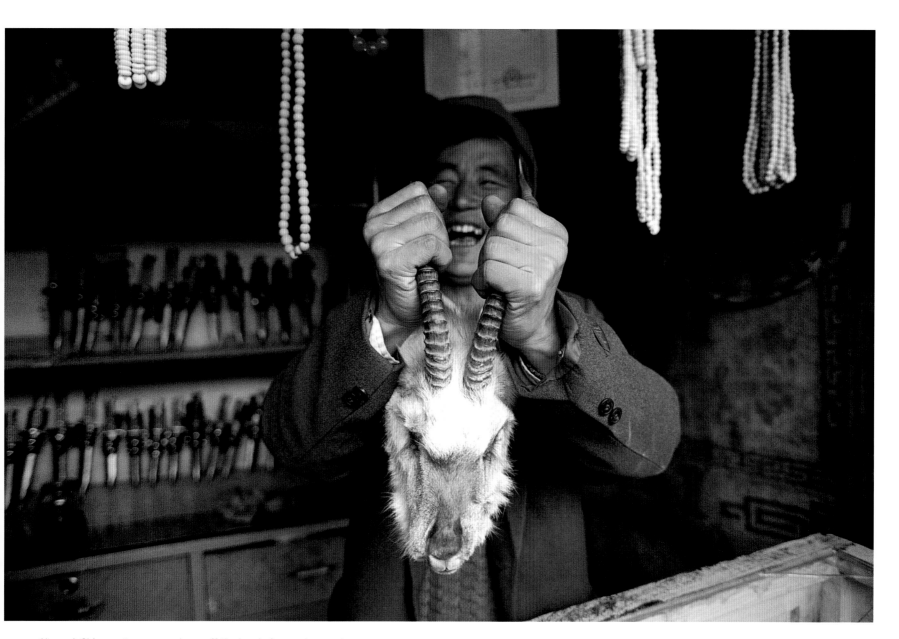

Above, A Chinese store owner shows off the head of an endangered antelope. Large Tibetan mammals continue to be poached, including several endangered species, such as the snow leopard and the tiger. Antelope antlers are used in the production of Chinese medicine.
Left, A Uygur Muslim from Xinjiang Province illegally sells a fox pelt on the streets of Lhasa. The demand for fox hats, traditionally worn by Tibetans in the winter, has brought the fox population in Tibet to the brink of extinction.

Look at this area—there's no grass. Last year
and the year before they were digging for gold.
There used to be beautiful grass—now there's
nothing. The roots are destroyed and the grass
will not grow back. Our yaks have nothing to
eat. Before our herds would increase—now,
every year more and more of our yaks are dying.
In ten years, with all this mining, the whole
valley will be rock. What use is the gold—there
will be no way to live.

—Tashi, Tibetan nomad

A dump behind a Chinese military
installation, half a mile away from
Sera Monastery. A Chinese army
rations can lies in the foreground.
There are no regulations concerning
dumping in Lhasa. The dramatic
population increase and lack of urban
planning in Lhasa has created
enormous strains on the fragile
Alpine environment.

Homeless boy - Shigatse, Tibet September, 1997 we...
and I needed this photograph. It was my last day in Shi...
...tent I guess he didn't understand. I take it back, I th...
...don't feel bad about exploiting a 10 year old beggar. He was...
...you represent a sociological issue. Where is t...
...didn't like me photographing him with his hand...
...and he would stop. I would back up, he...
...especially for a beggar. The average person doesn't make...
...question. The greater good - what is the...
...Despite all that has happened I...

KODAK TXP 6049 59 KODAK TXP 6049 60 KODAK TXP 6049

a mutual understanding, he wanted something
...tse and I didn't have enough material and I didn't have
...k he did understand. He realized I was trying to show what
...although persistent. It goes with the territory, if you...
...line between people's right to personal privacy and
...t begging. Who would I would you? most people
...would follow me. finally my film ran out. I felt bad, I tried
...e good. what is the greater good of this photograph. I wonder now I am able
...m idealistic, a guarded idealism. I wonder now

Everest - Trail Marker

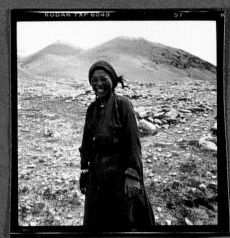

Nun - repairing road

Everest

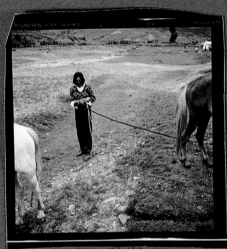

Kham (eastern Tibet) Horse Race

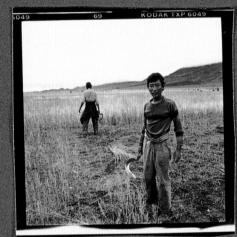

Central Tibet (U-Tsang) Barley Harvest

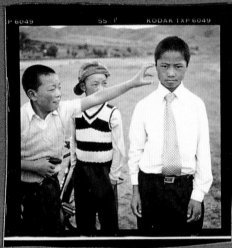

Kham (eastern Tibet) Boy with Tie

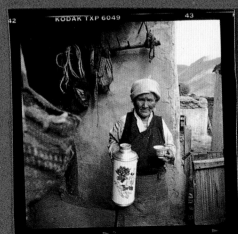

Central Tibet (U-Tsang) Amala Serves
Yak butter tea

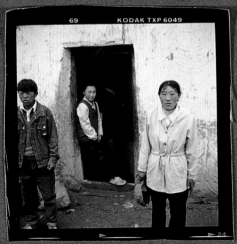

Central Tibet (U-Tsang) - Shop

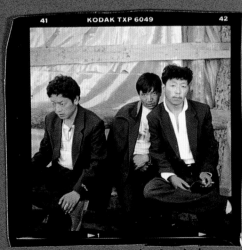

Kham (eastern Tibet) Artists

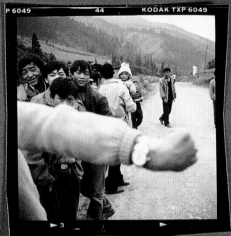

Amdo (w.a. Tibet) - Chinese settlers
wait for bus

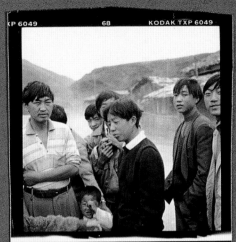

Amdo - Chinese settlers eat dust
Chizui

Amdo - Chinese bus

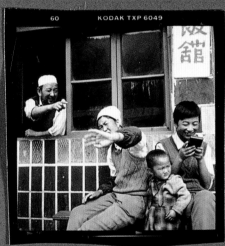

Amdo - Uygur (muslim) settlers

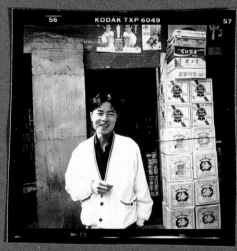

Lhasa - Liquor store adjacent
to military base-owned by Chinese

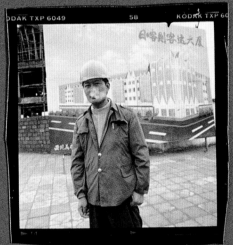

Shigatse - Shanghai Construction worker

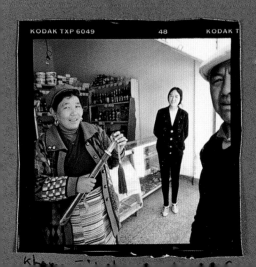

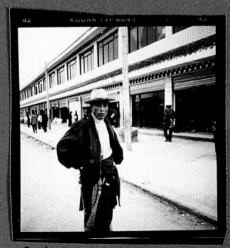

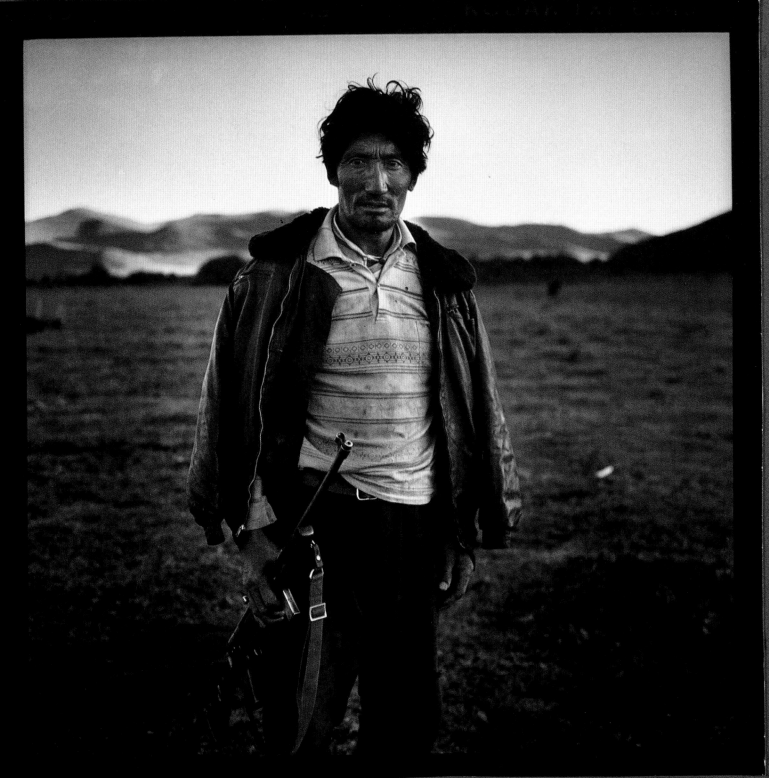

Amdo-Tibetan Nomad — Growing tensions concerning land ownership (due to policy changes, the influx of Chinese settlers, and population increases) have led to a series of nomadic "grass wars" that have left at least fourteen Tibetans dead.

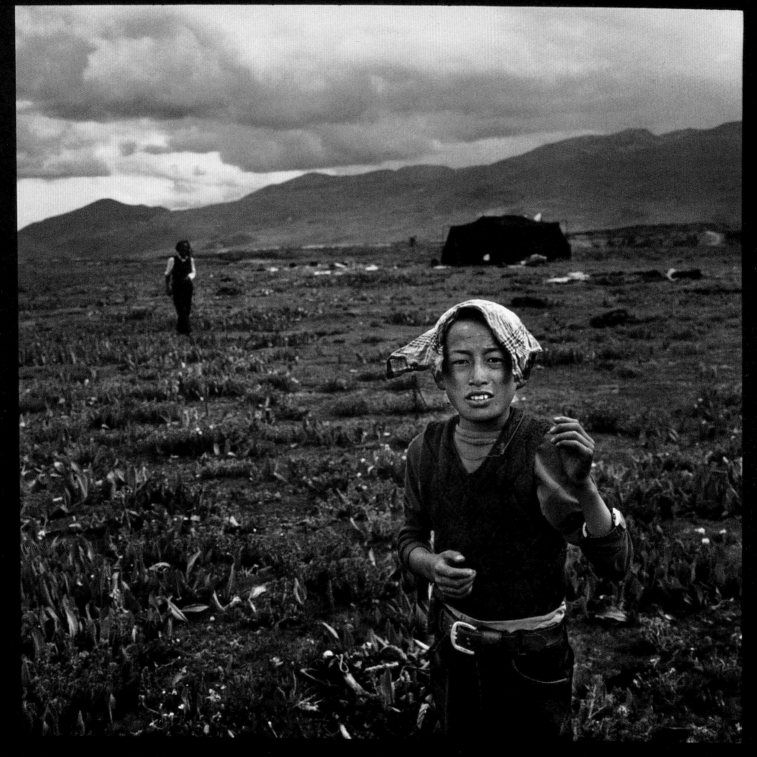

TXP 6049 68 KODAK TXP 60

Amdo Nomad Boy

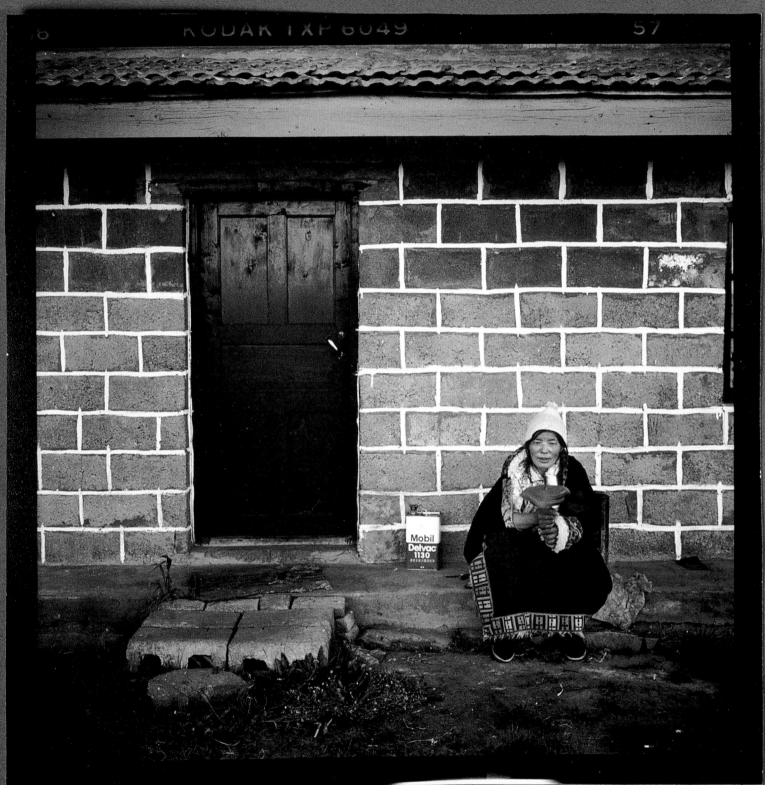

KODAK TXP 6049 57

Amdo (Qinghai) - A recently settled nomad woman sits in front of her government-allotted home. In an attempt to settle the Tibetan nomads, the Chinese government has implemented a controversial land program that destroys communal ownership and works to reduce the nomads' land base.

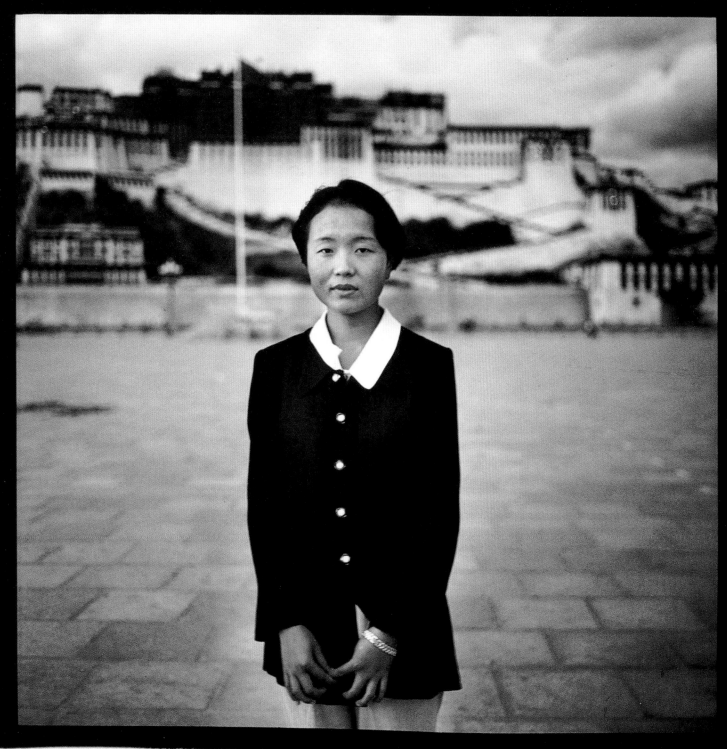

KODAK TXP 6049 48 KODAK

Lhasa, Tibet — A young Tibetan woman before the Potala Palace. This Chinese-style square was built in 1995 for the thirtieth anniversary of the Tibet autonomous region (TAR), its construction destroyed much of the historic village that stands below the Potala.

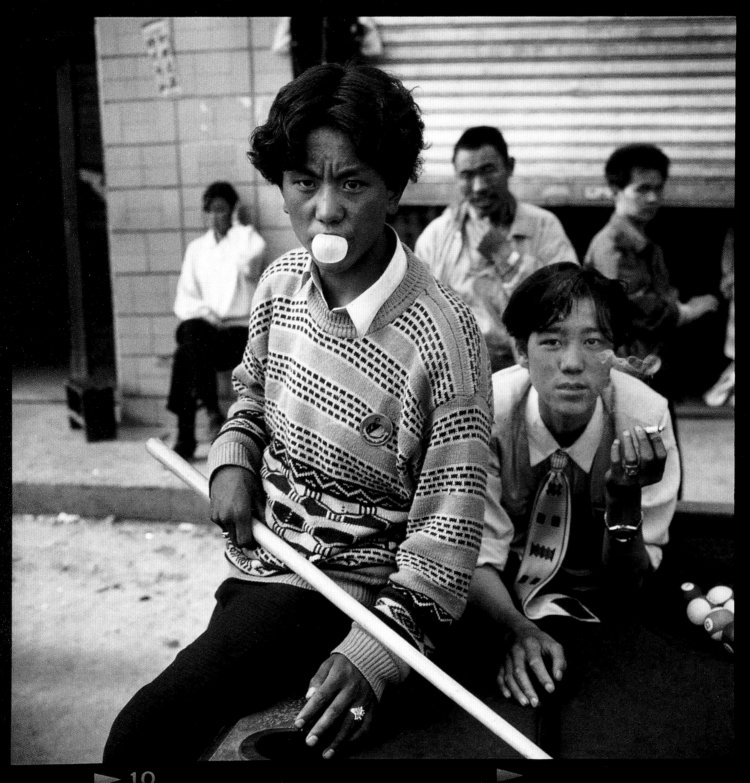

Kham — Tibetan boys play pool

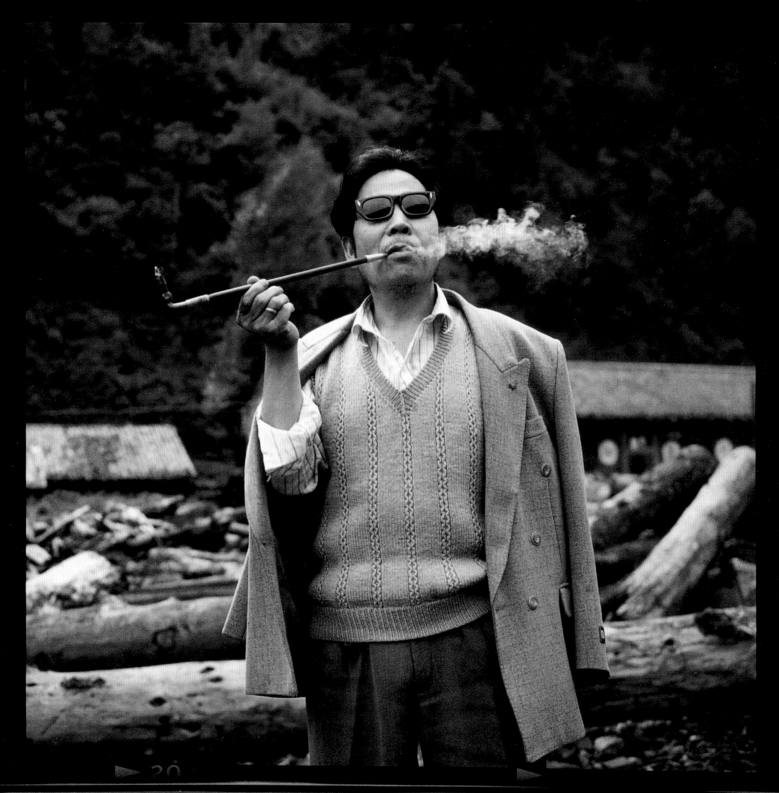

65 KODAK TXP 6049

Amdo-Chinese settler working as manager of a logging company

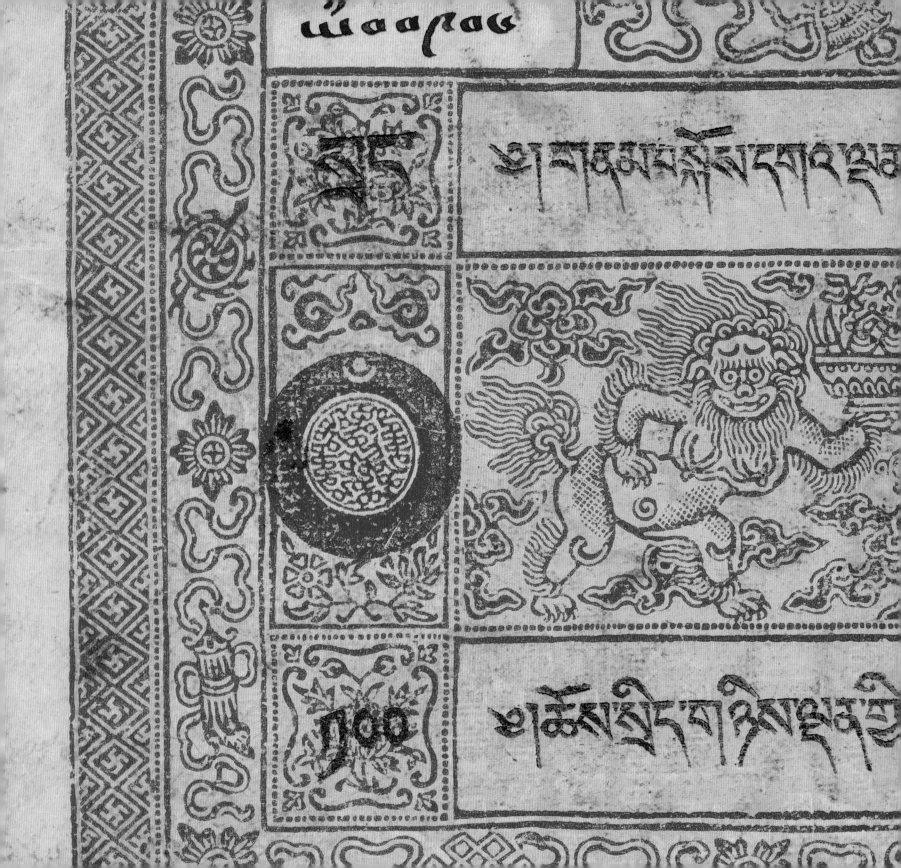

ཞེང་ཕྱོགས་བཞ་་བརྒྱ་རབ་ཀྱ་རྒྱ།

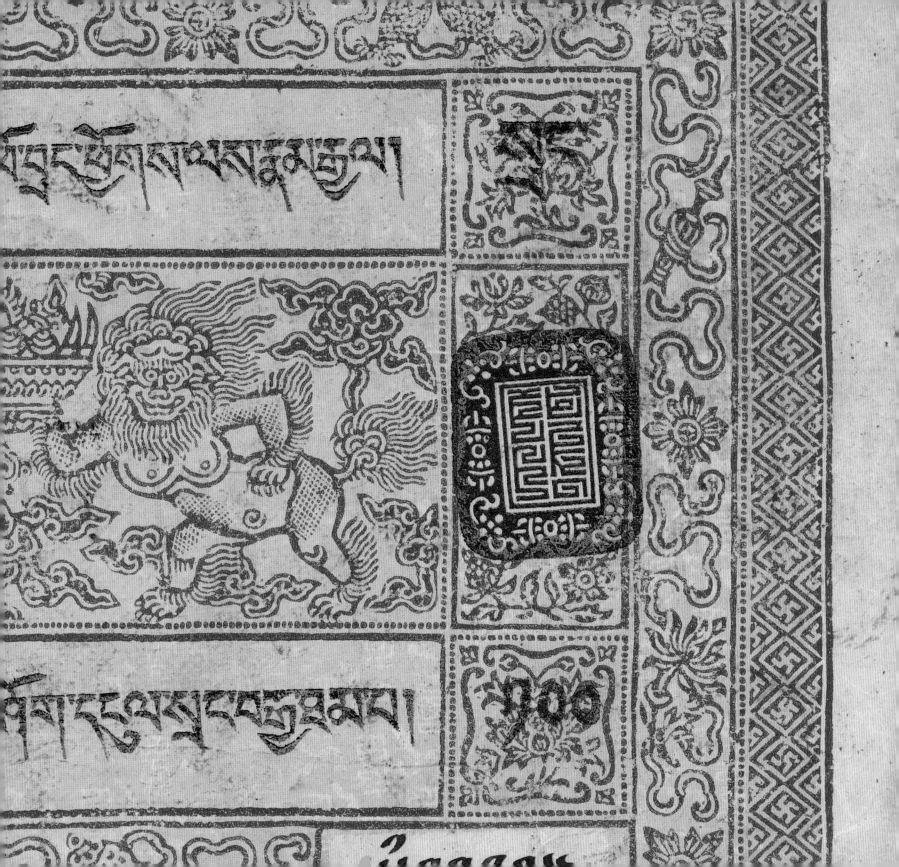

ཞབ་དང་ལེགས་སྦྱར་བཟང་པོ་མ།

ༀ་༡༠༠

We are required by the government to put up
fences. It is very expensive for us. I will
wait and see what happens. I don't know what
the government is going to do—maybe they will
buy the fence. There's no point for me to buy
the fence. I would have to sell all my yaks to
pay for it. All I would have is grass with a fence
around it and no yak.

—Pema, Tibetan nomad

Barley field in the Shigatse region
of central Tibet. Due to its ability to
grow in the harsh high-altitude
environment, barley is the staple
crop of Tibet. The grain holds strong
symbolic significance—Tibetans say
that barley does not discriminate,
feeding both the rich and the poor.

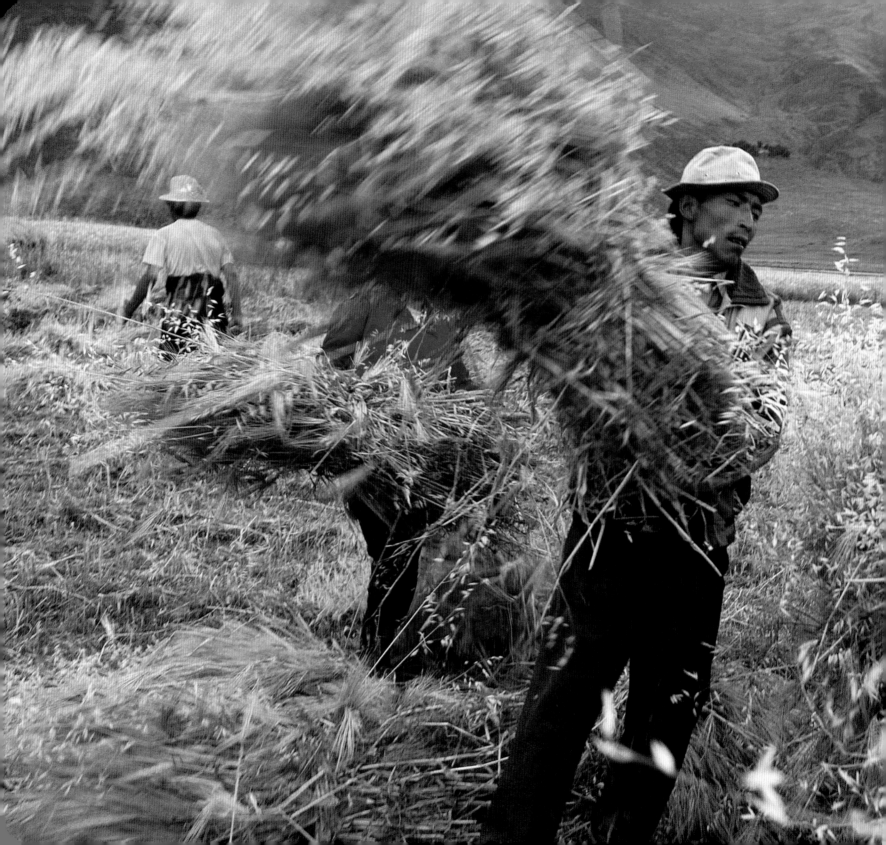

The Chinese come with fertilizer and at first they give it to us for free. They say science is good and that we must use it. They tell us the yak dung is no good. I think their aim is to sell fertilizer because many government factories make fertilizer. At first it is free, then they start to charge. The fertilizer is bad for the earth— you can only use it once and then the earth becomes like stone, dead earth. Tibetan farmers are not scientists but we have more than a thousand years of history and experience and have decided that animal dung is better. It is not bad for the earth, you can use it again, and it's free.

—Jampa, Tibetan farmer

Farmers harvest barley crop in central Tibet. 80 percent of Tibetans still live in rural areas where the economy is subsistence-based, surviving either through farming or raising yaks. The average annual income of rural Tibetans is the equivalent of US $125 per capita.

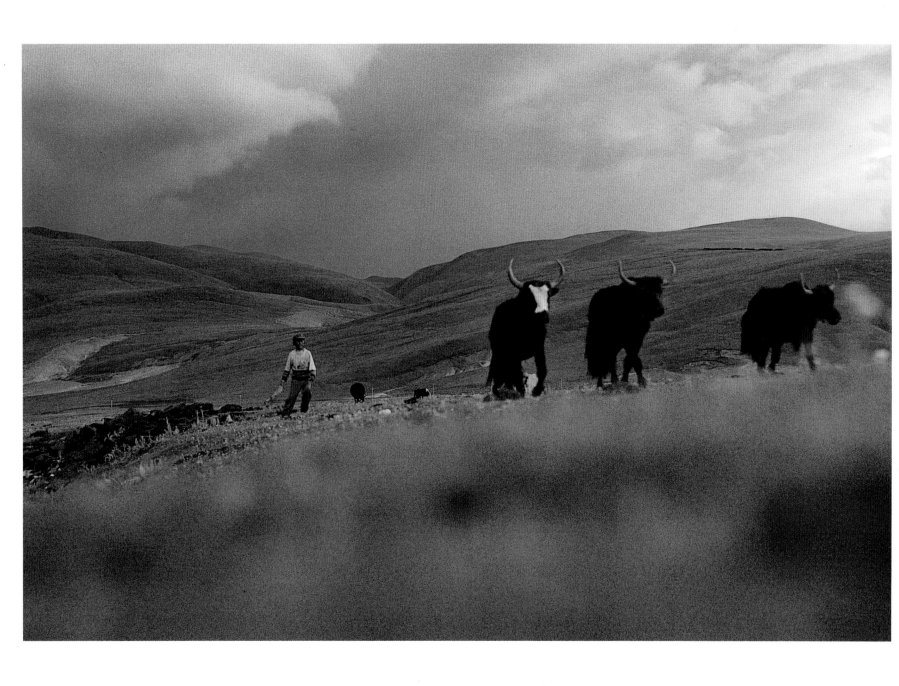

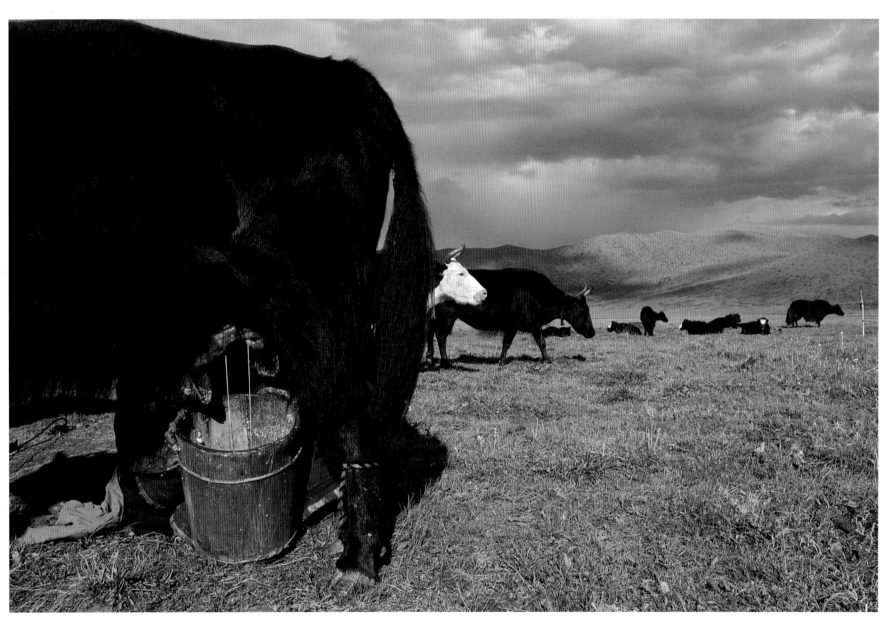

Above, Milking a *dzomo,* a hybrid
of a male yak and female cow.
Left, A Tibetan nomad boy
brings his yak herd back home
at the end of the day.

The yak is the symbol of Tibet because without the
yak we cannot live. I like yak very much—it is a
very honest, good animal. It is an animal you don't
need to feed, you just put it on the mountain.
Their dung we use for the fire so there is no rubbish.
We Tibetans eat yak, we wear yak—all is yak.

—Palden, Tibetan farmer

A group of villagers divide
the meat of a recently
slaughtered yak.

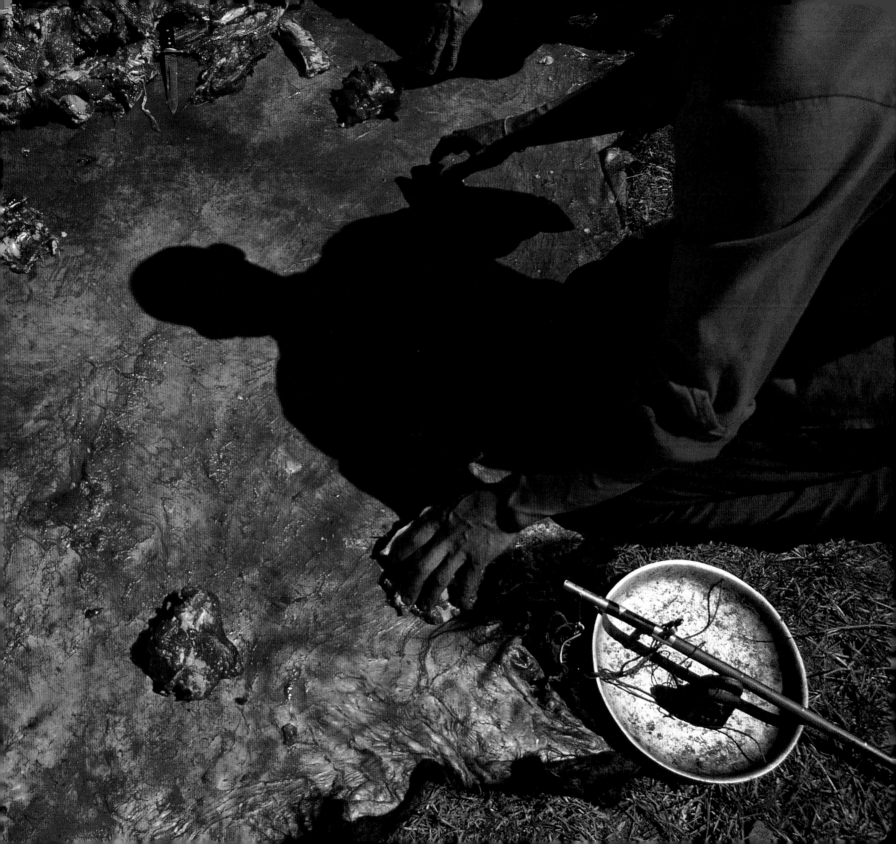

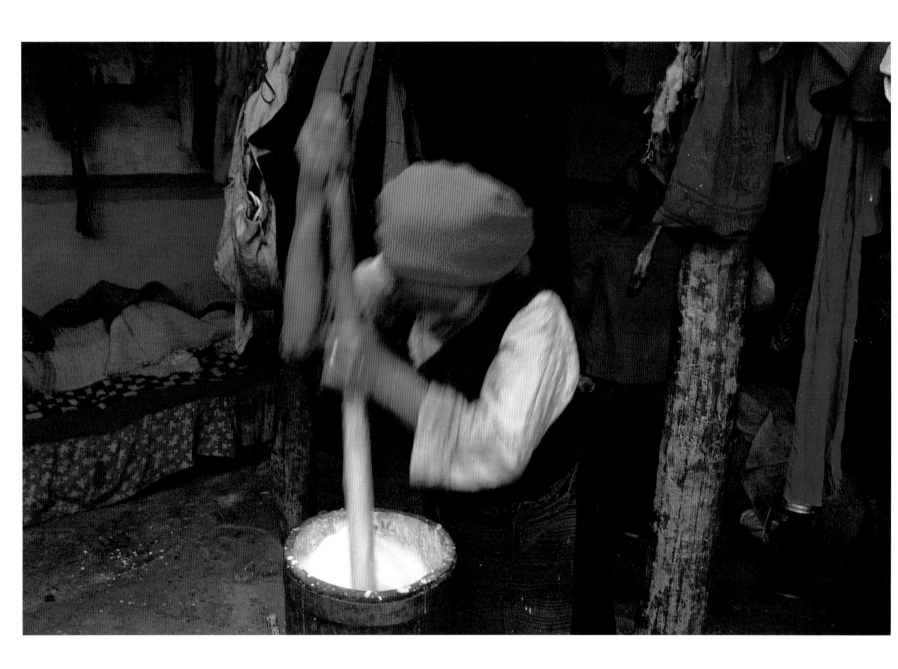

Above, Tibetans place a high value on hospitality.
It is customary to serve tea made with *dri*
(female yak) butter, whenever a visitor arrives.
Left, A Tibetan woman churns butter for Tibetan tea.
The tea is excellent for maintaining energy
in the high altitude and the grease produced by the
butter serves as a moisturizer, protecting both
skin and lips from the harsh elements.

Nomad women make yak hair yarn.

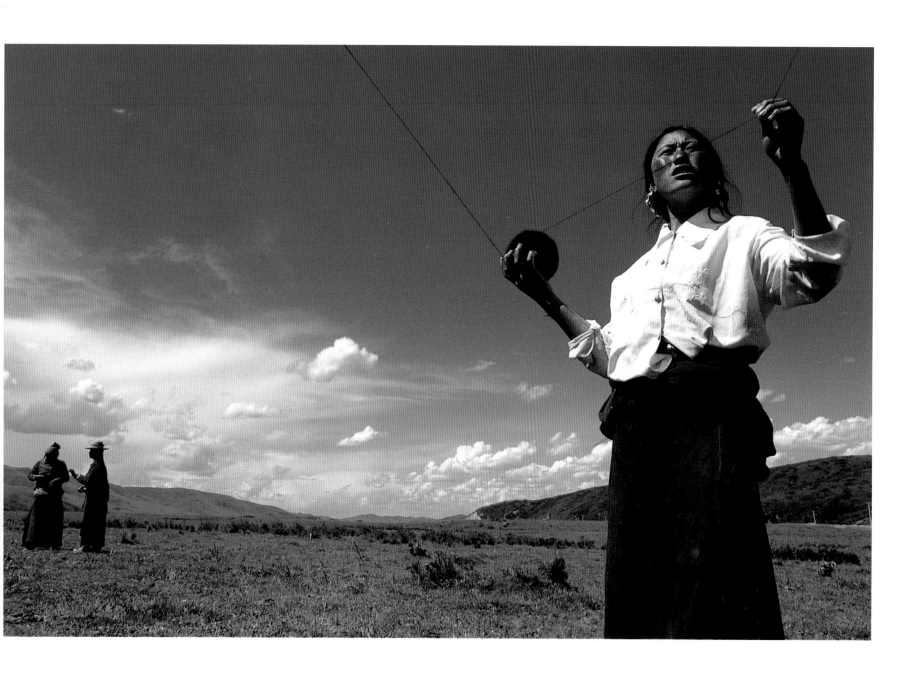

Most of the people here are nomads. They don't
think about Tibetan independence. They just
think about whether they have enough to eat.
The older people are satisfied. For them things
are so much better than before. Prior to the
reforms, people lived with barely enough to eat
and they could not own their own animals.
Now they can—this is enough for them. They are
scared to push for more because it was so bad
before. The younger people don't feel this way,
we didn't grow up with this. My mother says I am
crazy when I talk about Tibetan independence.
She has no education, doesn't understand what a
country is—it doesn't even concern her. She tells
me to stop, says all I will do is bring difficulty
and hardship to the family. She's right.

—Topden, Tibetan nomad

A young man leans from his horse to
pick up a ceremonial *kata,* or scarf. In
the summer months, Khampas (from the
Kham region) hold traditional horse race
festivals where young men show off their
bravery and incredible equestrian skill.

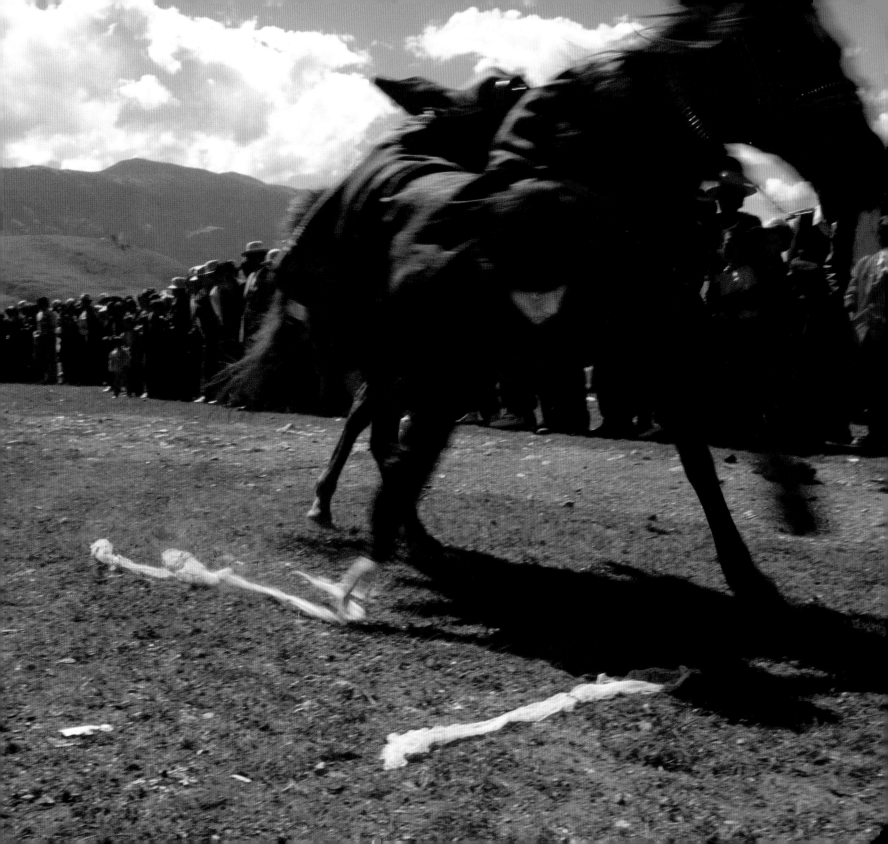

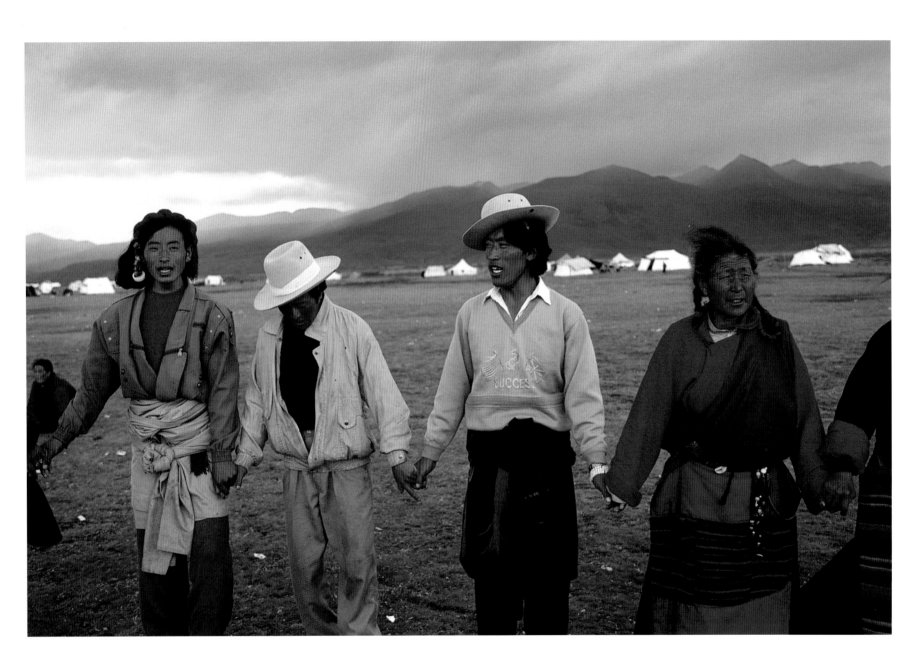

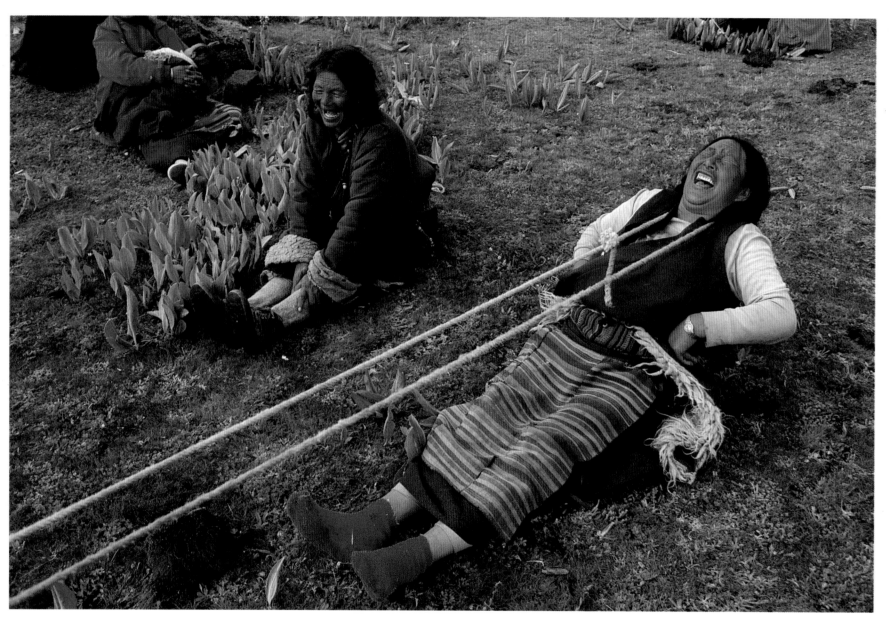

Above, Tibetan woman
plays a game of tug-of-
war with her family.
Left, Traditional
Tibetan folk dance.

143

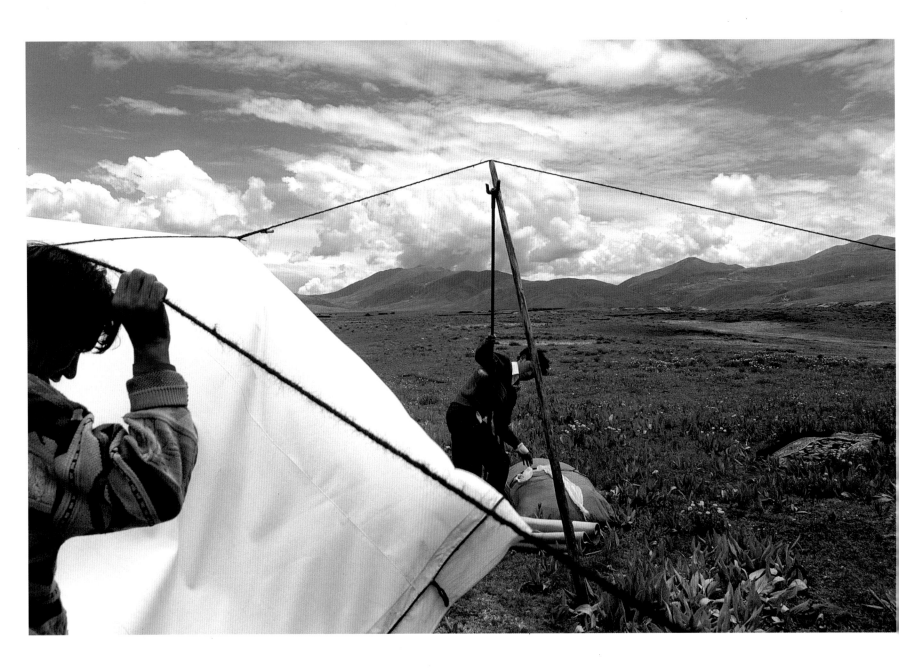

144

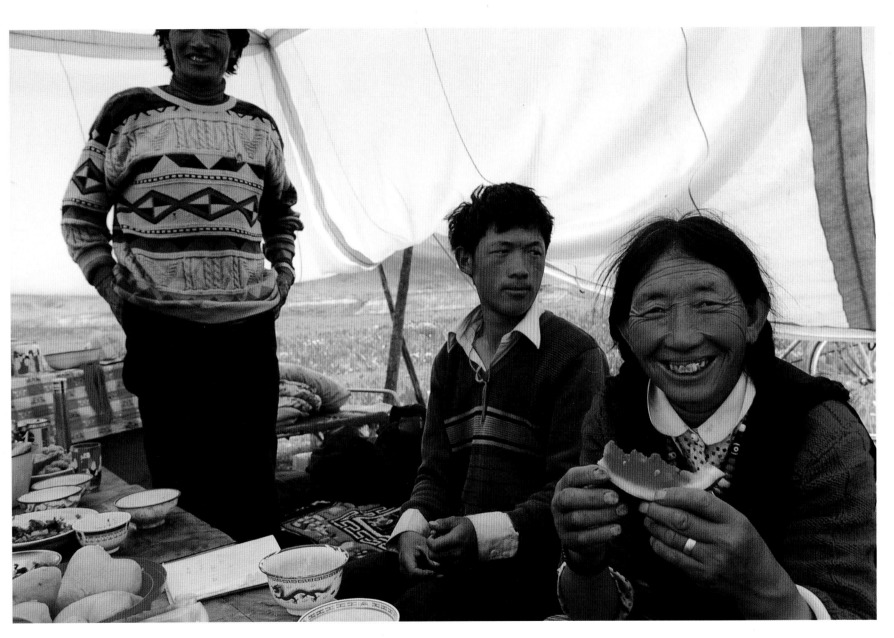

Above, Tibetan
family picnic.
Left, Putting up
a summer tent.

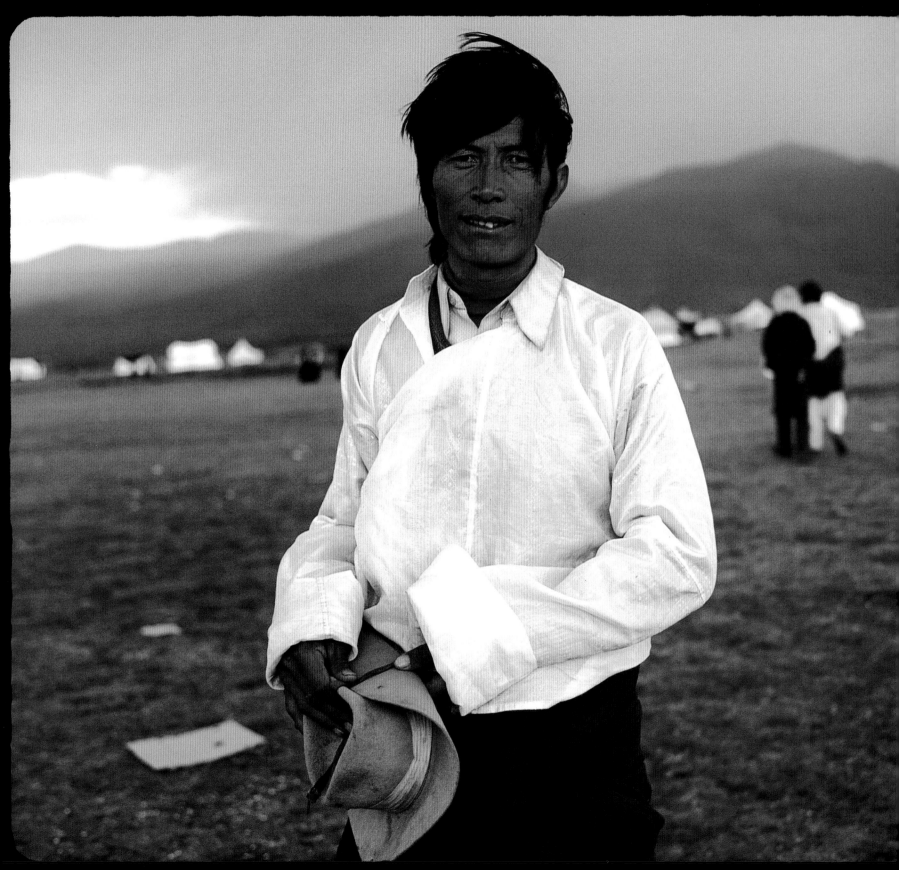

I consider myself to be a Chinese national because there is no other choice. For all intent and purpose, this place is part of China. History has already determined this. There is no other way.

—Buchung, high school teacher

A Khampa man poses at festival.

9/9? - This last visit was sad - it seemed as if
he had lost hope, it was as if he felt he had
exhausted all possible means and the only
options available were to make concessions and
hope for change in china. What was more
disturbing was that it
didn't seem like he had
a strategy. I was surprised
they are actually in the best position
that they've ever been in
— it's problematic - they
don't have clear objecti

The range of emotions
is incredible - his face
extremely expressive
constantly changing to
suite the specific
emotion - Despite
the time demands the
presidential schedule
the man emits compassion
and sincerity - the laugh
the incredible laugh of
chuckle of Dalai lama
Ho, Ho, Ho - the joy is
funny - wisdom and
knowledge in his eyes
not the evil
desire for
personal
power
that
is
revealed
in the
faces
of
western

Politicians and
leaders

MR STEVE LEHMAN TSURPHU
TO FROM

APRIL 1992

DATE

Tenzin Gyatso, 14 Dalai Lama of Tibet - Age 62

9/22/9? there is one thing to learn/observe
from him - it is to be kind to every person
that you meet - that is his power - He is truly compassionate

April 23, 1992 — Audience with His Holiness the Dalai Lama

Phone 2343
for the Dalei 2759

6 MONDAY

Print film
India Proposal
Slides
report
equipment

impressions -
Very human - a leader
busy as such - the eyes
- eyes kind of like
no other humans
ultra aware-looking
looking - kind of like
a super intelligent
deer - Decent
answers not mind
mind boggling though
to me he's a
person - impossible
to make
accurate Judgement
because normal interaction
impossible - personally
I dislike dealing with
leaders + politicians

OFFICE OF HIS HOLINESS THE DALAI LAMA

TO: STEVE LEHMAN
 HONG KONG, FAX NO. 00852-7611269
FROM: NGOUDUP TESUR
DATE: APRIL 18, 1992

RECEIVED YOUR FAX OF APRIL 16 ADDRESSED TO MR. TEN
TETHONG.

WE HAVE SCHEDULED ...
LAMA ON THU...
THIRD.

THERE A... ...ON FROM NEW DELHI
REACHIN... ...HOURS AND FROM WHERE
DHARMSA... ...LD ASK A
TRAVEL AGE... ...IMMEDIATELY
THE TRAVEL AGE... ...YOUR TRIP BY
CAR TO DHA... ...O BOOK YOUR
ACCOMMODA...

IN THE CASE THA... ...THAN 18:00
HOURS ON APRIL 22,URS (MORNING)
ON APRIL 23.

the interaction
is unnatural —
time is too much
of a factor they
are not normal
in that sense
me...
peo...
again...
my life
...ection
He re...
not su...
photogr...
first discussed ...
...eased question

We Tibetans believe in Buddhism. It is the only thing that holds us together. If it wasn't for our faith, we would have disappeared a long time ago.

—Dolma, university student

A *tulku* of the Gelukpa sect returns to Tibet from exile. Thousands of pilgrims arrive to greet him and listen to his teachings. A *tulku* is a spiritual teacher who has attained enlightenment and the ability to choose the manner of his or her rebirth. Tibetan Buddhism currently has several hundred known *tulkus*; however, prior to the Chinese occupation there were a few thousand.

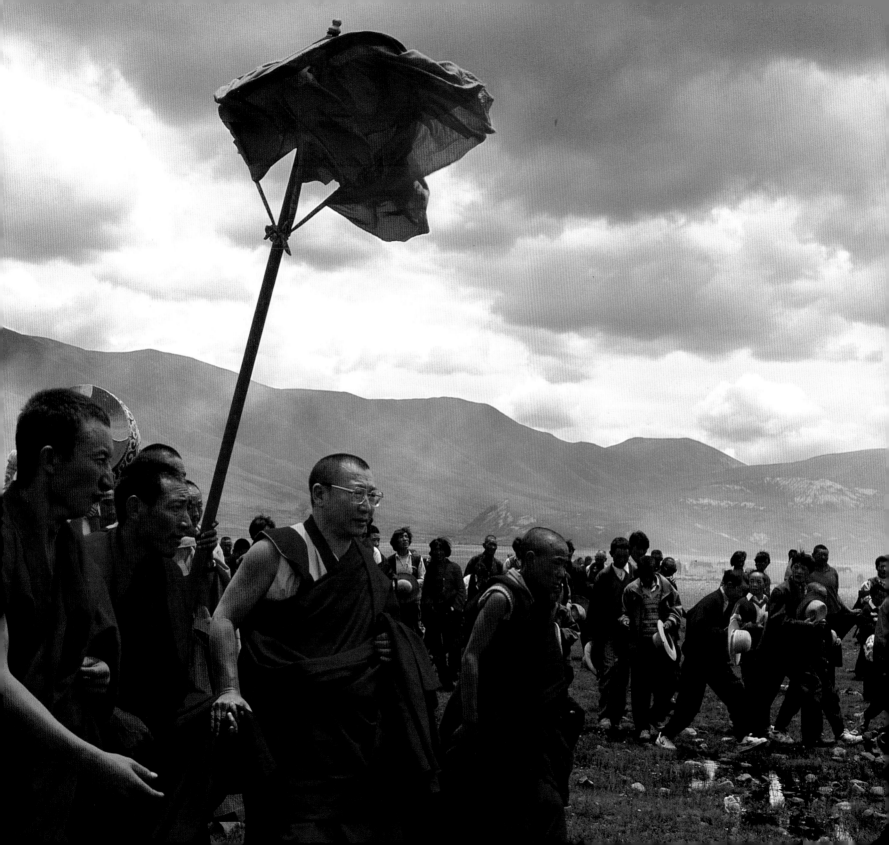

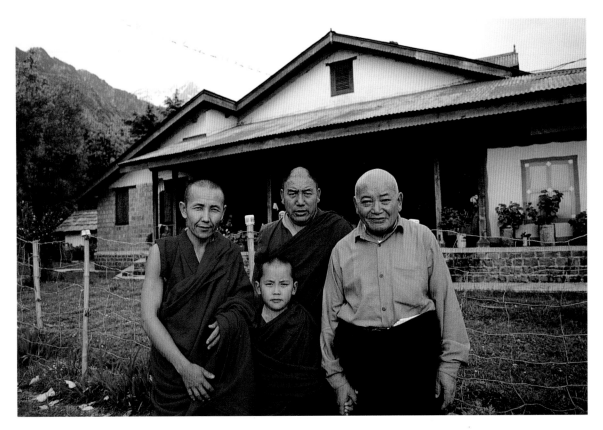

The young reincarnation of Ling Rinpoche, former tutor to the Dalai Lama, at his home in exile in Dharamsala, India.

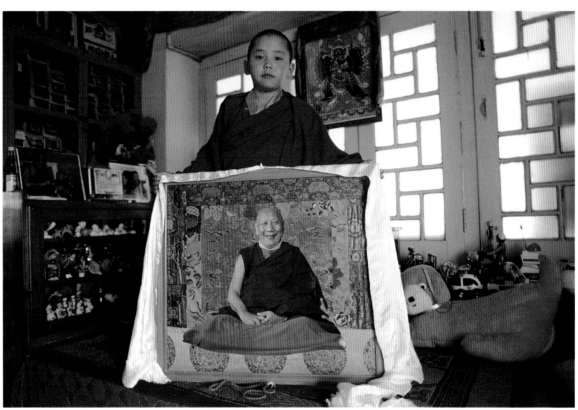

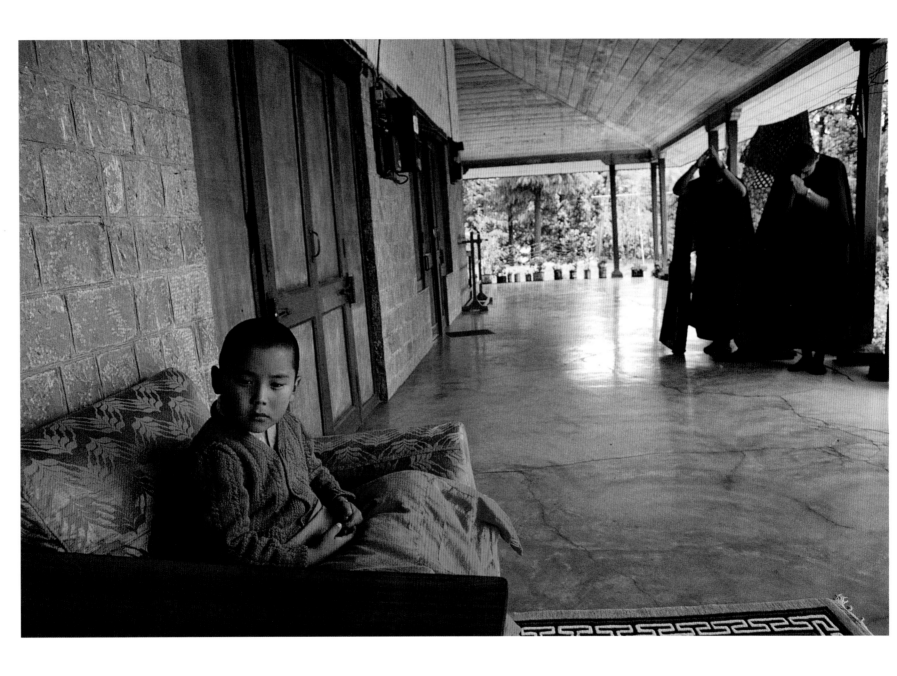

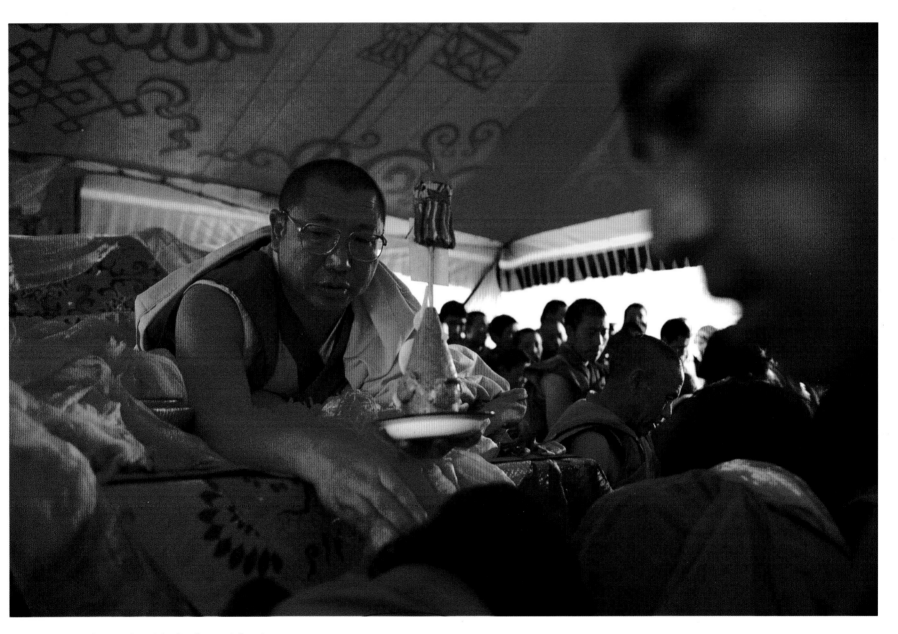

Above, Pilgrims receive a blessing from a *tulku* who
has returned to Tibet to give religious teachings.
The blessing of the *tulku* transmits a form of
positive energy, helping individuals purify their
minds and accumulate merit for their next birth.
Left, Ling Rinpoche receives pilgrims paying
homage to him at his home.

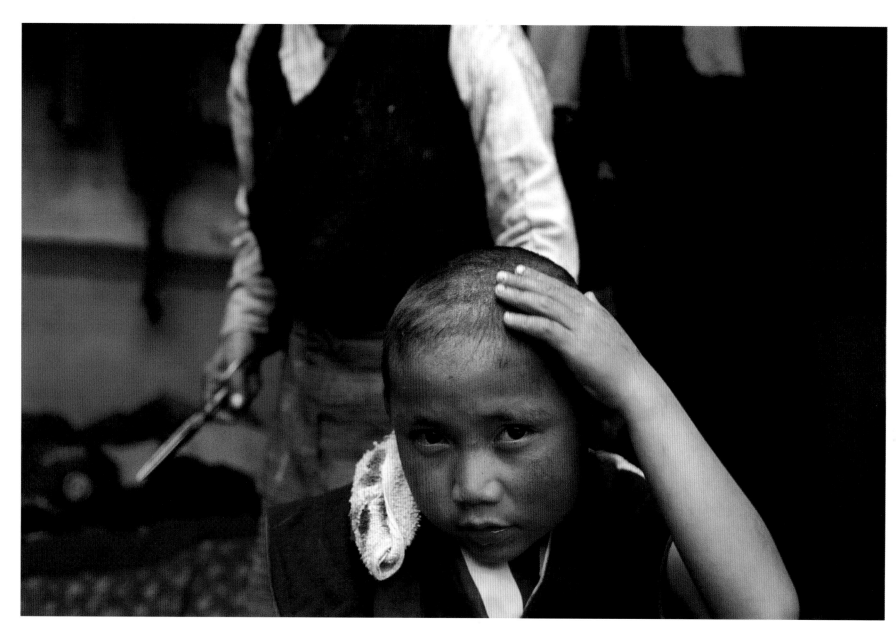

A young monk is given a haircut and dressed by his grandparents. While Tibetans believe that becoming a monk is the most worthy path a person can choose, from a practical standpoint it is seen as a happier, easier existence than living a secular life.

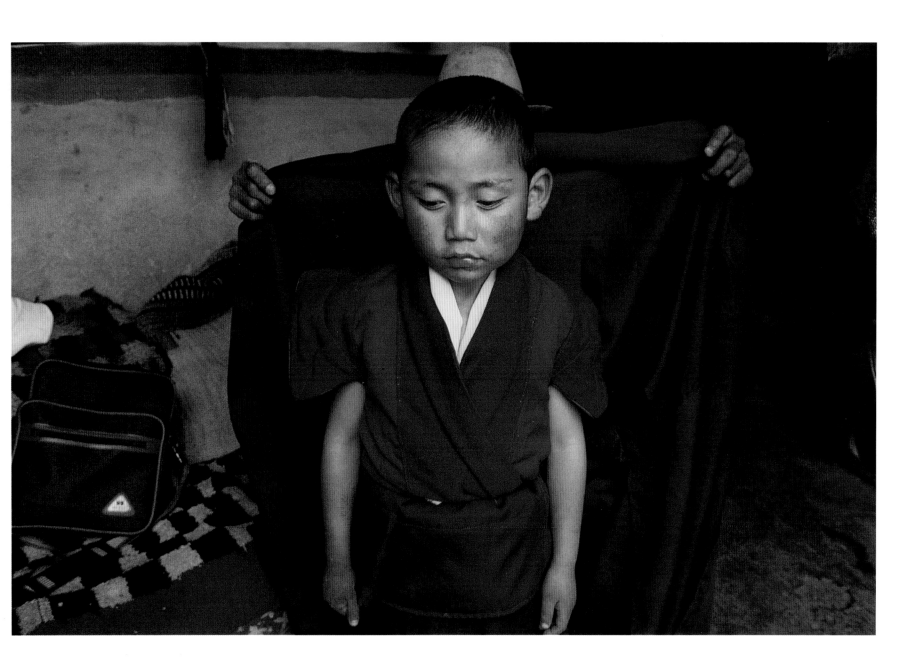

**The Chinese are also people. We should try to understand them.
People shouldn't try to hurt each other.**

—Youden, Tibetan journalist, Lhasa

After escaping to India, Ngawang Khetsun, one of the first monks to demonstrate on September 27, 1987, now studies at the Buddhist School of Dialectics in Dharamsala. Adjacent to the home of the Dalai Lama, the school is one of the most prestigious institutes for the study of Buddhist logic and philosophy. The monks study for fifteen to twenty years before receiving a *geshe* degree, the equivalent of a doctorate of divinity.

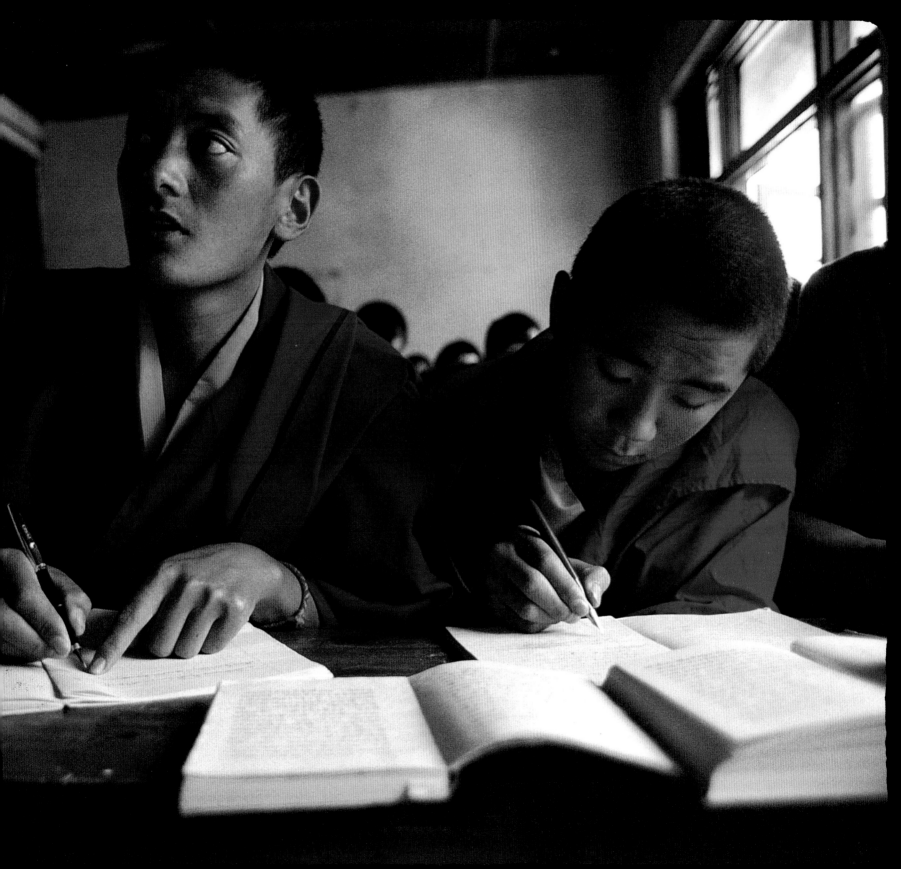

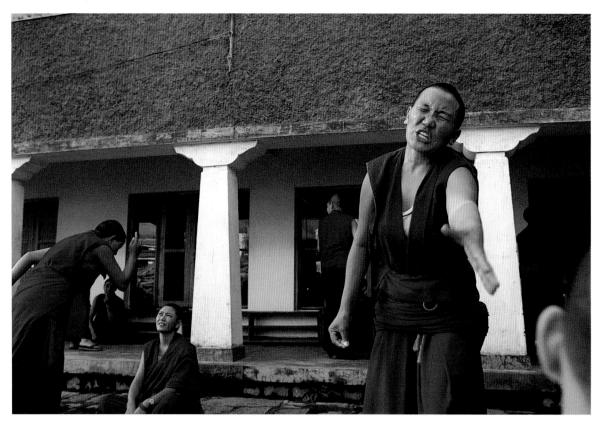
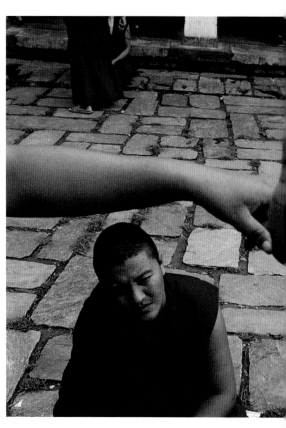
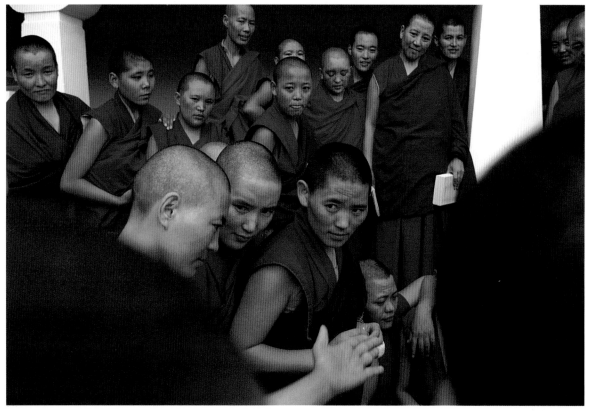
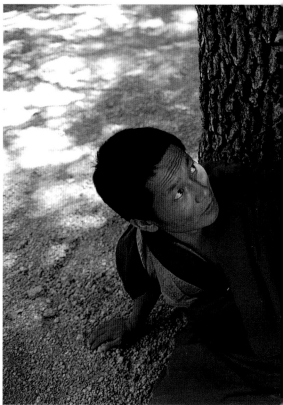

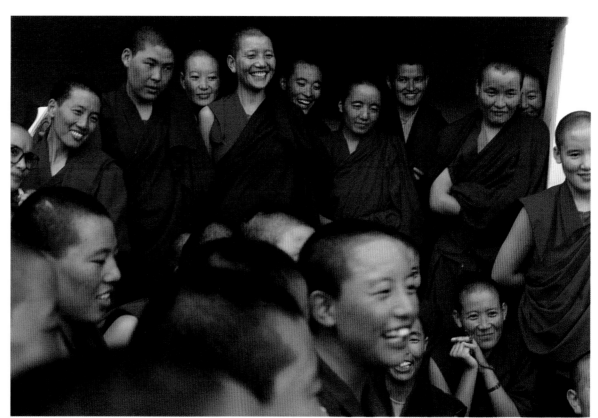

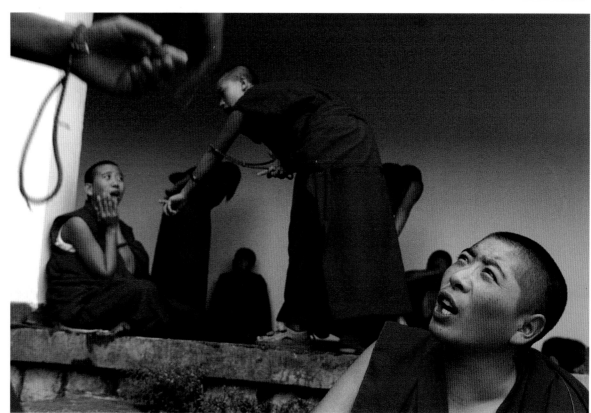

The debates are about Buddhist logic. They are very
complex and difficult to explain. I will try to give you
an example of the type of discussions we have:
"Are you a person?" "Yes." "What proof do you have?"
—Sonam, Sera Monastery monk

Preceding page and right:
Nuns from the Dolma Ling
Nunnery in India debate
Buddhist logic. The process
of debate is an investigative
technique used to teach
Buddhist philosophy and
sharpen a student's
analytical skills.

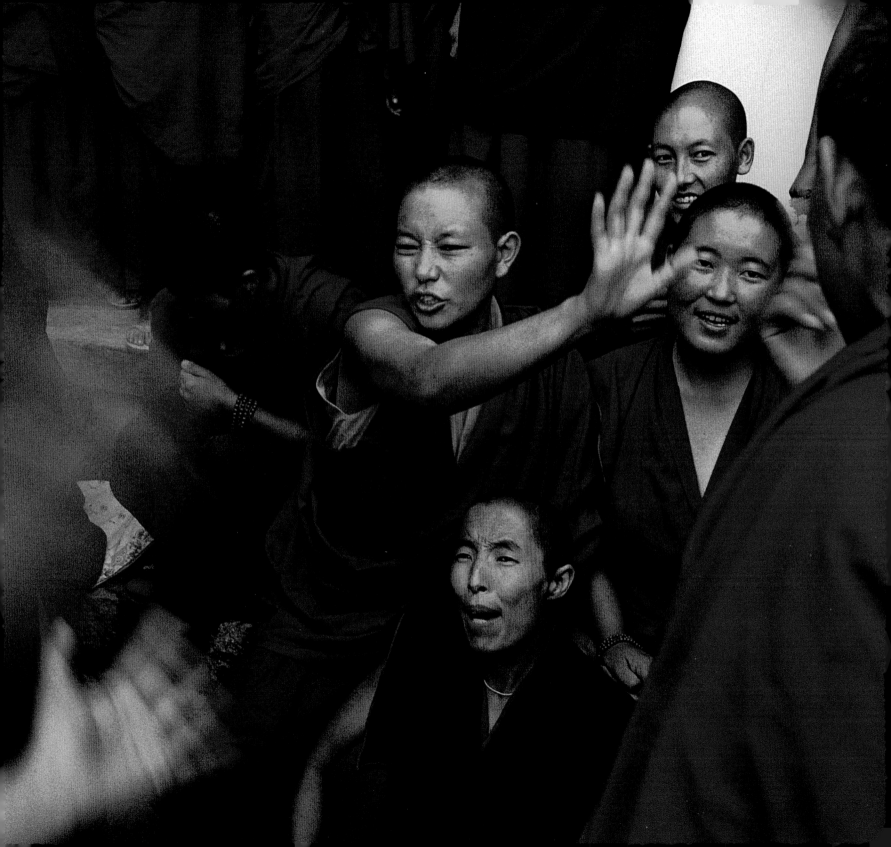

If we give too much emphasis to science and technology we are in danger of losing touch with those aspects of human knowledge and understanding that aspire towards honesty and altruism....No one can deny the unprecedented material benefit of science and technology, but our basic human problems remain; we are still faced with the same, if not more, suffering, fear, and tension. Thus it is only logical to try and strike a balance between material development on the one hand and the development of spiritual human values on the other.

—Tenzin Gyatso, Fourteenth Dalai Lama of Tibet

The abbot of Sera Monastery is aided by his attendant. Sera is one of the three major monastic institutions near Lhasa and has historically been one of the most important learning centers in Tibet. Construction of the monastery began in 1419 by Shakya Yeshe, a leading disciple of Tsongkhapa. Prior to the Cultural Revolution there were over 5,000 monks at Sera; today there are approximately 400.

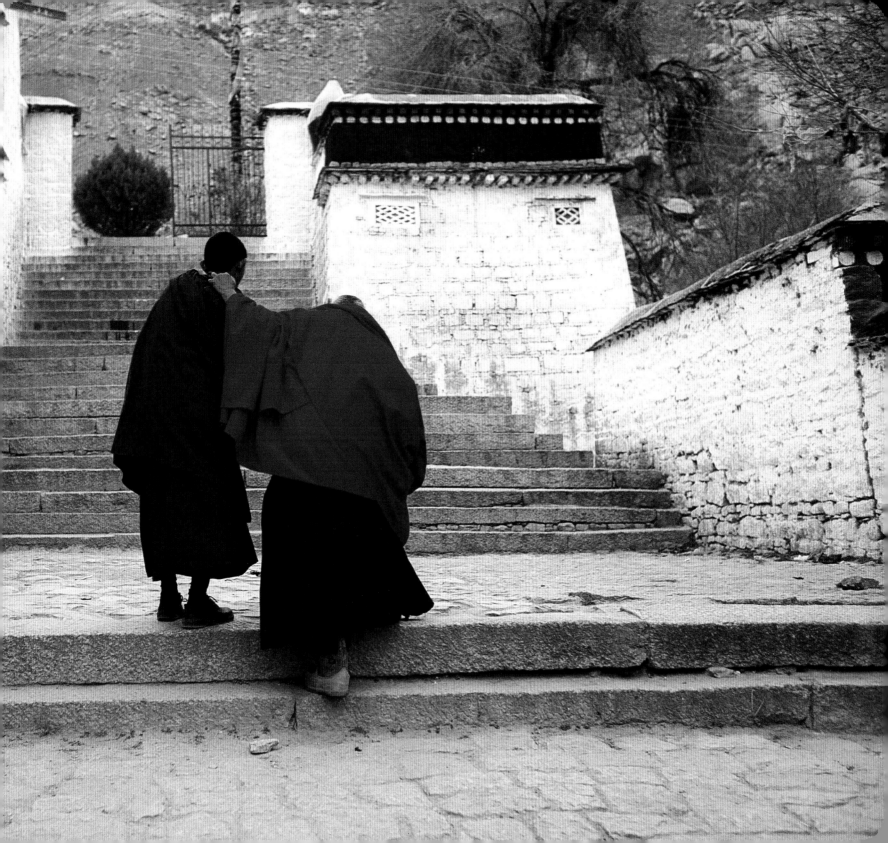

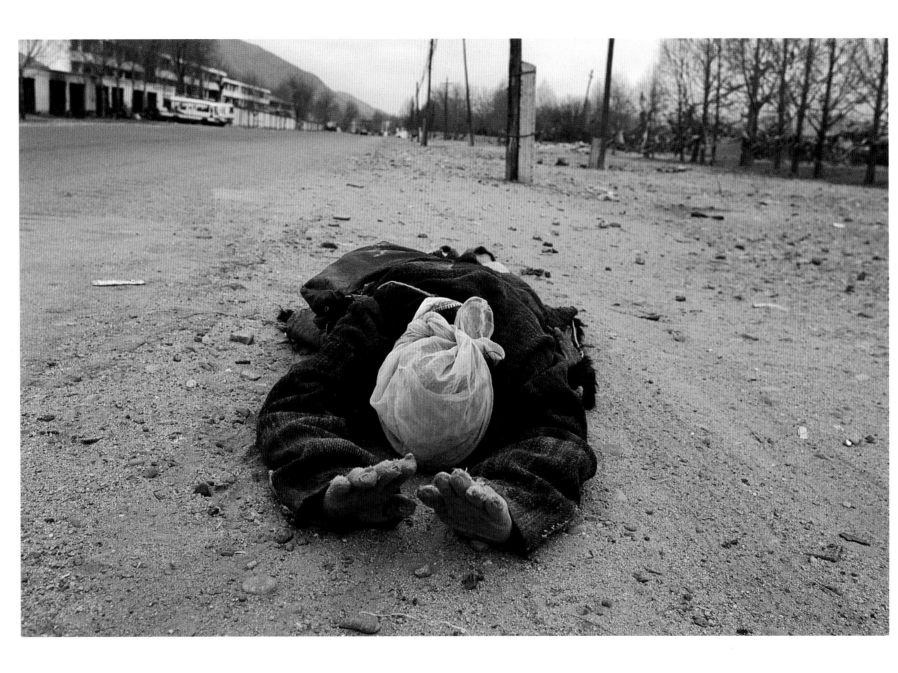

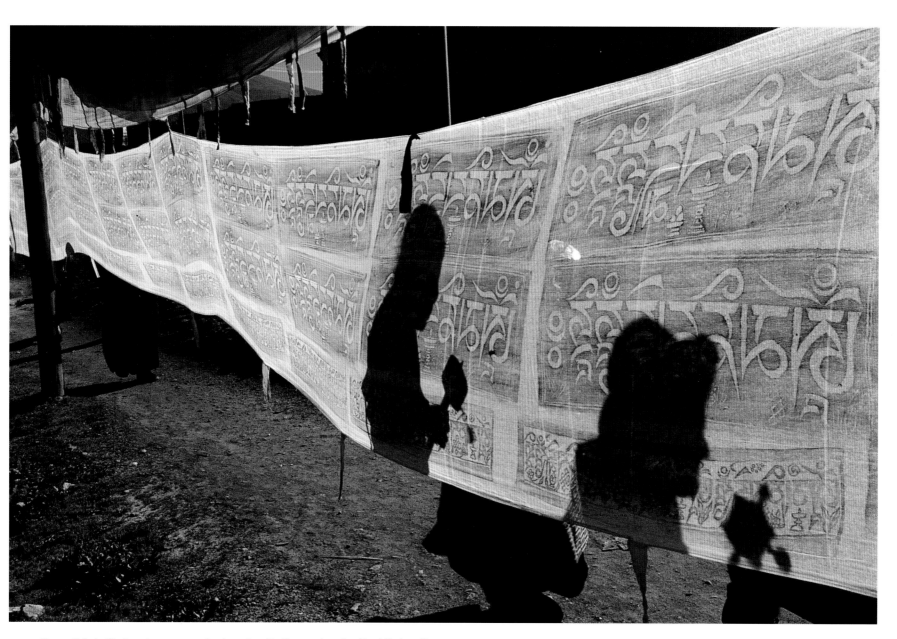

Above, Elderly Tibetans turn prayer wheels and recite the mantra, *Om Mani Padme Hum* (The Jewel in the Lotus), while circling their local monastery. The circle is a pervasive symbol in Tibet, representing the interconnectedness of all living things.

Left, An elderly pilgrim prostrates himself along the Lingkor, a sacred route that surrounds the old city of Lhasa. The man will cover a distance of several kilometers through his prostration, a form of prayer and devotion believed to build compassion and positive karma. Not simply an act of blind devotion, prostrations serve as a form of mental purification and a means for the abandonment of pride and arrogance.

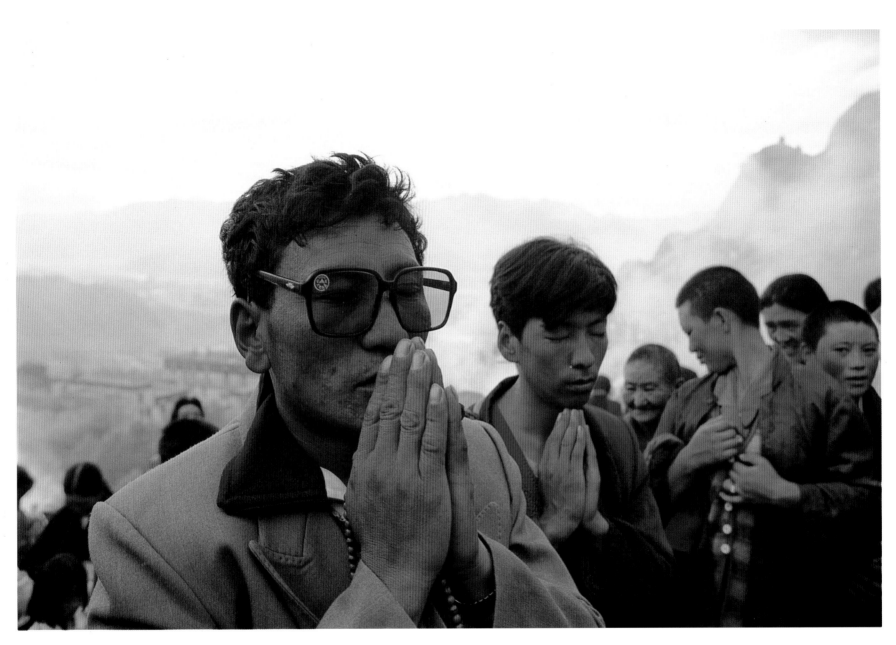

Tibetans give prayer offerings of *tsampa* (barley flour) and incense during the Yogurt Festival. Offerings in Tibetan Buddhism are a means of expressing gratitude, purifying the mind, and accumulating karmic merit.

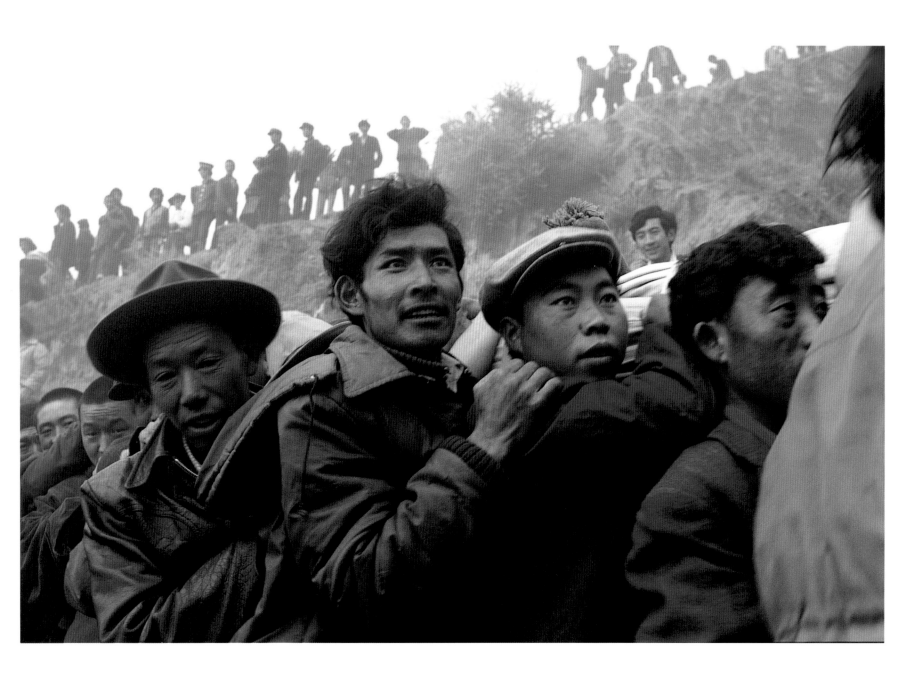

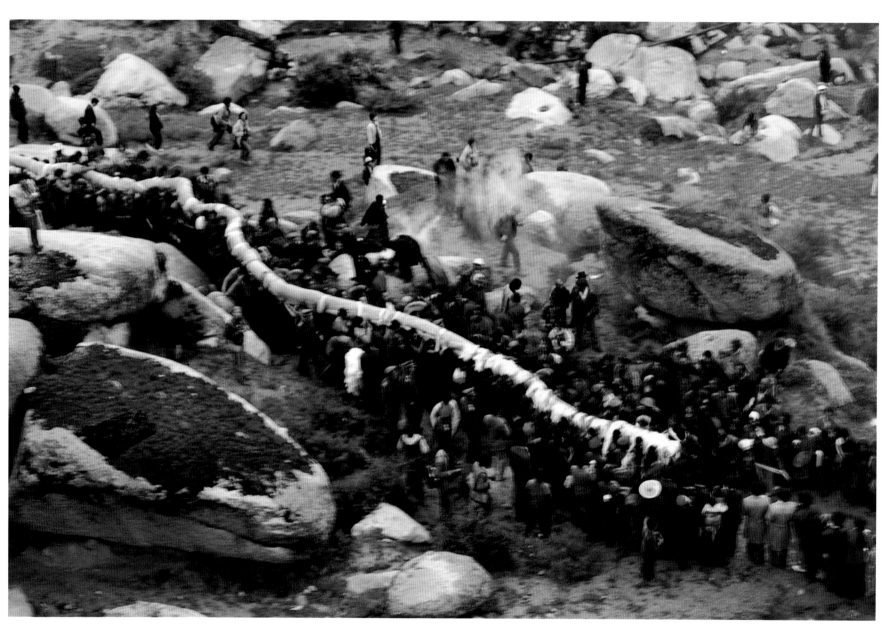

The unveiling of a giant embroidery of Buddha at the Drepung Monastery, Lhasa. These embroidered hangings are a religious form of art believed to produce deliverance on sight.

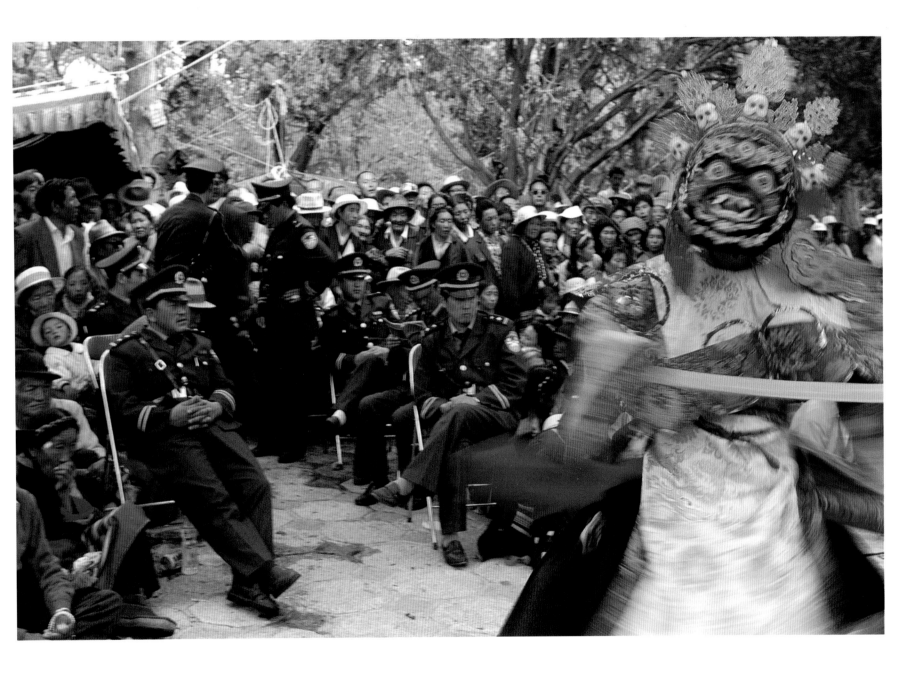

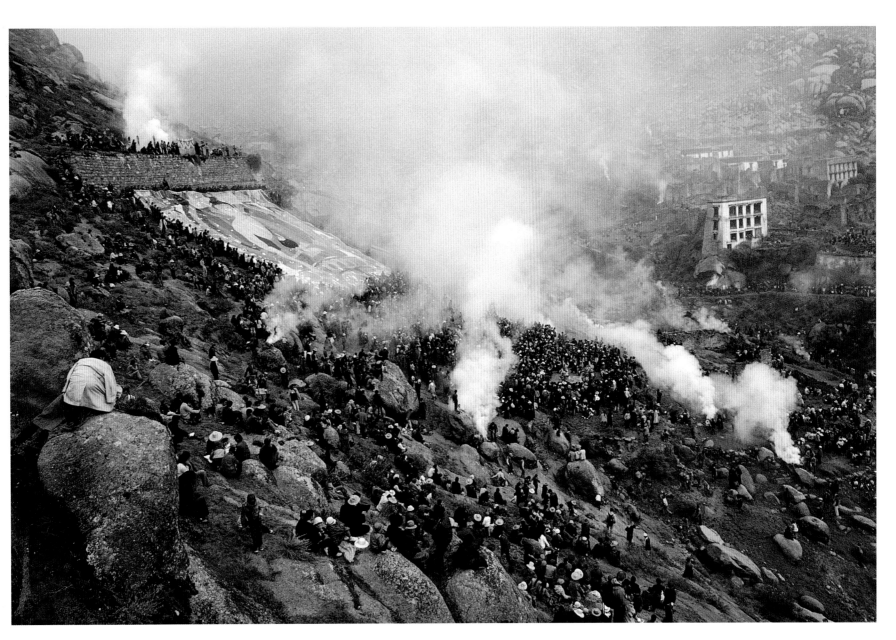

Above, Giant *thanka* signifying the opening of the Yogurt Festival in
Lhasa, a cultural festival that promotes Tibetan opera and dance.
Left, A Tibetan opera performer dances at the Yogurt Festival in Lhasa.
The performance was held at the Norbulingka, the former summer
palace of the Dalai Lama. The heavy police presence is meant to deter
pro-independence demonstrators, since Tibetan activists often use
such large gatherings to protest China's occupation.

Basically, all are the same. I come from the East; most of you here are westerners. If I look at you superficially, we are different, and if I put my emphasis on that level, we grow more distant. If I look at you as my own kind, as human beings like myself, with one nose, two eyes and so forth, then automatically that distance is gone. We are the same human flesh. I want happiness; you also want happiness. From that mutual recognition, we can build respect and real trust for each other. From that can come cooperation and harmony, and from that, we can stop many problems.

—Tenzin Gyatso, Fourteenth Dalai Lama of Tibet

Prayer flags blow in the wind atop the Lak Pa La pass (5220 meters high). Prayer flags are hung in trees and on mountaintops in an effort to spread the Buddhist dharma through the power of the wind. The five colors of the flags represent the elements of the universe (blue for sky, white for clouds, red for fire, green for water, yellow for earth). The origin of the flags can be traced to pre-Buddhist Tibetan tradition.

essay by robbie barnett

The question of Tibet is complicated by the myths and uncertainties that surround its perception by foreigners. None of us who are outsiders can dispel those difficulties at a single stroke, and even Tibetans themselves must from time to time find it hard to separate the perceived from the experienced realities of their condition: they too suffer from the lack of layered, unemotive information necessary to better explicate this complex issue.

Much of the initial work facing any westerner considering the question of Tibet is, in a sense, archaeological. For more than a century there has been in the West and elsewhere a sort of small-scale industry generating romantic or contentious notions of one kind or another about Tibet. Such notions lie like debris scattered around the area of our inquiry, so that we have to dig through an accumulation of misconceptions and half-truths before discerning even faintly the outlines of some concrete, lived experience. Even if we find such solid traces, we need still to resist the temptation to elaborate these as certain proof of the character of an entire history or civilization. The clues uncovered during any such excavation may be partial, anomalous, or atypical of the wider community whose story we seek to describe.

To some extent it could be said that the question of Tibet's political status is itself part of the debris. An entire literature has emerged that recites facts about Tibet as proof that the country was or was not independent at the time of its invasion by Chinese troops just under fifty years ago, while relatively little has been written about the basic elements of life in Tibet—the condition of the people who live there, the texture of their political and social aspirations, and the intellectual and cultural makeup of their society as it adapts to the stresses and complications of modernity. This book is part of an attempt to offer information about the condition of life in Tibet, as well as about our concerns and conceptions of that country.

* * *

One reason for turning to the society and the people who comprise it instead of focusing on the vexed subject of Tibetan independence is that it may in fact be impossible ever to give a definitive answer, in legal or historical terms, to the question of Tibet's political status. Supporters of each side in the dispute typically offer only the evidence that advances their case and ignore that which opposes it. The Chinese, on the one hand, claim that Tibetan leaders made their country a formal part of China in the thirteenth century, while the Tibetans argue that their leaders' historic links to China were merely those of religious teachers to their lay patrons. In fact the question of

independence is even more complicated than the polemical accounts suggest, because the fundamental questions underpinning these discussions are rarely broached: who are the Tibetan people? And what are Tibet's boundaries?

Ethnographically speaking Tibetans are less homogeneous than one is led to believe. The Khampas from the east speak several dialects that are more or less unintelligible to the Amdowas from the northeast, and together the two ethnic subgroups outnumber Tibetans from the central and western regions. It is those central Tibetans who speak variants of the Lhasa dialect with which most Western students of Tibetan are familiar, but their dialect is initially incomprehensible to the two million or more Tibetans from Kham or Amdo.

These subgroups within the main Tibetan language family are clearly all Tibetan—they share common physical traits, a culture, and a written language which distinguishes them from others—but it is not so clear what defines them as a unified people. It is often argued, for example, that they can all be called Tibetans because of their shared commitment to the Tibetan form of Buddhism, but in fact Buddhism is a relatively recent faith among Tibetans: although it dates back as a firmly established nationwide religion to approximately the eleventh century, Tibetans consider their history to have begun over a thousand years earlier. And there are significant communities within Tibet, such as the Lhasa Muslims or the Bonpo, who are not Buddhist but who are certainly Tibetan. Neither can we define Tibetans in terms of a distinctive lifestyle: the claim that Tibetans are a nation of monks and nomads conceals the facts that many rural Tibetans have always been settled farmers, that only 2 percent of the population are now monks or nuns, and that nearly 20 percent these days live in towns. The people we call Tibetans are more diverse than is sometimes suggested and the forces that bind them more complex than we might think.

This is not to say that Tibetans do not have a common sense of identity as a single nationality—the Chinese, for example, are more fractured by regional disparities in language and history than the Tibetans—but it does suggest that this identity is not so much a provable fact of history as a situation that Tibetans have created through their determination to be considered as a single people. This determination has been heightened by the Chinese claims to their territory. To some extent, therefore, the unity of Tibetans as a nationality is in part a political rather than a scientific fact, steeled by the arrival of a common enemy and the attack of a supremacist ideology.

Changes in the way the Tibetans view themselves have led to considerable inconsistency in defining other aspects of the situation, in particular the question of where Tibet's borders begin and end. There is no doubt about central Tibet, the heartlands around Lhasa ruled by the Dalai Lamas since the seventeenth century. But eastern Tibet had for generations been composed of a complex of principalities of differing constitutionality and with equivocal loyalties, sometimes offering allegiance to Lhasa, sometimes to China, and sometimes to neither. Amdo, formerly regarded as the northeastern area of Tibet and now mostly subsumed within the Chinese province of Qinghai, had not had any sight of Lhasa rule for some two hundred years before the Chinese invaded Lhasa in 1951. When the Chinese Communists wrested control of Qinghai from the Chinese warlord Ma Pufang in 1949, the Lhasa government made no intervention and did not claim that this area was part of Tibet, as it now does. In Kham, however, the area that lies to the south of Amdo and which is now part of Sichuan province, Lhasa had fought frequent wars with Chinese armies in the early decades of this century and, in fact, had briefly gained title to part of that area by conquering the local Chinese—but still Lhasa did not protest when the Communist armies took over that area. The

figures, much quoted by exiled Tibetans and westerners, that there are now 7.5 million Chinese in Tibet have been arrived at by including large areas and cities, such as Xining, which had not for centuries been part of political Tibet. Such uncertainty about the borders of Tibet further complicates the dispute over its political status.

There is general acceptance that Tibet was in some sense part of the Chinese Empire in the thirteenth century and again in the eighteenth century, when Chinese armies were sent to protect Tibet from internal conflict and to repel invasion by the Gurkhas of Nepal and when Chinese "Ambans" or imperial commissioners were stationed in Lhasa. But it is argued by many supporters of the Tibetan case that the Chinese Empire at that time was either a Mongol (in Chinese, Yuan) empire or a Manchu (Qing) one, and that the Chinese republicans who took over Beijing in 1911 did not inherit all the rights and respects that were due to their Manchu predecessors. It is a powerful argument in terms of Asian political traditions, but generally the international system accepts the transfer of rights between dynasties.

However one resolves this debate, it is clear that, if it is once admitted that in the eighteenth and nineteenth centuries (for example) the Chinese emperors had a significant right to participate in Tibetan affairs, the claim to a full and total independence by Tibetans is not at all as definite as it is sometimes presented. Those facts that can be asserted with some confidence give, accordingly, a more complex impression. Firstly, the Chinese (or their Mongol and Manchu rulers) definitely believed themselves, rightly or wrongly, to be for considerable lengths of time in some way overlords of Tibet. Secondly, however, it is certain that these rulers and their citizens did not view their Tibetan territory as identical in status to their Chinese provinces, which were handled by a different government office from that which dealt with Tibet and Mongolia. Thirdly, it is clear that until this century, at which time the British began actively to encourage a sense of separation in Lhasa, the Tibetans, as was natural in the traditional political culture of the time, did little to disabuse the emperors of their belief in their sovereignty over Tibet. Fourthly, it is not disputed even by the Chinese that after 1912, when all Chinese officials and residents in Lhasa were expelled by the Tibetan government following the collapse of the Qing dynasty, Lhasa thenceforth exercised full control of all its own affairs, internal and external, until the Chinese army invaded its eastern borders thirty-eight years later.

This last argument is persuasive to many people, especially because the Thirteenth Dalai Lama, in a 1912 treaty with Mongolia of which the original is lost, reportedly declared Tibet to be independent. Still, it is not as conclusive as it might appear, since large parts of China were also in effect autonomous during the first half of this century—Qinghai, for example, more or less governed itself under Ma Pufang during the same period. But this could be seen as a consequence of the weakness of the then Chinese government, beset by Japanese invasion and wracked by civil war; it was not necessarily a proof in itself of separate political status. Ma Pufang apparently did not see himself or his realm as historically or culturally distinct from other political entities within China.

In the final analysis lawyers and historians may not be able to come to a conclusive answer on this question. They may concede that the nature of Tibet's status before 1912 was not of a kind that can be exactly expressed by twentieth-century notions of statehood: it was not the same as a province of China, but, except when China was too weak to exercise central control, it did not define itself in modern terms as an independent state. The Tibetans like to express this by saying that there was a *chö-yon* or protector-patron relationship between the two

governments before 1912, meaning that Tibetans offered spiritual guidance to emperors in return for political protection. This, however, seems more a description of a personal relationship between leaders than a resolution of the question of statehood.

There is, however, one negative argument that powerfully supports the Tibetan view: no one seems so far to have found any document in which the Tibetan people or their government explicitly recognized Chinese sovereignty before the invasion of 1950. The importance of this argument lies not in its role in the legal debate, but in what it indicates in terms of the political realities on the ground. Chief among these is the question as to how Tibetans perceived and perceive themselves. The fact is that most Tibetans seem to have experienced themselves and their land as distinct from China. Few in central Tibet had seen any Chinese before the invasion and almost none of the Chinese there now have lived in Tibet for more than fifty years. Although Chinese armies traveled to Tibet four times in the eighteenth century, they were probably regarded by Tibetans as allies assisting the Tibetan government to repel threats of invasion or insurrection, not as overlords. If Tibet was at any recent time part of China, this affiliation seems to have been for the most part a traditional construct that has no exact equivalent in our time, or an abstruse diplomatic technicality arranged among the elite that seemingly was never communicated to the Tibetan people.

Certainly there were few signs of Chinese influence, let alone rule, in Tibet. All the major indicators of culture and society were entirely different from those of their Chinese neighbors—the coinage, postage, language, dress, food, and taxation of Tibet were all distinctively Tibetan, and before the Chinese invasion Tibet had developed all the political and social institutions, from an army to a civil service, that a country needs to function as a separate entity. It is these simple, experienced realities rather than any legal considerations that are of political significance, because it is largely to them, and to religious beliefs, that we must attribute the decision of hundreds of thousands of Tibetans in the 1950s and 1960s to face death in defense of their perception of Tibet as a separate country. It is in this context that we should view China's current campaign within Tibet to oblige all Tibetans to undergo "patriotic education," a program that requires everyone to attend lectures or to sign a statement saying that Tibet has been part of China since the thirteenth century. The campaign suggests that what matters to Beijing is not expert adjudication so much as popular consent: the Chinese authorities also see the Tibet issue as shaped not by the decisions of lawyers and leaders but by the views and beliefs of ordinary Tibetans.

Strangely, few people, and fewer Tibetans, have chosen to argue that, given the distinct status that the Chinese emperors accorded to Tibet compared to their provinces, Tibet must at best have been something like a colony. If this argument was pursued—and it is hard to contest—the present situation could be described as one of colonial occupation. It is one of the mysteries (some people might say tragedies) of the Tibetan case that its leaders in exile and their advisers have sought to show that Tibet has a right to absolute statehood, perhaps gambling to attract Western support, rather than to seek its people's right to decolonization, an option that might have gained them wider support in the developing world.

But these are in essence questions of strategy and definition, matters that are decided by political elites. At the fundamental, everyday level at which most of us operate, the reality is that, as far as we can tell, the majority of Tibetans do not accept their current masters as legitimate rulers. It is difficult otherwise to explain the thousands of Tibetans who since 1950 have taken part in revolt, in the guerrilla war,

or in civil protests, who have been to prison or have been executed for holding such views, or who have fled as refugees. The numbers involved in these actions are too great to be discounted as all members or beneficiaries of the political elite whose power and wealth was jeopardized by the Chinese advance to Lhasa. Indeed, it was the Tibetan aristocracy who were among the first to cooperate with the Chinese in 1950, attracted by offers of wealth and status: the Uprising of 1959 seems to have been more a popular movement than an agitation by dispossessed nobles. Whether we take a political or a humanitarian view of the Tibet problem, it is probably this general perception among Tibetans of foreign occupation that is the decisive factor in assessing their situation.

This is not to say that other questions, with all their difficulties of resolution, can be discarded as mere academic abstractions—we need to grasp them in their full complexity in order to equip ourselves with at least the rudiments of intelligent discussion. But most debate in the West on Tibet focuses either on seeking a politician's Holy Grail—the pure fact that will somehow prove that Tibet is or is not part of China—or assumes that somehow the moral force of Western opinion will lead to political change in Tibet and China. But from a political point of view the answer to such issues is relatively simple: reality and "truth" are largely decided by political determination and muscle, not by legal arguments or moral rectitude. The history of struggles for decolonization in this century suggests that if the Tibetan people living in these areas choose to assert their collective identity as a people and to exercise the political will to sustain it, even the Chinese might find it hard to stand in their way.

<p style="text-align:center">*　　　*　　　*</p>

Since the invasion, China's policies towards the Tibetans can perhaps best be described as a mix of brutality and concession. There were "hard" periods about which there can be little dispute, periods during which even the Chinese authorities now acknowledge that "serious errors" were made. But it is also important to recognize that these years of uncontested brutality were interwoven with periods during which few if any atrocities occurred. There is a tendency towards simplification in our perception of Communist regimes, which are often assumed to maintain power through force; in reality, gifts and promises are equally effective and as often used. But the complexity of Chinese rule emerges not so much from recognizing that China uses carrots as well as sticks to encourage subservience as from allowing that some of their concessions are genuinely well-intentioned. Like many colonial rulers, a significant proportion of the Chinese Communists sent to run Tibet after 1950 acted for largely altruistic reasons and believed they were offering to their new fellow-subjects practical and spiritual improvement in their lives. It is this anomaly that leads us into a bizarre hall of mirrors where Chinese officials appear simultaneously to be intent on assisting, seducing, or brutalizing their subjects.

There have been three hard periods, twenty years in total, during which Tibetans have suffered from the extremism of ultraleftist dogma in China; it is because of these periods that allegations of genocide or ethnocide have been made. The first such period was sparked by the Tibetan Uprising of 1959 and lasted until about 1962. During these years thousands of Tibetans were executed, imprisoned, or starved to death in prison camps. So far no officials have publicly acknowledged these atrocities, but we know that they took place and that the punishment was largely random because of a secret report written in 1962 by the Panchen Lama (appointed by Mao as the leader of Tibet)

which was smuggled out to the West in 1996. This period also included (particularly in Kham and Amdo) the artificially induced famines that resulted from the policies of the Great Leap Forward, an attempt by Beijing to make the production of steel take precedence over agriculture and to set up communes overnight throughout China. In 1981, the Chinese leadership finally conceded that the Great Leap, which some writers now estimate led to thirty million deaths, had been a "serious mistake." A report by Beijing's Economic System Research Institute found that 900,000 people died during this period in Qinghai province alone (where a quarter of the population were Tibetan), probably from starvation. Tibetan nomads were particularly affected because the plan for the communes required that all flocks be brought together in one place: the animals died en masse once they had exhausted all the available pasture. The plan did not allow them to be moved.

The second "hard" period was the Cultural Revolution defined by the Chinese as lasting from 1966 to 1976, although in Tibet it continued in effect until 1979. During these years, Mao Zedong set off a frenzied drive throughout Chinese territory to eradicate the "four olds": old thoughts, old culture, old customs, old traditions. For the non-Chinese peoples the campaign included an attempt to eradicate their culture and their distinctive identity as a people, since ultraleftist ideologists declared at that time that distinctions between nationalities and any form of religious belief were the results of the class system. The consequences for Chinese people, let alone for Tibetans, Mongolians, and other nationalities under Chinese rule, were terrible: they were forced to dress like Chinese, to profess atheism, to destroy temples, to burn books, and to condemn, humiliate, and sometimes even kill the teachers, writers, thinkers, and elders in their communities.

The period from 1987 to 1990 is still too recent for us to assess. During much of this third dark era, Lhasa was under martial law and at least one hundred people are believed to have been shot dead by police for taking part in demonstrations. Some three thousand Tibetans are estimated to have been imprisoned for joining protests during this period and a large proportion of them appear to have been tortured, often in brutal ways. It was a period of explicit repression by the security forces (in particular the People's Armed Police, a paramilitary body) and attracted international publicity, for the simple reason that it was the only one of the "hard" periods of Chinese rule to have been witnessed by foreigners. China had begun to open Tibet to tourism in 1981, so that in 1987 alone, the last year of that "open" experiment, there were forty-seven thousand foreign tourists in Tibet.

This period came to an end in May 1990, when civilian rule was to be reestablished in Lhasa after thirteen months of martial law. Unnoticed by the Western press, Chinese authorities announced that the security policy in Tibet was henceforth to shift from "passive" to "active" policing. This meant, in the obscure code used by Chinese politicians, that the practice of shooting demonstrators and of mass torture and detention would be replaced by more cautious and more restrained forms of control.

If we set aside these three "hard" periods, we are left with some twenty-seven years that cannot easily be categorized as periods of atrocity. The Chinese took over eastern Tibetan areas in 1949, those not under the rule of Lhasa, crossing into central Tibet a year later. Their army arrived in Lhasa in October 1951, by which time the Tibetan government had formally surrendered. But it was not until the Tibetan Uprising of 1959 that the Chinese authorities took over day-to-day running of the Tibetan government in Lhasa. In central Tibet those nine years from 1951 to 1959 saw no great difference for ordinary Tibetans between preinvasion and postinvasion Tibet, except that the Chinese

introduced modern commodities, built some schools and nurseries, constructed small power stations, showed propaganda films, offered scholarships in Beijing, and spread new fashions.

If we find it hard to imagine how an invading army and a triumphant colonizer could behave in such a restrained way in its new acquisition, we have only to look at Hong Kong today: there also we can see a conscientious effort to avoid any visible sign of change in daily life, despite the fundamental change in status and governance that has taken place. In Tibet, too, the initial policies were in many ways driven by the same concerns. The Chinese, once they had gained a legally valid recognition of their claim to sovereignty, were extremely careful to leave the apparatus of traditional government in place, with the Dalai Lama at its head. But in actuality, the Dalai Lama and his ministers were powerless. There was a party committee for Tibet run by Chinese generals that decided what the Tibetan government could and could not do; however, except in cases of emergencies, its instructions were most likely communicated in untraceable ways through indirect channels, and would probably have been described as "advice." The Tibetan leaders would have felt themselves to have had no choice but to follow such advice, since their army was largely disbanded. But the new dispensation meant that on the surface Tibetans remained in charge; in Delhi, for example, Nehru believed that the Chinese really had achieved a peaceful transition and in 1956 persuaded the Dalai Lama, then seeking exile in India, to continue his alliance with Beijing.

The strategy of winning over potential enemies by offering concessions, such as allowing the traditional elite to retain the semblance of authority, has its own term in the vocabulary of Chinese Communism: it is called "United Front work" and there is even an agency in the highest ranks of the party, the United Front Work Department, whose sole task is to implement such concessions. In Tibet in 1950, traditional leaders had the option of very high office within the new Chinese system if they agreed to cooperate with their new rulers, as well as the perks of high office—chauffeur-driven cars, ceremonial privileges, luxurious accommodation, and high salaries. Today, for example, the Chinese authorities are said to be offering the Dalai Lama the post of vice president, once he accepts that Tibet is part of China.

Describing these swings in Chinese policy from left to right, or from suppression to co-option, is a relatively simplistic analysis and does not fully reflect the complexity of Chinese politics. The Chinese, not unlike Western colonizers who believed that they were involved in a "civilizing mission" to bring Christianity and advanced culture to backward peoples, were part of an ideologically driven movement that had a self-appointed mission to liberate the poor and oppressed. During their softer phases the Chinese accordingly made much more of an effort than the European colonizers to bring practical improvements to their newly acquired territories, and in Tibet as in China those improvements were often to the benefit of the lower levels of society. China's invasion did, in part, lead to the ending of debt and serfdom, to the land reforms of 1959, and to the reform of the quasi-feudal system in Tibet.

The policies of the final "soft" period, initiated in the early 1980s, were in many ways similar to those of the 1950s. In May 1980, Hu Yaobang, then general secretary of the party, announced that Chinese cadres were to be withdrawn from the Tibet Autonomous Region and Tibetans allowed to take over their roles in the administration. At the same time there was to be a tax amnesty for the farmers and nomads; religion and Tibetan culture were to be allowed to flourish; and investment was to be poured into the area to help in education, infrastructure,

and development. It was broadly welcomed by Tibetans in Tibet, who seized upon the opportunity to acquire a high level of modern education and to take up positions as cadres in the administration. While thousands of young men and women chose to rejoin monasteries and nunneries, others became teachers in schools or colleges, or worked as writers or academics. These two areas of activity—religious vocation and Tibetan language activities—emerged as of paramount significance during this sudden phase of cultural rediscovery. Over fifteen hundred monasteries were rebuilt, mostly by local Tibetans with their own funds, allowing the community to reestablish its links to its heritage as it had been in 1959. But at the same time writers, scholars, and administrators cooperated to produce with extraordinary rapidity a significant corpus of literature in Tibetan, including creative writing as well as academic, scientific, and religious studies. This emergence of a Tibetan literature was unique, not because (as the Chinese from time to time have claimed) there had been no previous literature in Tibet but because for the first time Tibetans were producing a Tibetan culture that was at the same time both distinctive and modern.

During that period, particularly in the eastern areas of ethnographic Tibet that are now subsumed within the provinces of Qinghai, Sichuan, and Gansu, the opportunities offered by the concessional state were taken full advantage of by the coalition of reemergent Tibetan intellectuals, led by the Panchen Lama, and Chinese liberals, led by Hu Yaobang. This produced what one might call a new Tibetan intelligentsia—one could almost say, a Tibetan middle class. It was created with great speed, its members showed robustness and confidence, and they were, unlike most previous groups of educated Tibetans, fluent in Chinese and well equipped to deal with the modern world. In addition, they held positions within the administrative and cultural apparatus governing Tibet.

It is therefore perhaps not surprising that some sections of the Chinese Communist Party became nervous about the growing signs of confidence among Tibetans in the mid-1980s. In 1987, when the Dalai Lama began a campaign to seek political support in the West, the propaganda units in Tibet were ordered to publish a series of statements condemning him in language that had not been heard since the beginning of the decade. That decision led to the pro-independence demonstrations of 1987, and more or less marked the end of the last phase of concessional government in Tibet.

* * *

The situation in Tibet today requires a different understanding: it is neither a period of evident brutality nor of concession. The shoot-to-kill policy of the late 1980s has been dropped, and the number of political prisoners is (as far as we know) around seven hundred rather than three thousand. Far more Tibetans than ever before are allowed passports so they can travel abroad, and in 1992 the authorities announced a relaxation of tariffs and taxes on people setting up businesses in Tibet. The economy in the Tibet Autonomous Region has since grown by more than 10 percent each year, according to official government statistics, faster than the rate in China as a whole, and far above the world average. By the end of 1997, there had been almost no reported pro-independence demonstrations in Tibet for over twelve months, in contrast to the two hundred or more that had taken place during the previous nine years. Yet despite such indications of political calm, Tibetans currently living in Tibet say that the situation is worse than it has been at any time since 1980, when the opening up to the outside world was first announced. How then are we to understand the apparently concessional stage that Tibet is now in?

To answer this question we have to adjust the set of concepts and presumptions that we bring to it. Generally we equate repression with certain visible incidents, such as political arrests, detention of demonstrators, or military patrols. But such signs may be typical only in the early phases of military occupations. If, for example, we were to imagine how France or Denmark might have looked to a casual tourist today had the Nazis never been defeated, we can be reasonably sure that it would not have remained as it was in 1945: there would be no need, one can imagine, for men to be patrolling in jackboots or for sentries with machine guns to be placed at each corner. Even during the war much of France was, as we know, run by French collaborators with a civilian police force, so there was little day-to-day sign of its military masters. Some fifty years after the onset of an occupation we would not expect much need for visible controls, since the opportunities for heroic resistance would mostly have been exhausted, and the activists probably long since eliminated or cowed. Indeed, what is striking about Tibet is that the Chinese still found it necessary until 1990 to use unsubtle methods of control, and that five decades after occupation the Chinese have not yet depleted the Tibetans' reservoirs of resistance.

Political arrests continue to take place in Tibet, armed police can still be seen in the streets whenever there is a possibility of unrest, and there are continued reports of brutal incidents in outlying areas—in December 1997, for example, a Tibetan monk escaped to Kathmandu after surviving ten days of torture in Ngari, in the far west of Tibet, where soldiers had suspected him of planning to flee the country. But in general the indicators of the political atmosphere should be sought not in visible incidents of abuse but in the signs of systemic, policy-led strategies of control—in such things as the identities and affiliations of policy makers, the language of administration, the degree of participation in the political process by people outside the elite or the administration, the breadth of cultural expression, and the syllabi of school and college history courses.

If we look at the first factor, the policy makers, we find that 66 percent of all regional-level officials in the Tibet Autonomous Region are, by one estimate, Chinese. Yet, according to government statistics, only 3 percent of the population is Chinese. Similarly, the percentage of Chinese students in technical education in the region is around 40 percent. No figures exist for ethnic participation in the economy, but it can be reasonably assumed that most capital investment and profit extraction is not in the hands of Tibetans.

These are the signs of a political structure that is organized toward the preservation of power and influence within the orbit of a subcommunity: the Chinese. In the "soft" period of the early 1980s this structure of minority dominance had been eroded by Tibetans who had taken advantage of the new concessions to launch their own cultural activity and to acquire positions in the administration. Chinese policy makers militated against this and related developments, warning about risks to the maintenance of the power of the party, so that by 1987 they had engineered, through the campaign against bourgeois pollution, the fall of Hu Yaobang, and, two years later, the crushing of the 1989 student revolt in Tiananmen Square held in Hu's memory. In China some of those reforms have been recouped, but Tibet is a different story: what we are witnessing in Tibet today is the dismantling, piece by piece, of the concessional regime initiated by Hu some twenty years ago, and the reconsolidation of power in the hands of the Chinese oligarchy. The sudden death of the Tenth Panchen Lama in 1989, the last great religious leader still living within Tibet, removed the final remaining obstacle to revisionism.

The dismantling of concessions has been a gradual process. Its most obvious manifestation was the security operation of the late 1980s, which originally took the form of what the Chinese call "passive" policing, which meant mass arrests and street executions. This was followed in 1990 by a shift to a lower police profile, keeping troops in barracks, using video technology for surveillance, a growing role for the State Security Bureau, and a major increase in the funds allocated to establishing an informer network. These changes may have appeared as a form of moderation, but they were driven by a need for efficiency: we know that in 1990 a document was circulated among high-level cadres in Lhasa pointing out that the widespread torture of prisoners was counterproductive because it increased popular determination to fight the authorities. By mid-1993 the replacement of crude repression by more subtle and efficient methods had reaped its rewards: during that summer the majority of underground resistance cells in Lhasa were penetrated by State Security, and soon after most of their members were imprisoned or forced to flee.

By this time the authorities had already shifted their attention to a second front in their effort to reverse the liberal reforms of the early 1980s: the economy. Lhasa and the surrounding areas were to be opened up to entrepreneurial activity as a "special economic zone," under the banner of what was then being called Chinese market socialism. Thus Tibet became a frontier zone filled with pioneering entrepreneurs from areas such as Sichuan and Zhejiang, who began by mending bicycles in the street and who now run small shops, restaurants, and businesses in the towns of Tibet. And, although this "special economic zone" was never put into practice as such, it conveyed a simple message within China: a lot of money could be made in Lhasa very fast.

This radical change in the urban economy of Tibet did not come about unaided. In April 1992 every government office located on a main street was ordered to convert its street frontage to a row of small, garage-type shops; most of these were taken up by Chinese migrants, to the discomfort of Tibetans who perhaps saw the prospect of their newly revived culture slipping away under a wave of cheap modernism from which many of them did not even stand to profit. Later that year orders were passed removing any checkpoints on Tibet's intraprovincial borders: there were to be no restrictions on Chinese migrants into the region. By about 1995 the leadership decided that it should also offer economic incentives to the Tibetans and another policy emerged: large loans from the state banks became available at generous levels of interest to a number of Tibetan businessmen. The result has been the creation of a new appetite for wealth among urban Tibetans and a dramatic increase in the class of rich Tibetan entrepreneurs with home video systems, new houses, and all-terrain vehicles. At the same time there was a huge investment by the state (and by foreign states) in equipping Tibet with advanced telecommunications.

As far as one can tell from abroad, economic development has led to a surge in small businesses—usually karaoke bars and nightclubs, many of which are short-lived and in which much of the trade is prostitution—and has been sustained by the reinvestment of the cheap loans on the money market in Hong Kong. The current urban boom, with its fragile economic base, could in theory lead to a more stable development of the economy but is as likely to collapse once the state finds it can no longer afford to bankroll the loans. In the meantime a new plutocracy is emerging that is distanced from the majority of its fellow Tibetans, whose opportunities for trade and employment are unlikely to increase until, as the authorities promise, infrastructural development is sufficiently advanced to entice major investors. Even

then Tibetans might find themselves without increased opportunities for labor, let alone profit, because Chinese workers are likely to be brought in to work on the oil wells and copper mines planned for Tibet.

If policy in Tibet were still focused on the development of this dynamic, if dubious, economy, it could be argued that the objective of the current regime was a well-intentioned, if misguided, effort to improve the economy and social wealth. But in fact, the economic liberalism of market socialism was really being used by the hard-liners in 1992 as a mechanism to encourage migration to Tibet—a demographic device to facilitate control. And in July 1997, it was made clear that this economic reformism also included a more unorthodox political agenda. China's main representative in Tibet, the party secretary Chen Kuiyuan, made a speech in which he announced that Buddhism was "foreign" and not part of Tibetan culture. It was not that he was wrong in absolute terms—as we have seen, Buddhism arrived in Tibet only a thousand years or so ago. But the statement was clearly intended not as an academic observation but as a provocative criticism of the notion of Tibetan culture, the sustaining of which the Dalai Lama and many other leading Tibetans throughout the previous ten years had already declared to be their fundamental and overriding concern.

In November of 1997, Chen went on to identify a new form of enemy within Tibetan society, "the hidden reactionary." As examples he referred to unnamed individuals among the few great Tibetan intellectuals remaining in the universities and among the educated Tibetans who had secured relatively senior positions in the administration during the reform period of the early 1980s. These two announcements can be taken as the signal that China had opened its third front in the battle to regain control of Tibet: an attack on Tibetan culture. The police work of the early 1990s and the economic drive of the mid-1990s were now to give way to an attempt to redefine Tibetan culture.

It became clear that the unusual aggression discernible in China's religious policy in Tibet since 1995 has been part of a larger offensive. The banning of the public display of photographs of the Dalai Lama and the constant press attacks on him were a sign that he was now to be regarded as a religious fraud as well as a political outcast; this was a significant change in policy, because throughout the 1980s he had been attacked only in his political capacity. The campaign in 1995 against the child he had recognized as the reincarnation of the Panchen Lama was the most strident part of this wider cultural offensive; by obliging hundreds of Tibetan officials, scholars, lamas, and intellectuals to declare public support for the state's right to appoint the new incarnation, the authorities were persuading them to renounce any claims to the promises offered by the 1980s era.

In 1996, another major campaign, this time the drive to bring "patriotic education" to the monks and nuns in Tibet, extended the attack beyond the senior officials and lamas to the lowest levels of the monasteries and nunneries: each was to be visited by a *gongzuo dui*, or "work team" of party cadres who would hold daily sessions for three months on the correct view of religion, law, history, and the Dalai Lama. Each person was required to give a formal declaration of loyalty by signing a statement denouncing the Dalai Lama and recognizing Tibet as part of China. That effort is still continuing in monasteries and nunneries across central Tibet, and by October 1997 had begun in the great monastic universities of Amdo as well. In March 1998, the program was extended to schools and to the "citizens" of Tibet, so that in the foreseeable future, all Tibetans will eventually be required to declare their allegiance to the new regime.

The third, cultural, front goes beyond the strategies of policing dissent or of economic buy-offs: both are relatively straightforward mechanisms to suppress dissent. The cultural attack appears to be aimed at the long-term elimination of ideas that could in the future lead to dissent, as well as at the dismantling of the concessions offered in the reform era. It has, however, an unfortunate resonance: in language and conception it is reminiscent of the thinking of the Cultural Revolution, perhaps the most brutal of the hard periods in Chinese Communist history. At the same time it also has an aspect that did not arise during the Cultural Revolution: the fear of assimilation from the immigration of Chinese attracted to the region by economic incentives. This apprehension is fueled by frequent rumors of plans to send settlers in large numbers, as the Chinese did in earlier times in Manchuria, Mongolia, and Xinjiang. Indeed, retired Chinese soldiers based in the region have, since at least 1994, been officially encouraged to settle in Tibet. In fact, many of the new arrivals in Tibet are temporary, staying for a few years rather than residing permanently, and they are almost entirely confined to towns and cities. Their impact, however, is significant.

The "new Tibetans" are entrepreneurs, usually Chinese or Hui (Chinese Muslim), who play a prominent role in the emerging private sector of the economy, now the leading edge of China's development strategy. They not only dominate economic life but have also introduced a powerful new culture that has made rapid inroads into Tibetan life, especially in the towns. Its detractors say this alien culture is Chinese, and it is certainly true that Chinese language, art, customs, and ideas are replacing their Tibetan equivalents in many areas. But it is also true that much of the new imported lifestyle is not Chinese, but rather part of modern, global commercialism: discotheques, pop music, Michael Jackson cassettes, Adidas trainers, video recorders, a stock exchange, motorbikes, mobile phones, satellite television, and E-mail, not to mention heroin and AIDS. The onslaught that Tibetans face now with the easing of barriers to trade and travel is as much Western in origin as it is Chinese; they are confronted with many of the same choices that Nepal, Bhutan, India, and other developing nations faced as traditional societies forced to come to terms with the rough assault of modernity.

But Tibetans confront these developments with severe handicaps: except at the purely subjective level all the choices they now face—whether to regulate the inflow of modernity; what compensatory steps to take in terms of education or training; whether to adapt or to abandon Tibetan language, arts, and customs in the face of the new demands; whether to control or to encourage outside investment; whether to give preference to local, indigenous traders and initiatives—are made by their Chinese rulers on their behalf. And the signs are that the Chinese leadership in Tibet is deliberately making choices, such as encouraging the growth of prostitution and refusing to regulate immigration, that will stunt or destroy the nascent attempts of Tibetan culture, so successful in the early 1980s, to adapt itself to modernity. Thus we find that in the last two years Tibetan parents in Lhasa have started encouraging their children to study the Chinese language, because few if any jobs will be open to those children if they graduate proficient only in Tibetan. As if to emphasize the point, the University of Tibet has already closed admission to its Tibetan department.

What we are seeing is a strange, perhaps unique, hybrid, different from previous left-right swings in Chinese politics. Tibet today is a cauldron in which an experiment is taking place, where politicians attempt to achieve the intentions of totalitarians while pursuing the actions of economic reformers. The economic liberalism of market socialism was used by the hard-liners in 1992 as a mechanism to

encourage migration to Tibet. The indicators of this political composite—what some Chinese refer to as "hard on the inside, soft on the outside"—are not visible to the casual observer. There are no tanks on the streets or machine gun posts on the rooftops, as there were at the beginning of this decade; there are tourist hotels, computer shops, public phone booths, and all the other signs of affluence and luxury familiar to us from our own societies. Even the growing presence of an underclass, of unemployed Tibetans, is to us a sign of normal social disparity. If we saw a political education session in a monastery or a school, it would not look untoward to us as visitors. But in fact these are the images and the indicators of what Tibet is today—an experiment in achieving targeted repression and cultural restrictions within a context of economic relaxation.

<p style="text-align:center">* * *</p>

It can be argued that the perception of the Tibet issue has been confused or misrepresented by the form that popular sympathy in some Western countries has taken on the Tibet question. In the English-speaking world that interest culminated with the Hollywood films released in the late 1990s—Jean-Jacques Annaud's *Seven Years in Tibet* and Martin Scorsese's *Kundun*, to name the best known; it had previously been symbolized in the media by the involvement of American film stars like Richard Gere and Harrison Ford in support of the Tibetans. The surge of media and public interest reflected by those films (which attempted to express the exiled Tibetans' view of the conflict) took it for granted that there is a serious basis to the aspirations of the Tibetan nationalists and to the continuance of the Sino-Tibetan conflict. Such well-meaning support is influential in shaping the popular assessment of the Tibetan question; but it is also something of a chimera. In the long term there is a risk that support for the Tibetans of this kind could potentially do damage to the cause it espouses.

There are a number of aspects of Western coverage of the issue to date which give rise to concern. One of these is that the recent increase in media coverage gives the impression that there is popular support for the issue in the West, which in turn implies that Western governments support the issue; this is not necessarily the case. The Tibet issue in the West is a classic example of one of those legislature-executive struggles that figure frequently in the history of Western-style democracies: Tibet represents one set of interests to legislators and another set of interests to foreign policy decision makers. The implications of this disjuncture have not always been fully explored and have led to some apparently unnoticed consequences. While parliaments and congresses have been pulling in one direction, the executive branches (and the business interests to which they are much closer) have pulled in another, and the Tibetans have ended up with a small burst of publicity and occasionally a parliamentary statement that has no legal standing.

The U.S. Congress, for example, declared Tibet in 1991 to be an independent country under military occupation, but the resolution has no legal significance and has apparently been ignored by lawyers and policy makers. In any case, what appears to matter now to the Chinese authorities is the position taken by governments in their implementation of foreign policy. This was not always the case: until about 1994, Beijing was in the habit of reacting quite strongly to parliamentary statements, apparently out of the belief that they must reflect, as in China, the views of their corresponding government, or that they might have some impact in shaping those views; a number of Tibetan political prisoners were released or saved from execution during that period, as a result of outside pressure as expressed by foreign

parliaments and pressure groups. Experience has changed that misconception, however, and Beijing, which recently set up a research unit to study the anomalous ways of the U.S. Congress, now knows that the two units in the Western system can be treated quite separately, especially where peripheral or sentimental issues are involved. The eighteen-year sentence given in 1996, in defiance of congressional appeals, to Tibetan exile Ngawang Choephel, a graduate student from Middlebury College who was arrested for traveling in Tibet with a video camera, was presumably intended to make that clear.

Unless the Tibet issue is able to generate support more substantial than popular sympathy and media glamorization, statements by legislatures are not in themselves any longer of much concern to the leadership in Beijing, whose business is with governments and investors. It can of course be argued that in the past popular support has led to more significant institutional backing, and finally to government or financial action, but such a progression appears to happen because of a number of factors besides the extent of popular support. South Africa and Palestine, for example, became major issues, but they were of undisputed strategic significance, involved protracted military and terrorist struggles, had highly organized and sophisticated indigenous political parties representing them outside, as well as very large and active resistance movements inside the countries. None of these conditions, probably not even the last, apply at the moment in the Tibetan case.

A second weakness with the coverage of Tibet in the West is that the popular support it invokes is in fact more localized than it appears. After his escape from Tibet in 1995, the famous human rights activist Gendun Rinchen, who three years earlier had been voted Tibet's top tour guide, said that 80 percent of the tourists he escorted had little or no idea that there was any political problem in Tibet—and they were the ones interested enough in Tibet to pay to visit it. The Tibet question has remained corralled and specialized, a situation that is changed little by media coverage.

The miscalculation of the extent or significance of Western support is unfortunate, because it has communicated to Tibetans inside Tibet a false impression of international support; this has arguably encouraged them to stage demonstrations and protests in Tibet that courted publicity at great personal cost but that perhaps brought little concrete result. More importantly, it has contributed to the mood of disillusionment and frustration that now appears to be current among Tibetans who, perhaps thinking that Western support was substantive rather than marginal, expected improvements as a result of outside pressure but received few. Instead they have been left to find out that in the long run outside pressure has led to the increased sophistication of control that they now face in Tibet.

Perhaps more damaging has been the political message that Western support has communicated to the Chinese people and to those in other developing countries. The fact that foreign interest in the issue is mainly confined to westerners—and that the character of Western rhetoric about the issue is often polemical and anti-Chinese in tone, or self-evidently misinformed—has given the impression that Tibet is a Western preoccupation in part overstated to bolster the interests of the Western bloc. The unfortunate history of the Tibet issue, used by the Western powers, and by the United States in particular, in the 1950s and 1960s as part of their cold war strategy to destabilize China, has fueled the perception that criticism of Beijing's role in Tibet is a device raised by westerners to attack China in particular and developing

countries in general. This has enabled Beijing to rally support from the developing world and led to the collapse of the last nine attempts at the United Nations to criticize China's human rights practices.

Another difficulty with the general presentation of the Tibetan case in the West is that the wrong elements have been condensed: the exciting things to westerners about Tibet are its exoticism and its mysticism, the colorfulness of its religion, the irrepressible charm of the Dalai Lama, the mystique of the mountains, and so on. Yet in terms of politics these factors are incidental—Kuwait, for example, was not given support against invasion because of the charm of its sheikhs. What should have been condensed in discussions of Tibet, if those involved in creating the images wished to see a political outcome, are the same issues that we consider when dealing with other disputes over colonization or occupation—who holds power, who is not given access to power, what are the political demands and program of the people involved, how close are the representatives of the various groupings to the people they represent, and so on.

The trivialization of the Tibet issue has led a number of presumptions to accumulate that may need to be reconsidered if Western discussion of Tibet is to appear meaningful. For example, the perception of the Dalai Lama as supreme pontiff of Tibetan Buddhism is a recent phenomenon, reported to be an arrangement that other religious schools reached in the 1960s partly to simplify their relations with foreigners. The role of pacifism in Tibet has been overstated: it is true Tibetans have in general chosen to follow the advice of their leader not to take up arms, but this is also a recent phenomenon and not a condition of their culture. Until 1974, thousands of Tibetans took part in a fierce guerrilla war with the Chinese, which for a period was funded by the U.S. Central Intelligence Agency. The clergy who destroyed the attempts of the Tibetan government and the previous Dalai Lama to enlarge and modernize the Tibetan army in the 1920s (and who thus destroyed any chance of Tibet ever resisting incorporation into China) were not motivated in the slightest by objections to violence, but by the fear that modernization might, by increasing links with the un-Buddhist British, lead to the diminution of the monasteries' power; indeed there were several insurgencies against the previous Dalai Lama or his regents this century led by monks in defense of that belief.

Today some ten thousand Tibetans are members of India's military forces, soldiers with a special aptitude for high-altitude warfare, posing a threat that China views with some seriousness. Neither is the level of political violence among Tibetans as low as some Western reports would suggest: at least seven bombs exploded in Tibet between 1995 and 1997, one of them laid by a monk, and a significant number of individual Tibetans are known to be actively seeking the taking up of arms; hundreds of Chinese soldiers and police have been beaten during demonstrations in Tibet, and at least one killed in cold blood, probably several more. Within the exile community itself there is a continuing streak of political intolerance, especially towards those who have made the slightest perceived criticism of the Dalai Lama, who risk beatings or threats of assassination. Neither is religion by any means above conflict: at least two of the four schools of Tibetan Buddhism are at present wracked by disputes; both cases have led to murders or threats of murder.

The mythologized depiction of Tibetans as inherently religious and pacifist is attractive, but it is also reductionist. It implies that they are passive, and that their decisions are the result of tradition not choice, and it suggests that they are neither part of the modern secular world nor suited to the competitiveness of contemporary political decision making. The political presentation of Tibet has similarly tended to

focus on the suffering experienced by Tibetans under Chinese occupation. Sometimes this is presented as a general phenomenon, such as by citing the total number of those believed to have been killed, and at other times an individual case is described, such as that of a nun or monk who has been imprisoned and tortured. None of these references are invalid (although the figures used are often inaccurate), but because there is often an absence of harder analysis, they have the effect of portraying Tibetans as victims who need to be helped, rather than as agents of political change who might be supported.

It is in this area, the role of human rights in the Tibet issue, where another disjuncture between sympathy and political action can be seen. Media, parliamentary, and governmental statements have tended to focus on the question of how individuals in Tibet are treated by the current regime. But in the hard world of international politics, human rights issues are of little relevance to the process of political decision making. Although statements on human rights issues are frequently made by governments of all hues, their policies are unlikely to be significantly influenced by them—not least because almost every country has condoned human rights abuses of one kind or another within its own borders.

Governmental statements about human rights in Tibet or China are thus usually bargaining chips to create leverage for issues higher up the agenda or smoke screens designed to impress the domestic constituency while at the same time causing minimum anxiety to Beijing. A sophisticated regime like China could, if it wished, have resolved overnight most human rights criticisms by foreign governments by offering to appoint a commission of inquiry, arresting a few police chiefs for torture, or inviting UN officials to visit model prisons; that it has not done so, and that it has only recently started to respond at all to human rights criticisms, is because, among other reasons, it is in its interest, and in the interests of the Western powers as well, to keep public discussion and confrontation focused on such essentially marginal areas, thus avoiding issues of potentially irreversible conflict. The Tibetan activists inside Tibet have rarely (until recently) incorporated the issue of human rights in their protests or slogans—the language of human rights is largely a facet of exile rhetoric and Western simplification of the issue. Inside Tibet, the demands raised in wall posters have focused more on independence: rightly or wrongly, that has been to them the central issue.

No one can have been clearer about this than the Chinese leaders themselves: they have endlessly repeated the remark, usually unnoticed, that sovereignty is the main issue. When the Tibetan demonstrations in 1987 triggered a flurry of foreign criticism of China's human rights practices, the Chinese acted as if all allegations were veiled attacks on their territorial claims and demanded from each critical government assurances that its criticisms applied only to human rights practices and did not affect its acceptance that Tibet was part of China. In almost all cases the Western governments, apart from Britain, gave the required assurances to Beijing.

Thus, although China appears in the last ten years to have been battered in the Western media for its role in Tibet, in terms of the declared aspirations of its political leaders, in terms of power politics, and in terms of historical significance, it has emerged from those years of apparently stringent diplomatic attack with a wealth of political gains. Few if any countries apart from India and Nepal had specifically declared that Tibet was part of China before 1987; now most have been asked to do so and have complied. Tibet's claim to

separate or at least ambiguous status was at least in part supported by the fact that few countries had specifically described it otherwise; that situation was reversed at the same time as Western criticisms of China were being popularly presented as assisting the Tibetans' situation. In other words, it can be argued that support from the West, which was anyway limited, may have damaged the political prospects of the Tibetan issue as much as it helped them.

If we have to generalize, therefore, it can be said that the Western perception of the Tibetan question has been burdened with a romantic inheritance, oversimplified information, and a blurred political presentation. It is because of such characteristics of the Western approach to Tibet, and its sometimes unfortunate consequences, that we need to seek another, more disciplined and more layered, view. That there is some resistance to this in Western discussion of the Tibet question may be due to its associations with Tibetan Buddhism, which many westerners see as antithetical to pragmatism or political thought; they have tended to invest in the religious aspects of the Tibetan situation, often as a conscious antidote to Western rationalism. The effects of this on the Tibetans have been quite concrete: since the exile of the Tibetans to India forty years ago, for example, large amounts of money and energy have been expended on the preservation of Tibetan culture outside of Tibet. A more pragmatic approach would have invested in encouraging that culture to develop rather than to remain static, equipping it in its encounter with modernity instead of helping it to become a museum exhibit. As the controversial American Tibetologist Melvyn Goldstein pointed out in 1990, Western funds have financed the production of much abstruse religious literature in Tibetan but not the writing by exiles of novels, stories, plays, or poems, so that (until the founding of the Amnyemachen Institute's translation project in India in 1992) there has been little other than advanced metaphysics for an exiled lay Tibetan to read in his or her own language. While there are thousands of Tibetan monks in exile who have received higher education, few Tibetans in the exile community have been trained in technology or sciences. Among Western scholars of Tibet, too, the study of modern Tibet has been seriously considered only in the last eight years or so: the bulk of Tibetology was and still is focussed on classical studies. Even the contemporary study of Tibet or the writing of a modern, secular literature in Tibetan can scarcely be found anywhere outside China or Tibet itself.

The limitations of the general Western efforts to date do not mean that the Tibetan pursuit of national identity is trivial or doomed. Political change is not dictated by logical certainties, as the Soviet experience has indicated, and there is certainly nothing trivial about the Tibet experience, nor any reason why its quantitative insignificance should preclude it from having disproportionate regional impact. For example, in 1987, when Steve Lehman and I met by chance in a Lhasa backstreet during a wholly unexpected demonstration, the Tibet question was nowhere on the Chinese, let alone the international, agenda. If the Chinese government had not chosen to conceal the details of that protest, to deny that they had shot a number of Tibetans dead when we and other tourists had seen it, or to close the country off from foreign journalists ever since, the Tibetan issue might not have received much attention in the last decade. The errors of Beijing on that occasion had an effect that could hardly have been foreseen and that has had lasting repercussions.

It was not so much that Tibetan discontent became known to the outside world: what was of lasting importance was that the events of that day propelled Tibetan resentment to develop into the deep and highly motivated alienation that resulted in the far greater turmoil that

took place in subsequent months. Before the outbreak of protest in 1987, Tibetans had apparently been aware of the likely withdrawal of the concessions that Hu Yaobang had offered them some seven years earlier; but the response of the authorities to their demonstrations revealed the fear within the Chinese leviathan of the pinprick of Tibetan dissent. That fear, as seen in the decision to open fire on the protestors in Lhasa, was an indication that the dragon is more fragile than its fiery breath would have its subjects believe. It is in that perception that the potential for significant Tibetan impact resides.

In more technical terms, what the Chinese accomplished and are further fomenting as they move to attack Tibetan culture itself has been the stoking of a modern form of mass political consciousness among Tibetans. The politicization that several decades of explicit indoctrination had failed to inculcate is now being achieved by the same Chinese efforts that are currently directed against the rise of nationalist consciousness in Tibet.

Current Chinese policy in Tibet, replete with such examples of contradiction and extremity, has suffered ever since from a sense of fragility and insecurity, with a tendency to concentrate its attack on the apparently innocuous. Since 1995 it has banned the photographs of an amiable man in a skirt, run a state campaign ordering the denunciation of a six-year-old child, forced forty thousand monks and nuns to sign declarations concerning thirteenth-century history, and declared a thousand-year-old religious tradition to be a foreign import. Such decisions cannot be easily explained by the logic of realpolitik or national interest; we have to look elsewhere to explain the forces that drive Chinese leaders in Tibet.

It is as if China were operating, in its dealings with Tibet, in a universe sustained not so much by its army or its factories, as by its ideological constructions. After all, the central question for the leaders in Beijing may not be, perhaps has never been, their creditworthiness with international financiers or their standing with the international community, but their credibility with the people of China. They are a regime of considerable youth, scarcely fifty years old, whose power was achieved through conquest, through the incompetence and barbarity of their opponents, and through lavish, utopian promises to their followers. During their period of rule, despite some notable successes, they have committed atrocities that in many ways dwarf those of their predecessors—even Chiang Kaishek, for example, did not initiate a famine that killed a reported thirty million people. And the current regime has largely repudiated the aspirations and claims of its revolutionary progenitors—not so much because it clearly espouses capitalism and social disparity, but because it has also renounced the provision of free education, medical care, or guaranteed employment to its people.

Whatever else one might say about the Tibetans, the one thing they have in their favor is a substantial claim to legitimacy. As a nation-state, they may have failed to register their credentials, but they enjoyed all the characteristics of statehood; as a political force, they are unified to an exceptional degree in their objectives; as a movement they have a leader who enjoys unusual respect not merely in the West, where his significance is more symbolic than actual, but inside Tibet, where the political unity he commands may well be the final arbiter of Tibet's future. The strategic advantage of even partial pacifism is of great relevance not at all because of any moral virtues we may see in it, but because it can lay claim to legitimacy in a conflict where the Tibetans' opponent has little legitimacy and has depended on force.

This is not to say that there can be any predictable outcome to this dispute. The Tibetans are also capable of making strategic errors (as events have already indicated) on a large scale, just as the Chinese are. They could reject the leadership of the Dalai Lama, return to sectarian or regional conflict, decide to revive their autocratic tradition, or reach such a conciliatory compromise with the Chinese as to have no rights remaining. Or they could, for example, decide on other objectives, such as the pursuit of immediate wealth, already currently on offer to a certain class in Lhasa.

But even in these scenarios, the history of nationalist disputes suggests that such tendencies are in a sense diversions. People may be distracted for a period by the attractions of modernization or by internal conflicts, but eventually their interest in asserting their identity will reemerge, and when it does it will be equipped with increased expectations and better resources. In other words the current Chinese (and Western) strategies for deflecting Tibetan aspirations are unlikely to succeed in the long run, and may serve only to exacerbate the dispute.

When Steve Lehman, I, and other Western tourists first saw protestors take to the streets of Lhasa in October 1987, an arcane dispute emerged amongst us as to the role of foreigners. Should we witness these events silently from the sidelines, some of us asked, or should we stand in the middle of the crowd to show support and to deter the soldiers from opening fire? In the event, those who decided to stand among the crowd and wave their fists found that they were shot at, too. More significantly, perhaps, their involvement was photographed and filmed by officials so that to this day they are cited as evidence that those protests were fueled by foreign provocateurs and not an expression of Tibetan belief. Perhaps that would have happened whatever we, the outsiders, had done, but the episode was a reminder that in the final analysis the role of the foreign journalist or observer may be more limited than we like to imagine.

Though the West's response will undoubtedly be a factor in the dispute, its outcome will ultimately be decided by Tibetans and Chinese, and whether they eventually resolve their differences will depend almost entirely on their ingenuity and tenacity. The landmark decision of the Chinese in 1990 to stop killing demonstrators in Tibet may have been seen as a consequence of international criticism of Beijing, but it was also to do with the realization in China that the shooting was further antagonizing Tibetans in Tibet. In other words, the Chinese were to a considerable extent afraid of Tibetan unrest. The bottom line in this issue is thus not the legal status of Tibet, the magnitude of the army, the stature of the Dalai Lama, or the moral power of the demands: it is the risk that determined Tibetans may decide en masse to actively oppose Chinese rule.

It is ironic, therefore, that it is the Tibetans in Tibet who are least often consulted by foreign journalists and politicians, and their opinions which are most rarely documented in any detail by observers and writers. It is also why a book of this sort, as an attempt to communicate something of the experience and thinking of those people, is neither a tribute nor an elegy: it is a demand that we, the observers, focus our attention on those who are in every sense the key to the future of Tibet and the only arbiters of the seriousness or otherwise of this issue— that is, the Tibetans themselves.

recommended reading about tibet

Avedon, John F. *In Exile from the Land of Snows.* New York: Vintage Books, 1986.
Barnett, Robert, ed. *Resistance and Reform in Tibet.* Bloomington: Indiana University Press, 1994.
Bell, Sir Charles Alfred. *Tibet Past and Present.* Oxford: The Clarendon Press, 1924.
Cutting Off the Serpent's Head: Tightening Control in Tibet. New York: Tibet Information Network; Human Rights Watch, 1996.
The Dalai Lama. *My Land and My People.* Potala, 1962.
———. *Freedom in Exile.* New York: Harper Collins, 1990.
———. *A Human Approach to World Peace.* Massachusetts: Wisdom, 1984.
———. *The World of Tibetan Buddhism.* Massachusetts: Wisdom, 1995.
Fleming, Peter. *Bayonets to Lhasa.* London: R. Hart-Davis, 1961.
Forbes, Ann, and Carole McGranahan. *Developing Tibet? A Survey of International Development Projects.* Cambridge:
 Cultural Survival; Washington, D.C.: International Campaign For Tibet, 1992.
Goldstein, Melvyn. *A History of Modern Tibet, 1913-1951.* Berkeley: University of California Press, 1989.
———, and Cynthia Beall. *Impact of China's Reform Policy on the Nomads of Western Tibet.* Asian Survey 29, No. 6, June 1989.
Gyatso, Palden, and Tsering Shakya. *The Autobiography of a Tibetan Monk.* New York: Grove Atlantic, 1997.
Harrer, Heinrich. *Return to Tibet.* London: Weidenfeld and Nicolson, 1984.
———. *Seven Years in Tibet.* Translated by Richard Graves. London: R. Hart-Davis, 1953.
Hopkirk, Peter. *Trespassers on the Roof of the World.* London: J. Murray, 1982.
Human Rights in Tibet. Washington, D.C.: AsiaWatch, 1988.
Leaders in Tibet: A Directory. London: Tibet Information Network, 1997.
Panchen Lama. *A Poisoned Arrow: The Secret Report of the Tenth.* London: Tibet Information Network, 1997.
People's Republic of China: Persistent Human Rights Violations in Tibet. New York: Amnesty International, 1995.
Richardson, Hugh Edward. *Tibet and Its History.* Boulder: Shambhala, 1984.
Sambhava, Padma. *The Tibetan Book of the Dead.* Translated by Robert A.F. Thurman. New York: Bantam, 1994.
Schwartz, Ron. *Circle of Protest.* New York: Columbia University Press, 1994.
Shakabpa, Tsepon W. D. *Tibet: A Political History.* New Haven: Yale University Press, 1967.
Sogyal, Rinpoche. *The Tibetan Book of Living and Dying.* San Francisco: Harper San Francisco, 1992.
Tibet, The Sacred Realm: Photographs, 1880-1950. Millerton, N.Y.: Aperture, 1983.
Thurman, Robert A. F. *Essential Tibetan Buddhism.* San Francisco: Harper San Francisco, 1995.
Van Walt van Praag, Michael. *The Status of Tibet.* Boulder: Westview Press, 1987.

Maps
Map and Index of Lhasa City. Dharamsala, India: Amnye Machen Institute, 1995.
On This Spot (Map): An Unconventional Map and Guide to Tibet. Washington, D.C.: International Campaign for Tibet, 1994.
Tibetan Old Buildings and Urban Development in Lhasa, 1948, 1985, 1998. Berlin: Lhasa Archive Project, 1998.

Travel Guides
Batchelor, Stephen. *The Tibet Guide.* London: Wisdom, 1987.
Chan, Victor. *Tibet Handbook: A Pilgrimage Guide.* California: Moon Publications, 1994.
Dowman, Keith. *Power Places of Central Tibet: A Pilgrim's Guide.* London: Routledge & Kegan Paul, 1988.
McCue, Gary. *Trekking In Tibet.* Seattle: Mountaineers, 1991.

tibet: a twentieth-century chronology by robbie barnett

1902 Rumors reach the viceroy of India, Lord Curzon, that the Russians have signed a secret treaty with the Tibetans. Britain prepares for a military invasion.

1903-4 Three thousand British troops march to Gyantse. The Thirteenth Dalai Lama flees from the approaching army and takes shelter in Mongolia and in China. The British withdraw after signing the Anglo-Tibetan Convention, which allows them to have trade agents inside Tibet.

1909 The Dalai Lama returns from exile. Chinese troops occupy parts of Kham (eastern Tibet) and the Dalai Lama appeals to Great Britain for assistance.

1910 The Chinese Army, with two thousand troops led by Zhao Erfeng (Chao Erh-feng), invades Tibet and enters Lhasa. The Dalai Lama flees to India.

1911 In Beijing the Qing (Manchu) dynasty is overthrown and the Republic of China is established under Yuan Shikai (Yuan Shih-kai), who declares Tibet, Xinjiang (East Turkestan), and Mongolia provinces of China.

1912 The Tibetans rise up against the Chinese, who sign a surrender agreement and return to China via India.

1913 The Dalai Lama returns to Lhasa and issues a formal Proclamation of Independence in conjunction with Mongolia.

1914 Tibet, Great Britain, and China attend the Simla Convention as equal powers and initial an agreement to settle the Sino-Tibetan border dispute.

1918 Tibetan troops defeat the Chinese; a treaty is brokered by Eric Teichmann.

1920 Sir Charles Bell is sent to Lhasa as the British representative to reassure the Tibetans of British support for its self-rule.

1923 The Panchen Lama, long distrusted for his close relations with the Chinese, disputes his tax liability to the Tibetan government and flees to China.

1933 Choekyi Gyaltsen, the Thirteenth Dalai Lama, dies in Lhasa.

1935 On July 6, Tenzin Gyatso, the Fourteenth Dalai Lama, is born to a family of farmers in Amdo. (Lhamo Thondup is his birth name.)

1937 The Ninth Panchen Lama dies in Jyekundo (Yushu) on the Chinese border.

1938 The Tenth Panchen Lama is born on February 19 in Xunhua County, a Tibetan area of Qinghai Province, to Gonpo Tseten and Sonam Drolma and given the name Gonpo Tseten.

1940 The Fourteenth Dalai Lama is enthroned in Lhasa at the age of four.

1941-46 Tibet remains neutral during the Second World War and refuses permission for Americans or Chinese nationalists to transport military supplies through Tibet.

1947 Tibet sends a delegation to discuss trade and to open formal relations abroad with India, China, Britain, and the United States. Civil war threatens when Retring, the former regent, supported by the monks of Sera, attempts a coup.

1949 On June 3, officials of the Ninth Panchen Lama recognize Gonpo Tseten as the tenth incarnation of the Panchen Lama. In China, the People's Liberation Army (PLA) overcome the Nationalists (KMT) and Mao Zedong proclaims the People's Republic of China (PRC) on October 1. The Tenth Panchen Lama, then eleven years old, telegrams Mao to "unify the motherland." The PLA says it will "liberate Tibet from foreign imperialists."

1950 The Fourteenth Dalai Lama, then fifteen years old, takes over the running of the government. The first military contact between the Tibetan army and the PLA occurs in July, when the Chinese attack a wireless transmission office in Dengo, Kham. On October 7, Chinese troops cross the Yangtse into central Tibet and destroy the small garrison force at Chamdo in Kham. The Tibetan government and the Dalai Lama move to Yatung (near the Indian border) and appeal for help to the United Nations (UN), where the British and the Indian delegates persuade the General Assembly not to discuss the matter.

1951 On May 23, the Tibetan negotiating team led by Ngabö Ngawang Jigme signs the Seventeen-Point Agreement, promising cul-

tural and political autonomy but relinquishing claims to sovereignty. On June 13, General Zhang Jingwu is named representative of the central government in Tibet. The first PLA unit arrives in Lhasa on September 9. On October 24, the agreement is approved by the Dalai Lama and the National Assembly.

1953 Land reforms are initiated in Kham and Amdo, sparking the revolt known as the Dartsedo (Kangding) Rebellion.

1954 India and China sign a treaty enumerating the "Five Principles of Peaceful Co-existence," recognizing China's claim to Tibet. Revolt grows in eastern Tibet when the Chinese begin destroying monasteries and imposing collectivization. The Tibetan resistance movement and the Voluntary National Defense Army is formed. On December 25, the Sichuan-Tibet Highway and Qinghai-Tibet Highway reach Lhasa.

1955 The Preparatory Committee of the Tibetan Autonomous Region (TAR) is set up, with the Dalai Lama as chairman and the Panchen Lama and Zhang Guohua as deputy chairmen.

1956 The Dalai Lama travels to India for the Buddha Jayanti and tells Nehru he wants to stay; after Zhou Enlai and Mao promise that there will be no forced reforms, he returns to Lhasa. In May, the Hundred Flowers Movement is launched, encouraging intellectuals to speak out about problems in China.

1958 Revolt in Kangtsa, Amdo, in April. Founding of Four Rivers and Six Ranges (Tibetan resistance organization) in May.

1959 On March 10, thousands of Tibetans take to the streets in Lhasa in a popular uprising against the Chinese; on March 17, the Dalai Lama flees to India and 80,000 Tibetans follow him. Tibetan troops join the uprising, but by March 23 it is suppressed. The Chinese dissolve the local government and impose a military regime, fronted by the Panchen Lama, and in April begin "democratic reforms." Thousands of Tibetans are executed, imprisoned, or sent to labor camps. Destruction of monasteries begins. The Central Intelligence Agency (CIA) begins to train Tibetan guerrillas.

1959-61 The Great Leap Forward leads to

widespread famine, with millions dead.

1962 War breaks out between China and India over disputed border claims.

1965 The TAR is formally established. The Panchen Lama is placed under house arrest and Ngabö Ngawang Jigme is elected chairman. The UN passes a resolution supporting the Tibetan people's right to self-determination.

1966 The Cultural Revolution formally begins, destroying the remaining monasteries and outlawing most Tibetan cultural customs and religion.

1971-72 The PRC is admitted to the UN. The Central Intelligence Agency withdraws aid from Tibetan guerrillas. U.S. president Richard Nixon visits China in 1972.

1976 The Cultural Revolution ends. Mao dies on September 9. The Chinese acknowledge "past mistakes in Tibet," blaming them on the ultraleftist policies of the Gang of Four.

1979 Deng Xiaoping opens China to the outside world. He invites the Dalai Lama to return from exile, on the condition that he remains in Beijing. Other exiled Tibetans are now also welcomed to return. The Dalai Lama is allowed to send a fact-finding mission to Tibet. The mission delegates are greeted by demonstrations calling for independence and the return of the Dalai Lama; many demonstrators are imprisoned.

1980 Chinese party secretary Hu Yaobang visits Tibet and initiates the Six-Point liberalization program, allowing some private trade, the outward display of religious activities, and the recall of several thousand Chinese cadres.

1983 The Tibetan economy is recentered on tourism. The Dalai Lama sends a negotiating team to Beijing, but talks collapse in 1984.

1986 Monlam, "The Great Prayer Festival," is held for the first time since 1966.

1987 On September 23, the Dalai Lama proposes the Five-Point Peace Plan to the U.S. Congressional Human Rights Caucus in Washington, D.C. On September 27, a pro-independence demonstration led by twenty-one monks

in Lhasa gets worldwide attention. A second demonstration on October 1 leads to police opening fire on a crowd of three thousand demonstrators, killing at least nine. Foreign journalists and tourists are expelled.

1988 Major demonstrations take place on March 5, the last day of Monlam Festival in Lhasa; hundreds of arrests follow. A Chinese policeman and several Tibetans are killed. By June, the Dalai Lama puts forward the Strasbourg Proposal, offering the Chinese control of Tibetan foreign policy and defense in return for full internal autonomy. The Chinese promise to negotiate with him. Hu Jintao replaces Wu Jinghua as Tibet party secretary. On December 10, International Human Rights Day, police shoot dead two monks carrying the Tibetan national flag in Lhasa.

1989 The Panchen Lama dies on January 29. On March 5, police open fire on a small group of demonstrators in Lhasa. The demonstrations spread, involving over ten thousand people. Up to two hundred are believed killed by security forces before martial law is declared; four hundred are arrested. Foreign tourists, journalists, and diplomats are again expelled. Later that year the Dalai Lama wins the Nobel Peace Prize.

1990 The Chinese government expels dozens of politically suspect monks and nuns from monasteries. Martial law is lifted on May 1, though varying restrictions on foreign visitors and journalists remain in force. Small demonstrations continue in the capital but most are dealt with rapidly by the increased presence of armed police. On July 1, President Jiang Zemin visits Tibet, calling for dual policy of "security and development" and low-profile policing. He is accompanied by Chi Haotian, chief of defense staff (suggesting that the visit has military objectives). In October, the first foreign official is allowed to visit a Tibetan prison. In exile, the Dalai Lama is officially received by the Swedish, Dutch, and French governments, and privately by the Czech and German presidents.

1991 The Chinese organize obligatory celebrations throughout Tibet of the fortieth anniversary of the "Peaceful Liberation," choosing the May 23, 1951, signing of the Seventeen-Point Agreement as the representative moment to remember. Tibet is declared

"open" to foreign investment; in practice this economic liberalization favors investment from inland China and overseas Chinese.

1992 Deng Xiaoping's "spring tide" calls for implementation of economic reforms to introduce the "socialist market economy" to Tibet. An increase in shop building is ordered on all main streets and migration of Chinese entrepreneurs and petty traders increases noticeably. Chen Kuiyuan takes over as party secretary in December.

1993 Human rights activist Gendun Rinchen is arrested to prevent him from contacting high-level EEC ambassadors on a fact-finding visit to Tibet. The visit dissolves into confusion as the Chinese first deny the arrest and then refuse to release Rinchen. On May 24, a major demonstration by about one thousand Tibetans in Lhasa over price rises becomes a pro-independence protest, the largest since 1989; police use tear gas to disperse the crowd, with some injuries. In July, for the first time since 1984, an exiled Tibetan official accompanied by the Dalai Lama's brother is allowed to travel to Beijing to discuss the possibility of negotiations. The delegation is asked to request the Dalai Lama's help with the Panchen Lama search. Nevertheless, by September relations between the Dalai Lama and Beijing abruptly come to an end, and the Dalai Lama publishes his correspondence with Deng Xiaoping.

1994 Gendun Rinchen is released in apparent concession to international pressure. On May 26, President Clinton announces the dropping of all human rights conditions attached to Sino-U.S. trade. Protests by two hundred shopkeepers over tax increases are treated as political opposition and lead to some arrests. Chinese leaders hold the "Third National Forum on Work in Tibet" in Beijing to rubber-stamp implementation of even faster economic development for the "three rivers" area around Lhasa and to impose restrictions on the spread of religion. On August 9, the Chinese stage celebrations to mark the reopening of the Potala after five years of renovations. Later that year, Yulu Dawa Tsering, a former abbot of Ganden and the most senior surviving Tibetan political prisoner, is released on parole. He meets with the UN special rapporteur on religious intolerance on the first UN human rights visit to China and

issues a critical report, calling on China to change its constitution and release all monks and nuns in prison. On the same day, official statements order a ban on unauthorized construction of monasteries and the induction of new monks or nuns.

1995 From January through March, demonstrations in Lhasa call for independence, resulting in over a hundred arrests of political activists, more than in the whole of the previous year. On January 30, authorities counter with a denunciation campaign against the Dalai Lama. In March, over sixty monks are expelled from Nalandra Monastery north of Lhasa after officials "reorganize" the monastery. On May 14, the Dalai Lama announces in exile that Gendun Choekyi Nyima, a six-year-old boy from Lhari, northern Tibet, is the reincarnation of the Tenth Panchen Lama. Three days later, the Chinese arrest Chadrel Rinpoche, abbot of Tashilhunpo and head of the search team for the child Panchen Lama. The child and his family are removed under escort from their home, apparently to a holding place in Beijing. Five thousand troops move to Shigatse. On July 13, up to thirty monks are arrested from Tashilhunpo monastery after protesting the denunciation of Chadrel Rinpoche. All foreign tourists are expelled from Shigatse. A small bomb explodes at a Chinese memorial to road construction in Lhasa on July 3; a second explosion is reported at the same place about two weeks later. On September 1, the Chinese hold celebrations to mark the thirtieth anniversary of the founding of the TAR amid tight security. Reports of explosions at a fuel depot and a power station in west Lhasa follow. On November 11, the Chinese press announce that "leading lamas" have rejected Gendun Choekyi Nyima and selected a different child as the reincarnation. Chadrel Rinpoche is publicly denounced for his "crimes" as the "scum of Buddhism." On November 29, five-year-old Gyaltsen Norbu is officially named as the reincarnation of the Panchen Lama. Gendun Choekyi Nyima, whose whereabouts are still unknown, is condemned by the official press for having once "drowned a dog."

1996 On January 18, a bomb explodes at the house of Sengchen Lobsang Gyaltsen, the main supporter of the Chinese in the Panchen Lama succession dispute. By February,

700,000 cattle and at least fifty-six people in Jyekundo (Yushu), in northeastern Tibet, are dead in the worst snowstorms of the century. Another bomb goes off outside the party headquarters in Lhasa on March 18.

1997 On February 19, Deng Xiaoping dies in Beijing. Chadrel Rinpoche is sentenced to six years for "conspiracy to split the nation" for having sent letters to the Dalai Lama requesting assistance in identifying the reincarnation of the Panchen Lama. On July 1, Hong Kong returns to Chinese sovereignty. Ten thousand Tibetans attend an obligatory celebration in Lhasa. TAR party secretary Chen Kuiyuan says that Buddhism is a "foreign import" that is not part of Tibetan culture and that Tibetans must welcome "culture exchange" with the Chinese. Tibet is described by the official Chinese media as "the last and largest" inland reservoir of oil in the world. Severe winter snowstorms lead to the death of over 20 percent of cattle in Nagchu. A UN human rights delegation visits Tibet, failing to report that it witnessed a political protest in Drapchi Prison. Officials announce that the two-year "patriotic education" campaign in Tibetan monasteries is to be extended to schools, towns, offices, and villages. The full text of the Panchen Lama's 1962 report to Mao describing famine conditions and widespread persecution in Tibet is leaked from China and published in London.

1998 Zhu Rongji replaces Li Peng as prime minister of China. In April, a Tibetan activist in Delhi burns himself to death. In May, after India's defense minister cites China as their main strategic threat, India carries out five nuclear test explosions, triggering a major shift in regional politics; on May 28, Pakistan follows with six explosions. Large-scale protests in Drapchi Prison leave at least one Tibetan prisoner dead. Legchog replaces Gyaltsen Norbu as chairman of the TAR. Economic growth in the region reaches 13.2 percent, higher than the average in China for the fourth successive year. On June 24, prior to President Clinton's visit, a bomb explodes outside a police station in Lhasa. On June 27, in a joint news conference televised live to the Chinese public, Clinton urges Chinese leader Jiang Zemin to begin dialogue with the Dalai Lama.

acknowledgments

In any project of this kind it is important to recognize that it is ultimately a group effort, a collaboration of people and resources. I must thank the many people who realized the importance of this work and helped to make this book a reality:

Firstly, the Tibetan people for teaching me compassion and offering such valuable insight into the human condition. Jampel Tsering—an inspiration—for his courage and willingness to allow me to tell his story. Ngawang Rinchen, Ngawang Phulchung, and all the Tibetan activists—including those I cannot name—who have risked so much for Tibet's survival. My parents for their unconditional love, encouragement, support, and their belief in my work. Susan Shaugnessy for the incredible love and support that has nurtured my spirit over these difficult years. My cousin, Mark Bailey, the project's editor, for pushing me to complete the book and for all his selfless hard work; without his vision, commitment, and guidance this project would never have been possible. I am indebted to Robbie Barnett for his incredible dedication and generosity with both his time and his knowledge; his painstaking research made this book a reality. Nan Richardson for her experience, wisdom, and insight, patiently working with me and stepping in during a moment of crisis to carry the project through to completion—I cannot thank her enough and will always be grateful. Rory Kennedy for all of the advice, generosity, and support she has provided. Jack Woody for assuring the book's distribution. Cara Sutherland and Beth Tuttle of The Newseum for realizing the importance of this issue and making The Tibetans exhibit possible—ensuring that these photographs are widely seen. Francesca Richer for all her hard work and patience in the beautiful design of this book. Robert Coles for recognizing the importance of the work and so generously contributing his brilliantly crafted introduction. Noureddine El-Warari of Photo Impact for his magical printing of the black-and-white photographs of the book. My brothers Jim and Mike, as well as Linda, Jessica, and Joey Lehman for their love. My cousin, Paul Bailey, for the inspiration. My late grandparents Sam and Sylvia Bailey, Doris and I. D. Lehman. My uncle Ed Bailey and aunt Madelyne Bailey, and my late uncle and aunt Roger and Rhoda Lehman for their love and support. Rand Mayer for his friendship and support over the last twelve years and for ensuring that the first television footage of unrest in Tibet reached the outside world. Bruce Abrams for the many years of friendship. The British researcher who sent out the first telex to Reuters on September 27, 1987, and Jayne Ferguson, for taking my film of that day to Hong Kong and securing its publication. Jamyang who took enourmous risks to help me on October 1, 1987, and the unknown person who lent me their camera on that same day. Cliff Toliver for all his help, Annette Egholm for taking my film to India, and David Brauchli and Richard Ellis for transmitting the film from the Lhasa riot. To Marcel Saba for his dedication and guidance throughout my career. To Guy Cooper of Newsweek for his support and encouragement—I would not have been able to complete this book without the work he has assigned me. Melissa Cohen for her amazing generosity throughout the project; Melinda Liu of Newsweek for her consistent help and enthusiasm. Andrea Doering for all her hard work and for her friendship, Dave Zabel for always being there when I needed him. Campbell Bradford for her friendship and free legal advice. Tenzin Chokey of Tibetan Center for Human Rights and Democracy (TCHR) for her enthusiasm, patience, and hard work. Topden Tsering for his hard work and precise translation of the Jampel Tsering interview, Akemi Takahashi for additional translation. The staff of Circum-Arts Foundation: Doris Caravaglia, Rick Biles, Ken Maldonado, and Rosa Nemirovskaya for all their help. The staff of The Newseum for their dedication and support: Joe Urschell, Ann Rauscher, Marion Rodgers, Eric Newton, and Tracy Quinn. Charles Overby, Peter Prichard, and Robert Giles of the Freedom Forum. Our assistant editors Rula Razek and Catherine Byun for their thorough and considered work. Nancy Bagley for her interest and incredible generiosity, Ahsie

Warner, Charlene Engelhard, Steven Farber, Dr. Cordulla Kirchgessner, and William Zabel for their generous support. Max and Vicki Kennedy, Bertis Downs, Michael Stipe, Bob and Nena Thurman, and Jeanine Pepler for their help with fundraising for the project. Ganden Thurman, Peter Matthiessen, and Philip Glass. Victor Hou for his always wise counsel. Tsering Shakya, Louise Fourtin, and the staff of Tibet Information Network for all their hard work. Leslie Goldman who helped me so much during my early work in Tibet. To Stephen Ferry and Alex Webb for their insight and advice. The staff of Photo Impact for their incredible commitment to excellence: Yvonne Sarceda, Don Weinstein, Hugh Milstein, Jimmy Fikes, Steve Moulton, Ira Mintz, Morris Taylor, and Bobby Peele. The staff of Nardulli Lab: Phillip Nardulli, Khodr Cherri, Art Nardulli, Alfred Acosta, and Stephanie Voychik. Steve Oliver for his precise copywork of the original art that went into the book. Rick Two Dogs, Edna Two Dogs, Ethlene Two Dogs, and Dennis White Shield for the knowledge they have given me. Daniel Power and Craig Cohen for all the long hours that they put into the project. Gary Breece for his friendship and help, Joel Barral, Bill Wintersole, and Marlene Silverstein for all their assistance. Pat Casteel and Steve Wiley for painstakingly transcribing the Jampel Tsering interview. The strangers who helped me and asked nothing in return.

This project could not have been completed without the support of the following people who contributed their time, energy, and resources toward fundraising for the project: Wangmo Gelek, Pema Gelek, Vicki Riskin, Alex Rose, Kerry Kennedy Cuomo, Jeffrey Sachs, Dana Giacchetto, Robin Chasky, Ed Emerson, Lisa Anzalone, Ed Beason, Emily Horowitz, Tim Nunn, Elizabeth Wagley, Kathy and Amy Eldon, Julie Wilson, Todd Rosenburg, Trouz Quavis, Carol Hamilton, David Kohen, Diana Takata, Robin Cornman, Carol Sauvas, Betsy Dossett, J. Marc Pouliot, Carl Rosenstein, Richard Boele, Christine Sarazen, John Silva, Saar Klein, Annie Tien, Peter Mensch, Susie Forzano, Beth Anne Buddenbaum, Marina Illitich, Karen Mullarkey, Robert Mullin, and Baine Ennis.

I am grateful to the people who let me into their lives to photograph and interview them: Dr. Dawa for his analysis and insight, Dr. Dachoe, Gyaltsen Choetso, Lobsang Dechen and Tenzin Rangden of the Tibetan Nuns project, Tsering Norzom Thonsur, Dr. Tenzin Chodak, Dr. Yeshi Dhonden, Dr. Namgyal Kusar, Dr. Tenzin Geyche Shilok, Thukop Dorjee, Dr. Jamyang Gyatso, Tsewang Dolma, Dr. Nyidom, Kharma Thutop, Dr. Tashi Dolma, Tashi Rabten , Ling Rinpoche, Thupten Tashi. The members of Gu-Chu-Sum: Thupten Gyaltsen, Ngawang Khetsun, Jampel Leksang, Tsering Dorje, Lobsang Dekyi, Tsering Choekyi, Ngawang Yangdon, Tsering Sonam, Ngawang Jamchen, Jamyang Kunga, Ngawang Topchu, Ngawang Thardoe, Ani Panchen, Nyma, Ganden Tashi, Tsering Norbu, Ngawang Dorje, Chupsang, Ngawang Woebar, Namdol Tenzin, Dawa Kyjom, Dolma Sangmo, Tashi Dolma, Ama Adhi, Tenzin Choesang, Thupten, Tenzin Lobsang, Reting Tenpa Tsering, Tenzin Choekyi, Rinzin Choenyi, Lobsang Norbu, Ngawang Jampa, Jigme Dorje, Ngawang Choejom, and Ngawang Rengdril.

To the Dalai Lama who embodies the word compassion. To the Tibetans living in exile who facilitated my research. To Tenzin Geyche Tethong for always finding the time and the staff of the Private Office of the Dalai Lama: Tenzin Taklha, Kelsang Gyaltsen, Tsering Tashi, Ngodup Tesur, Singe Rapten, and Lobsang Jinpa. Lobsang Nyandak at Tibetan Centre for Human Rights and Democracy for the enthusiam, patience and hardwork. Lodi Gyari and Buchung Tsering of the International Campaign for Tibet, Tenpa Tsering, Director of the Tibetan government-in-exile Office of Information and International Relations. To Tendar for all his hard work, Tenzin Atisha, Tsering Wangqiu, Neema Phenthok, Tseten Samdup, Thupten Wangyal, the staff of the Hotel Tibet in Dharamsala, India, Tinley Nyandak, Narkyid Nawang Thondup (Kuno), Tenzin Kongsta, Lhasang Tsering and Jamyang Norbu of the Amnye Manchen Institute, and Tenzin Sherab.

The small group of individuals who have worked to ensure

the flow of information from Tibet, whose dedication to the issue is admirable: Nick Howen, S.H., Ron Schwartz, John Akerly, Tom and Sue Piozet , Christa Meindersma, Bradley Rowe, Steve Marshall, Blake Kerr, Cristophe Besuchet. The people who helped me at varying times during my field work: Alexis Wichowski, Fabrizio, Paula Quenemon, Richard and Althea, Murray Spence, Phil Sugden and Carol Elchert, Jim Ziolkowski of Building with Books, Jude Bueno de Mesquita, S.C., Kurt Thorson, Phillip, James Spalton, Philip Coggin.

I also would like to thank my editors and colleagues who have worked behind the scenes and supported me throughout my career: The staff of SABA Press Photos: Janet De Jesus, Don Standing, Elizabeth Lagrua, Leslie Powell, Jean Saba, Jerry Arcieri, Mary Iuvone, Evan Nisselson, Katie Grannan, Nina Schoenbaum, Galina Andreauc, Jojo Whilden. Jean-Francois Leroy, Christian, Sylvie Grumbach and the staff of Visa Pour l'image. Aaron Schindler of Photoperspectives for his friendship and advice, Grazia Neri and Elena Ceratti, Sophie Gibeau, Liz, and Ann of REA, and Roberto Koch and the entire staff of Contrasto. Karen Bearson and Stephen Mayes of Tony Stone. The editors of Time magazine that have consistently supported my work: Hillary Raskin, Martha Bardach, Jay Colton, Robert Stevens, Michele Stephenson, Rick Boethe, Karen Zakrison, Lisa Botos, Ames Adamson, Christina Holovach, Julia Richer, and Mark Rykoff. Elizabeth Massin, Elizabeth Gallin at Newsweek, Kimberlee Acquaro, MaryAnne Golon, Olivier Picard, and Alice Gabriner of U.S. News and World Report, Mary Dunn at Entertainment Weekly, who assigned me to photograph the Dalai Lama in 1988, Marie-Claire Sudres, and Nicole Nogrette of L'Express. Elizabeth Avedon at Swing magazine, Allison Morley at Audubon and Civilization; Yukiko Launois, Pierre Langblade and Vincent Migeat of Le Nouvel Observateur; Jean Jacques Nodet and Carol Squires of American Photo, Kent Kobersteen and Jon Schneeburger at National Geographic, Linda Rubes at React, Joseph Csallos at Der Spiegel, Dieter Steiner, Angelika Hala, Harald Menke, and Sue Lapsien at Stern, Akiko Hirota at GEO Japan, D. I. Lee and J.G. Seo at GEO Korea, Jean Luc Marty, Philippe Bordes, and Sylvie Rebbot of GEO France, Rhonda Rubenstein at Mother Jones, Angela Reichers at Harpers, Bridgette Booher at Duke Magazine, and Colin Jacobson.

On a more personal side, I would like to thank all my friends and relatives who over the years have provided much encouragement and support: my cousins Missy, Jon, and the late David Lehman; Jeanne, Rosemary, and Jennifer Lehman; Molly, David, Roger, Sara, and Katie Lehman; Charles Miller and Sheila Bailey; and Lisa Tracy, Dave Lefkowitz, Lillibet Foster, Nancy Chen, Larisa Olson, and Peggy King for their advice and help on the book. Mark and Molla Lazarus, Drew and Wendy Kaye, Drs. John and Joyce Harrison, Joseph, Mike Abert and Hensley Evans for always opening their home to me, Yasemine Tong, Andy Plantinga and Alex Reagan, Adam Werbach, Mack Sharrip, Prapod Assavavirulhakarn, Abbas, Liz Gould, Anne Seidlitz, Christine and Chris Campe-Price, Daphne Howland, Alfred Aung Lwin, Brian Turlington, Simone Tan, Bobby Oneil, Danny Fitzsimmons, Phil Costello, Bill Brunnel for all his help in my early years, Michael Oatman, Tom Stahl and Julie Kim, Cathy Ching, Scott Frazier, Barry Elbaum, Sally Liu, Ana Yee, Steve Chasan, Drew Hoegel, Gary Sklar, Craig Freeman, Stacie Renfro, Chris Jube, Chris Frost, Lofton Abrams, A.S., K.M., A.T., D.P., Carrie Raben, Pete Stein, Jim Ziolkowski, Bettina, Sabine Schuldes, Stephanie Adams, the late Dr. Sid Hurwitz and the Hurwitz family, Peter Weinburg, Laura Dillon, Richard and Noah Horse, Buzz Iron Cloud, Ken Lone Elk and his family, Richard Iyotte, Russ Cournoyer, Bob Lone, Elk Milo Yellow Hair, Amos American Horse, Brian Dodge, Dolma Tsering, Stacie James, Tracy Strayer and Shi Cun, Frank Barnaba.

I am grateful to the people involved with the Tibetan issue who have shared their expertise and resources: Nancy Nash, John Dolfin, Michael Van Walt, Congressman Tom Lantos and Congressional aide Kay King. Paul Berkowitz of Congressman

Benjamin Gillman's office, former Congressman Charlie Rose and his aide Keith Pitts, Ken Allen of the Stimson Center, Gregory Craig, Special Coordinator on Tibet Issues, Department of State; Maura Moynihan, Paul Donovitz of SFFT, John Hassavar, Jane Moore of Tibet Image Bank, Martin Wassel, Francis Fourcade, Claude Challe, Tseten Phanucharas of the L. A. Friends of Tibet, John Garfunkel of Tibet Educational Network, John Avedon, Erin Potts, Andrew Bryson, and Sam Chapin of Milarepa, Ellen Bruno.

To the people who have provided me with legal, medical and professional advice and assistance: Wendy Smith, Sam Silverman, Ed Gallant, Mark Pollard, Martin Garbus, Dr. Wayne Winnick for fixing my body, Dr. Harry Mark, Dr. Marsha Woolfe, Emily Miggins and Aaron Lehmer of Rethink Paper, Amy Armstrong of the Stinehour Press, Archie Beaton of the Chlorine-Free Products Association, Terry Smith of Scheufelen Paper, and Ron Fouts. My assistants: Natari Mwine, Chris Martinez, Brad Hoegel, Catrina Siegmund, and Dennis Komick. Susan Osnos of Human Rights Watch, Sylvia Wachtel, Jane Tenbrink at the Museum of Tolerance, and David Thorpe, Tom Chase, and Carolyne Wakeman.

To my friends and colleagues in print and televison who helped during crucial moments: Cinde Strand, Mike Maren, Juan Senor, Pico Iyer, Anderson Cooper, Paul Watson, Jeff Cochran, Josh Hammer, Helen Palmer, Michael Kirsh, Li fellers, Desmond Wright, Masaomi Karasaki, Dominic Faulder, Tom Sampson, Daniel Sutherland, Allan Little, Carrie Gracie, Chuck Lustig, Stephane Dujarric, Deborah Wang, Jim Laurie, Greg Fisher, Ingrid Formancek, Larry Doyle, Allen Pizzy, Hugh Williams, Steve Miller, Gunilla Von Hall, Keith Kay, Jon Steele, Mark Austin, Carlos Marveleon, Steve Robinson, Danielle Mattoon, Matt Futterman, Laura Haim, Janet Reitman, Liz Garbus, Erika Euler, Margo Hornblower, and Terry McCarthy.

To my photographer friends and colleagues who have provided inspiration and support throughout: Christopher Morris, Jacob Holdt, Tomas Muscionico, Greg Girard, Jeff Dworsky, Paula Skully, Klaus Reisinger, Heidi Bradner, Mariella Furrer, Patrick Chauvel, Gerald Herbert, Lee Celano, Ron Haviv, Luc Delahaye, Scott Peterson, Phillip Dietrich, Joanna Pinneo, Corrin Dufka, Paul Lowe, Justin Leighton, Harriet Logan, Lauren Greenfield, Robert Maas, Joe Rodriquez, Tom Stoddart, Wesley Bocxe, Andrew Lichtenstein, James Natchwey, Andy Hernandez, Patrick Robert, Antonine Kratochvil, Mark Peterson, Jim Lindsay, Mark Asnin, Peter Blakely, Gilles Peress, Manuel Bauer, Nancy Jo Johnson, Stephanie Heimann, Noel Quidu, Olivier Jobard, Colin Findlay, Evy Mages, Carol Guzy, Dominic Cunningham-Reid, Elizabeth Rappaport, Viorel Fioresco, David and Peter Turnley, Alfred, Arif Asci, Michael Yasakovic, Cedric Galbe, Alexandria Avakian, Frank Fournier, Ira Wyman, David Burnett, Peter Dejong, Lee Romero, Maggie Steber, Jane Atwood, Eligio Paoni, Jeff Mermelstein, Thomas Kern, Mark Gamba, Steve Prezant, Sylvia Plachy, Dan Habib, Les Stone, Greg Smith, Robert Wallis, Brian Baer, Jose Azel, Yunghi Kim, Bill Robinson, Phil Borges, Sonam Zoksang, Laura Jo Reagan, David Butow, Jason Escanazi, Joe Cavaretta, Jeffery Vock, Mark Richards, John Giannini,Tony Suau, Michael Schumann, Greg Marinovitch, Erica Lanser, Rick Friedman, Mark Avery, Bruce Strong, Scott Applewhite, Harvey Stein, Nancy Sirkis, Q Sakamaki, Steve Shames, Arthur Grace, Peter Manzel, P.F. Bentley, Steve Liss, Dirk Halstead, Malcolm Linton, and Simone Norfolk.

To the dedicated individuals who helped me with professional services throughout my career: Dave Metz, Chuck Westfall, Tony Sun, and Joe Delora of Canon Inc., Itzach of K and M Camera, Color Center Lab, Sal Nasca and Gregg at Colorite Photo Lab,Voya Mitrovich of Picto Lab, Mise Au Point Lab, Tony at Chrome and R Lab, Brian Finke for his wonderful printing, Antonio Hernandez and the staff of Copymat, Helen at DGI Travel, Sophie at S and K Travel, Adden Chrystie at Valerie Wilson Travel, Bob Lamb Video, Leonard Washington, Alex Hestoff and Harrison at Kinkos, Professional Photographers of America, Asia Emergency Assitance (AEA), and Sonal Desai of Cigna. Tom Brown of the Tracker School.